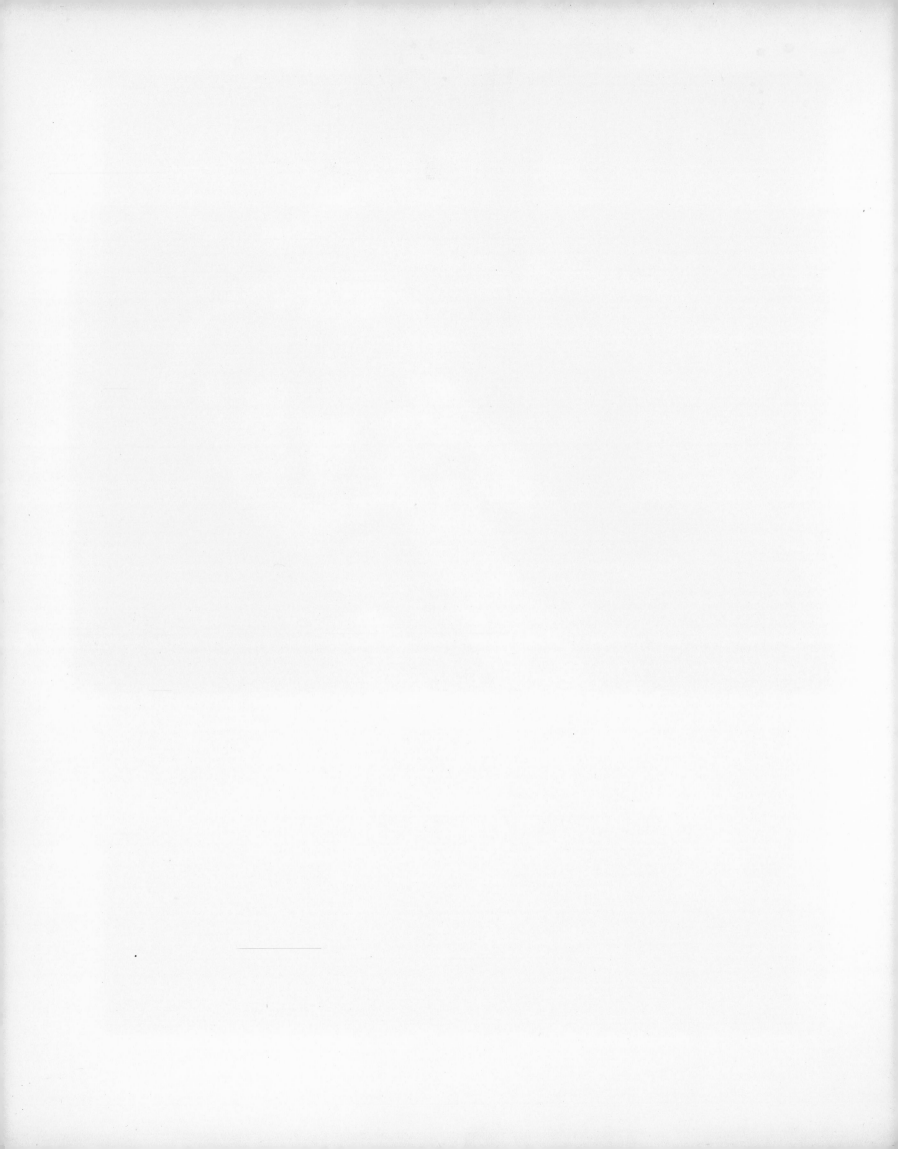

ATHLETES

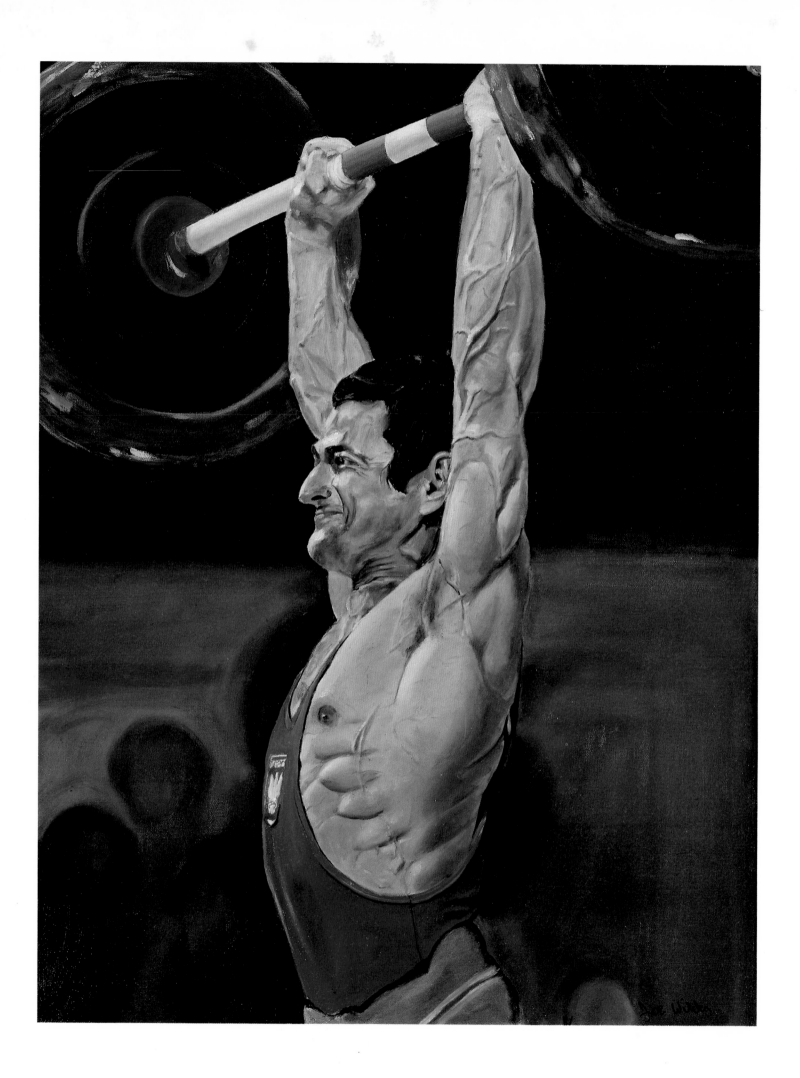

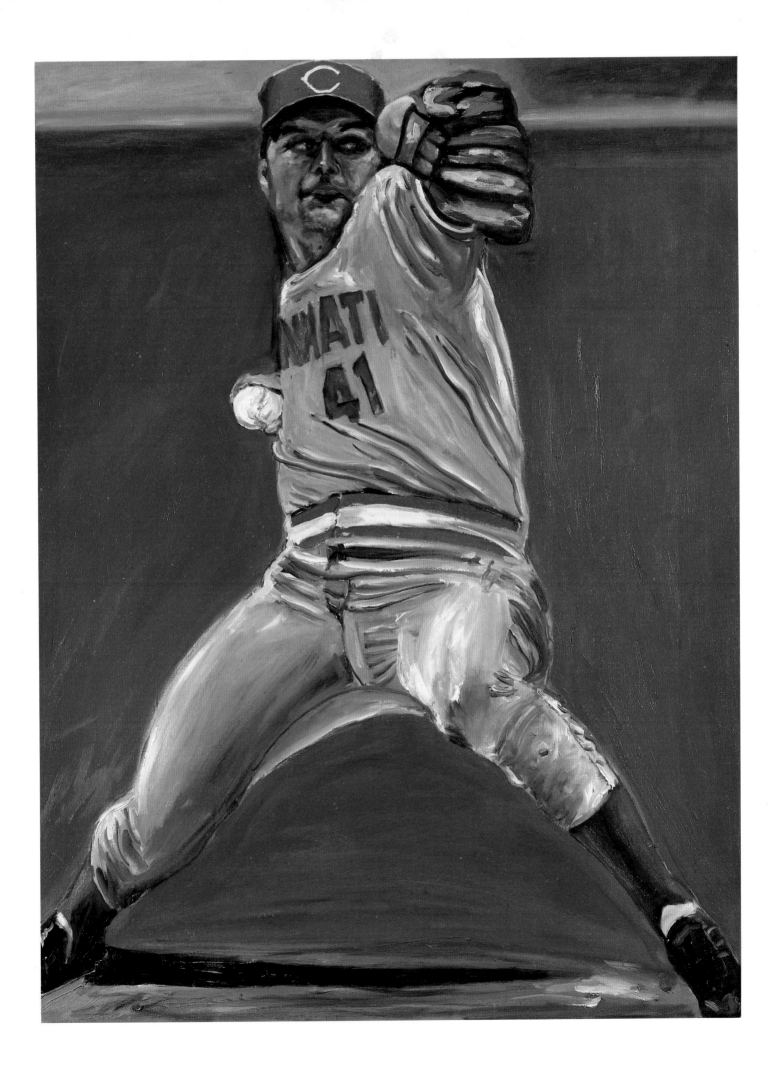

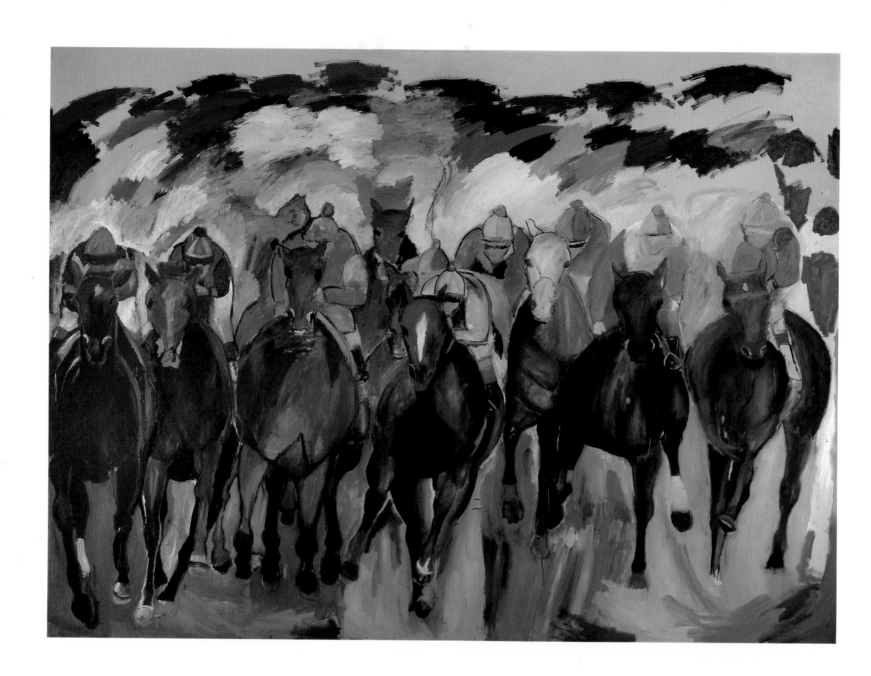

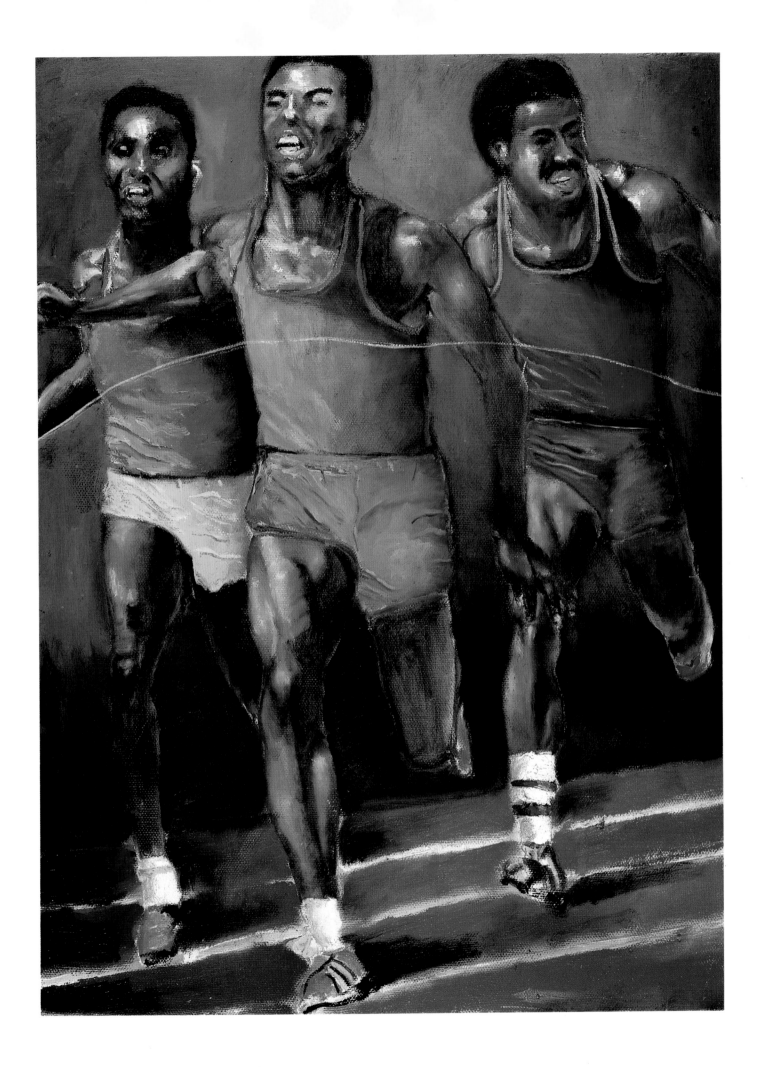

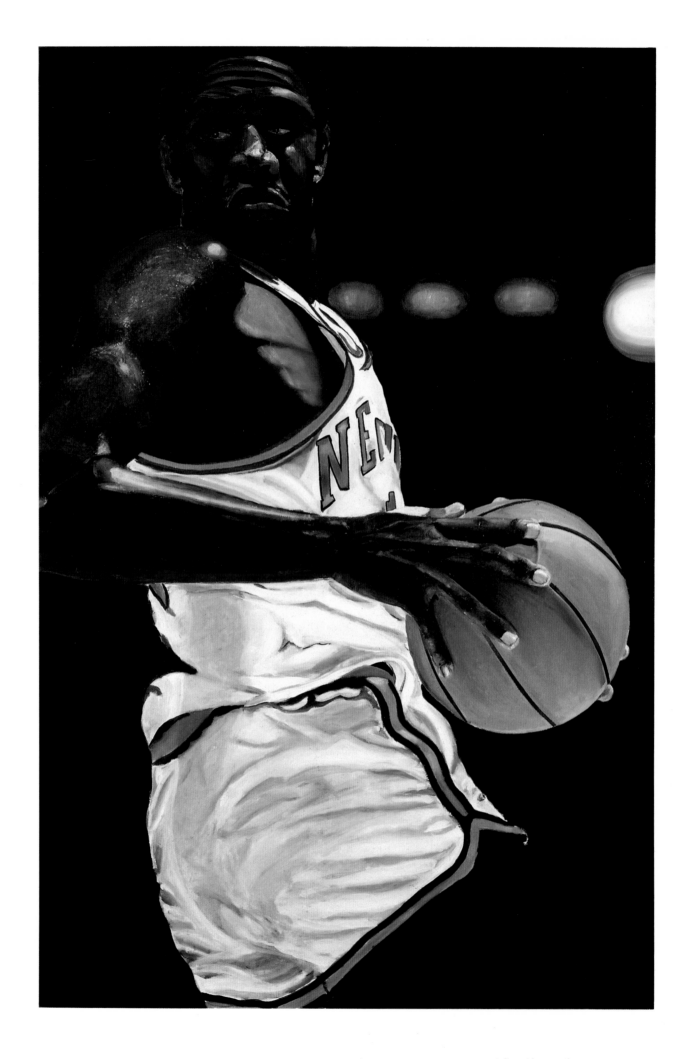

ATHLETES

· THE PAINTINGS OF JOE WILDER, M.D. ·

FOREWORD BY LEWIS THOMAS

ESSAYS BY

RED AUERBACH · IRA BERKOW · JOHN H. BLAND, M.D.
JAMES COUNSILMAN · STEVEN J. DANISH
ELLINGTON DARDEN · ROGER KAHN
FRANK LITSKY · SAM POSEY
TOM SEAVER
MORTON H. SHARNIK · WILFRID SHEED
MICHAEL WATCHMAKER

AFTERWORD BY DORE ASHTON

HARRY N. ABRAMS, INC., PUBLISHERS, NEW YORK

THE C.V. MOSBY COMPANY, ST. LOUIS,
TORONTO, PRINCETON

Editor: Margaret Donovan

Designer: Michael Hentges

Photo Research: Barbara Lyons

LIBRARY OF CONGRESS CATALOGING IN PUBLICATION DATA

Wilder, Joe, 1920–
 Athletes: the paintings of Joe Wilder, M.D.

 1. Wilder, Joe, 1920– . 2. Athletes in art.
I. Auerbach, Arnold, 1917– . II. Title.
ND237.W648A4 1985 759.13 85–7368
ISBN 0–8109–1623–1
ISBN 0–8016–5445–9 (Mosby)

PAGE 1 *Lotus Ford.* c. 1962. Encaustic on canvas, 36 x 61"

PAGE 2 *Smalczerz, Flyweight Champion.* 1976. Oil on canvas, 37 x 28". Collection Cynthia Wilder

PAGE 3 *Tom Seaver.* 1977. Oil on canvas, 49 x 36". Collection Richard Waters

PAGE 4 *The Great American Horse Race No. 2* (in progress). 1979. Oil on canvas, 80 x 120"

PAGE 5 *Breaking the Tape.* 1983. Oil on canvas, 16 x 12"

PAGE 6 *Willis Reed.* 1975. Oil on canvas, 60 x 40"

Printed and bound in Japan

CONTENTS

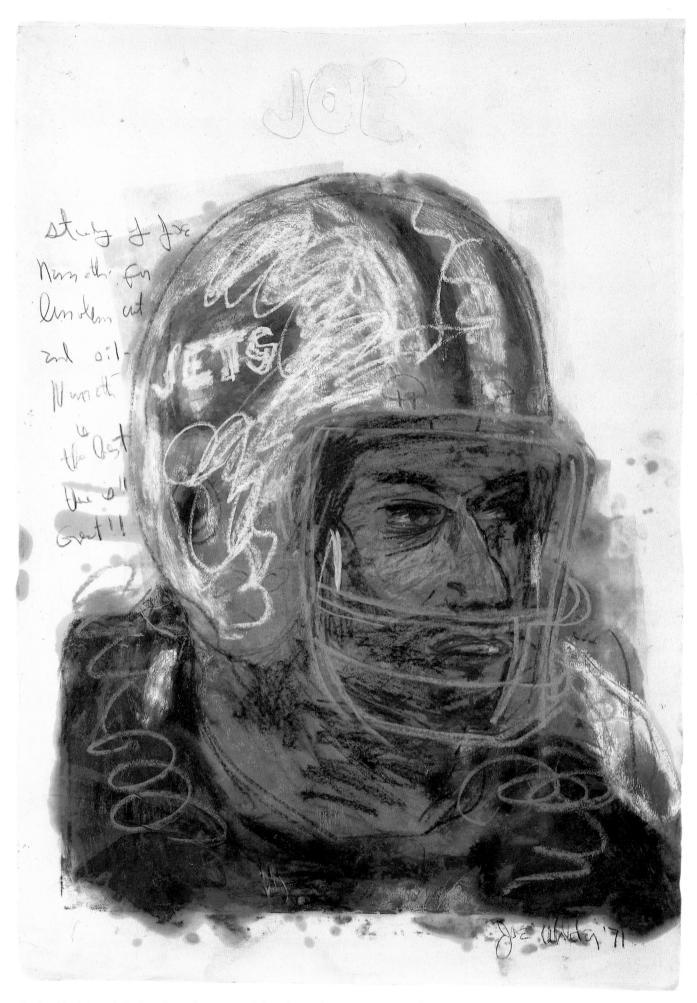

Study of Joe Namath for Linoleum Cut. 1971. Oil and pastel on paper, 34 x 24″

FOREWORD
Lewis Thomas, M.D.

A while ago, I opened a package of typed pages, the chapters now contained in this book, just after leaving New York on an early morning shuttle to Washington. It was raining. The long delay in getting off the La Guardia strip, and the longer time circling National Airport before landing, gave me hours enough to zip through the essays. By the time I'd climbed into a Washington cab I knew that this was a book I'd want to read again, slow and easy, learning all the way, for the fun of it.

It is a world I've known almost nothing about. Mostly sessile and sedentary, my contact with professional sport has been restricted to brief flashes on television news programs, mostly incomprehensible hockey and basketball. I had a theory that the networks kept a little file of clips from a single football game played long ago and simply ran the same pictures night after night with different voices and crowd noises. As for baseball, I had the sense that I was probably missing something very interesting, but missing it clean anyway. Now, after reading these essays, I plan to sit up and pay attention.

Inside the taxi, driving across Washington in the rain, I watched the hundreds, maybe thousands, of earnest joggers out for their morning ritual of pain and penance. Looking out at the glum, stubborn, determined expressions, the elaborate running costumes, the fantastic, always new-looking sneakers, the mixture of rainwater and sweat on all those sad faces, I suddenly realized that this was another new and unfamiliar world, not at all connected to the kind of sport displayed in Dr. Wilder's paintings or in these essays.

It was an unexpected surprise. After all, when you pick up a book on sport conceived and organized by a doctor these days, you might be expecting another set of instructions on healthy habits, the therapeutic virtue of exercise, how to avoid coronary thrombosis or stroke or cancer or what-all, maybe even how to change your life-style or get thinner or acquire a different personality, all in aid of living longer.

Surely not a book on the sheer beauty of professional sport, with paintings providing vivid glimpses of the aesthetics of athletics. But that is what this book is really about: the strangeness, the particularity, and the occasional pure perfection of the human form, achievable by only a few of us but there for all the rest of us to take pleasure in watching. Henceforth, I hope to be spending more of my time somewhere on the sidelines, sitting up straight, paying closer and more respectful attention.

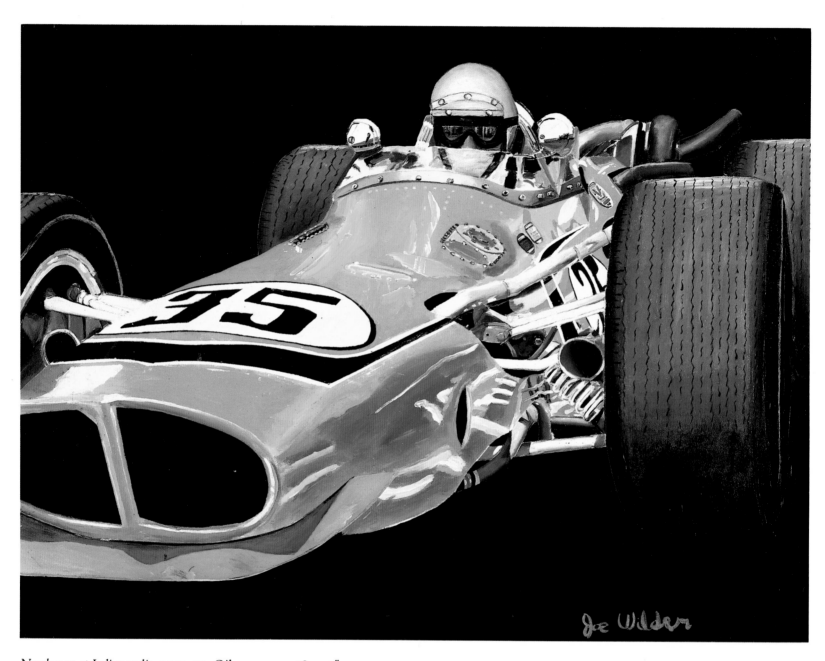

Number 35 at Indianapolis. 1971–72. Oil on canvas, 38 x 47″

INTRODUCTION

> There are some things which cannot be learned quickly
> and time, which is all we have, must be paid heavily
> for their acquiring. They are the very simplest things
> and because it takes a man's life to know them
> the little new that each man gets from life is very
> costly and the only heritage he has to leave.
>
> ERNEST HEMINGWAY, *Death in the Afternoon*

I am an athlete, a surgeon, and a painter.

I have learned that the good ones in these three fields have much in common. They have enormous energy, dedication, motivation, and concentration. They are strong-minded and strong-willed, with good physical coordination. They all pay attention to the fine details. They have a compelling commitment to excellence. They all have open minds and are willing to listen. They all have insatiable creative energies.

Witness the great painters in each generation who break with tradition and their peers as they provide society with bold new visions. Witness the courageous surgeons transplanting hearts and reimplanting legs in spite of the hostility and criticism of their peers. Witness the great athletes who refuse to be stereotyped and, in the process, develop new techniques as they set new records.

I am confident that many of these men and women could trade professions with each other if circumstances made it possible. Willem de Kooning would be a superb neurosurgeon: tough, tenacious, and imaginative. Jasper Johns, with his gentle patience and brilliance, would be an outstanding diagnostician and internist. Jim Dine, with his great love for the workings of tools, would be an outstanding orthopedic surgeon. Senator Bill Bradley, with his background in basketball, could easily join Dr. William C. DeVries implanting mechanical hearts. Al Davis, whose Los Angeles Raiders football team has the best record in professional football, would be a brilliant president of a medical school. Baryshnikov, that unbelievable master of dance, would be a great shortstop in baseball. I am sure of these facts for I have been there. As an athlete, a painter, and a surgeon, I have lived in these worlds intensely and fully.

13

I love sports. From the games of my own childhood to those I share with my sixteen-year-old son, Nick, today, sports have been a source of enormous fulfillment to me. I have taken thousands of photographs of all kinds of sports events, which is definitely the next best thing to participating. *Sports Illustrated* has sent me on photography assignments, and *The New York Times,* among other publications, has published my sports articles and images. One way or another, I have managed throughout my lifetime to keep my love for sports alive and vital.

In medicine I have known the exhilaration and deep rewards that come with teaching surgery to young men and women and the great satisfaction of surgically repairing the sick and injured. As a chief of surgery I have been responsible for the care and treatment of a great many patients, and I have developed some new basic approaches to the traumatized patient. One of the richest moments in my career came when a nun in Africa wrote to tell me that my *Atlas of Surgery* had enabled her to perform certain operative procedures for the first time.

My commitment and excitement as a surgeon remain as intense today as on my first day as a freshman medical student standing outside the entrance to the Columbia University College of Physicians and Surgeons Medical School and looking up with awe at the handsome Gothic architecture.

Painting, on the other hand, has nourished my creative energies and has given me a deep inner satisfaction which comes from creating with only myself, my paintbrush, and my canvas for company. This fulfillment is in dramatic contrast to the busy worlds of medicine and sports, where commitments to others play such a vital role.

Combining these three worlds has given my life a very special dimension. There are twenty-four hours in a day—six for sleeping, ten to twelve as a surgeon, and the other six devoted to my family and to sports and painting. I paint at 5:30 in the morning, 11 at night, or whenever I can find a chunk of time, but I paint every day.

The strategy, preparations, research, and planning for a painting, an operation, or an athletic contest have so much in common that I am constantly trading off these three worlds, one with the other, favoring none and loving all.

When I paint I use lessons learned in the world of sports and in the surgical operating room. The drawings I do in preparation for a major painting are almost identical to the research and studies I do in the anatomy laboratory in preparation for surgery. In teaching my medical students, I constantly use lessons and practical experiences learned in painting and sports to pry open their eyes a little bit and give them better insights into human behavior. I try to stretch their brains and their creative energies by providing anecdotal material from the worlds of sport and art. I know this stimulates them. I can see it in their eyes.

14

In 1916 my father, David Wilder, deserted the Russian army and at risk of death torturously made his way to England, then to the United States. He finally settled in East Baltimore, Maryland, where he became the head of a large clan. His eighteen-year-old wife, Dena, joined him and together they raised four children in the shadows of the grocery store at Wolfe and Pratt Streets. Working from 5 A.M. to 9 P.M. six days a week and half a day on Sunday, the family eked out a meager existence among the row after row of canned goods and the pungent, sweet odors of bakery goods and vegetables.

Our main contact with our parents was watching them deal with the working-class customers and the smart-aleck salesmen as they matched wits in Polish, Russian, Yiddish, and terrible English. We four children were expected to survive and accomplish by our own efforts. Our parents clothed us, fed us, loved us, and with an affectionate hug or kiss encouraged us to succeed in the world. I still remember my father's only, but often repeated, gesture of encouragement: a gentle pat on the back accompanied by almost a whisper, "Do well, my son." That was it! How we did it, how we got on in the outside world, was our problem.

The germination of my interest in sports dates to my flight from the grocery store—desperate for freedom, desperate to find a release for my pent-up energy, and determined to find a way to win acceptance among my peers. The only world available to me at that time was the streets of East Baltimore.

A wiry, agile kid, I became streetwise, mastering every ingenious game invented by other street achievers. Wireball: you matched talents with your opponent by throwing the ball straight up in the air at the overhead telephone wires, the object being to strike the wires, making it hard for your oppponent to catch the ball. Wall ball (played in a narrow alleyway with two parallel walls): the object was to slither the ball up one wall with just the right touch and spin, so the ball arched over to the opposite wall and slithered down it like water, making it difficult for your opponent to catch. There was also tin can willie; home sheep run; street hockey; pickup games of football and baseball—until by the age of twelve, I was a bona fide street sports jock, constantly perfecting my physical skills.

This was followed by the exciting discovery that I could get into any major sports event in Baltimore by selling the *Evening Sun* at two cents a copy. I graduated from selling newspapers to becoming the team stickboy, waterboy, or batboy, which had the added advantage of gaining immediate access to the players, the coach, and the locker room. I also won new status with my street friends as I came home with sports paraphernalia given to me by the various players.

What excitement! I was able to observe at close range professional wrestlers grunting and groaning, young boxers fighting for their lives, ice hockey players

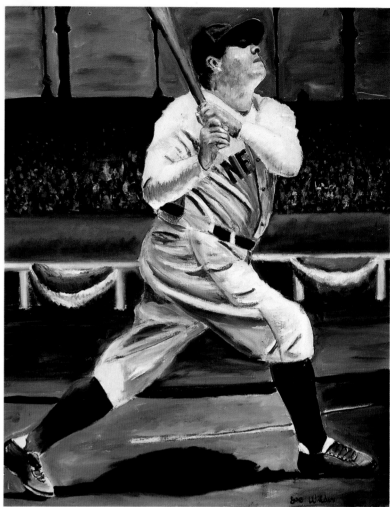

Babe Ruth. 1984. Oil on canvas, 30 x 24″

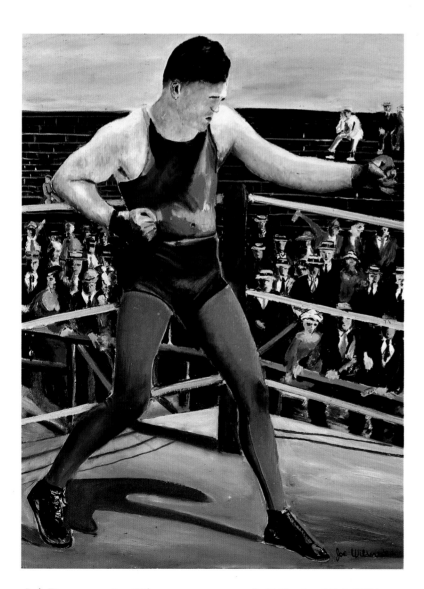

Jack Dempsey. 1984. Oil on canvas, 32 x 24″. Collection Nick Wilder

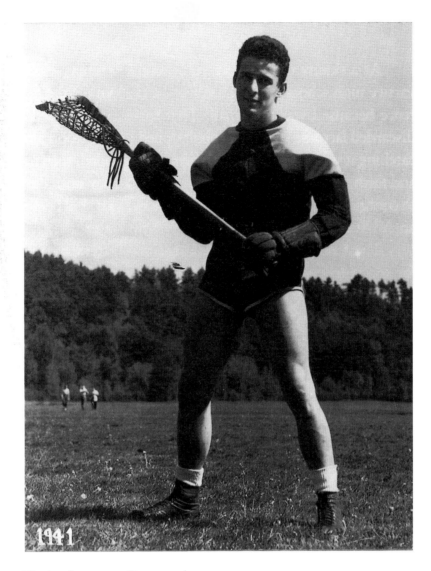

Playing lacrosse at Dartmouth, 1941

speeding up and down on the beautiful white ice, baseball players gracefully lifting balls over the fence. The violent sports of football and lacrosse became my favorites and I played them throughout my high school and college life. I was also developing hero worship for some of the legendary sports figures, like Babe Ruth and Jack Dempsey.

Early on I became familiar with the rituals of the locker rooms as the injured athletes, shouting, joking, and having their legs wrapped, made a vivid impact on my senses. The smells, noises, and excitements of locker rooms, first seen as a youngster, were later repeated many times for me as an active athlete, as a busy surgeon in the surgical locker rooms, and as a lonely painter. Each activity elicited the same odors, coming from the same body salts, and each ritual—whether changing into football uniform, surgical scrub suit, or painting clothes—produced identical thrills.

As a skinny thirteen-year-old weighing ninety-eight pounds, I went out for varsity high school football, only to be thrown off the field by Coach Harry Lawrence because I was too small. That spring, undeterred and using a patched-up, discarded lacrosse stick in a cobblestoned alley, I stood alone throwing the ball and catching it with the stick—ten times right-handed, then ten times left-handed, back and forth, hundreds and hundreds of times a day until darkness made it impossible to continue. Three years later, the ambidextrous skill I developed helped me become an All Star high school champion lacrosse player.

These rich sports experiences as a youngster gave me tools I still use. My love for sports followed me through Dartmouth College, where I played many sports and was a first-team All-American in lacrosse. In medical school I played professional lacrosse on weekends, and in all the years since that time I have continued to jog, swim, ski, and exercise whenever possible. One of my great thrills at sixty-three is sparring with Nick, who keeps me on my toes while I watch him with joy as he uses his agile young body. When I watch him wrestle or play varsity football or lacrosse, I get so excited and nervous I lose all inner composure and can hardly breathe.

My experiences as an athlete made the difference to me in becoming a doctor and a surgeon. Although I was warned that becoming a doctor was a long, arduous task, sports had given me the confidence necessary to compete with the elite of my generation. I went through medical school observing at first hand the great mysteries of the human body with its thousands of intricate systems working in harmony with each other. The amazing, complicated, and yet beautiful body systems have always fascinated me. I find myself equally excited watching any virtuoso performance of body coordination, whether it is a short-order cook tossing pancakes, a pizza flipper, Joe Namath throwing a pass, or Isaac Stern on the violin.

One moment I shall never forget was at five o'clock on a Sunday morning as I returned from an all-night emergency operation on a policeman who had been badly shot. As I was slowly driving along Riverside Drive, collecting my thoughts and watching the Hudson River and the sun just beginning to light up the sky, I noticed a slim black man all alone, with most of New York asleep, shining a big, sleek, silver gray Cadillac. He had choreographed a graceful set of dance movements as he leaped, jumped, and pirouetted from the front of the car to the back; with exquisite coordination he polished the car with both hands in an intricately worked out, rhythmic set of movements, not missing a beat. He turned a dull, menial task into a dancing fantasy. And the beauty of it was that he was doing it, as any true physical purist would, for the sheer joy of it. I understood that.

18

When I graduated from medical school, my dream was to become a chief of surgery. Once again I carefully used those tools learned as a competitive athlete—first establish basics, the rest follows as night follows day. I spent a year in a medical residency learning about body systems, then a year in a pathology residency learning about diseases, then six years in surgical training. I was never deterred from my goal as I watched my classmates go into practice and buy fancy houses and cars. All in all, I spent eight years training, twice the required time, but I was convinced that I would outdistance them down the road. I had learned this so well as a thirteen-year-old when I spent all those hours bouncing the lacrosse ball against the wall. I continued to learn many valuable lessons, but the old one of "a little at a time" was my mainstay. (My dream to become a chief of surgery was realized a few years later at the age of thirty-two.)

During my surgical training, I noticed that many of my colleagues, like many of my former teammates on the athletic field, refused to master fundamentals. I still observe this today: many young surgeons are so preoccupied with keeping "score sheets" of how many operations they perform that they fail to learn basics. I observe well-coordinated and intelligent young men and women refusing to stretch themselves and learn difficult surgical techniques; instead, they all too frequently settle for easier but less efficient approaches.

One example is the use of scissors instead of a scalpel for dissection. Scissors are gross, crude instruments compared to the sweeping, efficient, and graceful scalpel. Scissors cut in short, jerky, chopping steps, leaving behind uneven clumps of mutilated tissue, whereas a scalpel, properly mastered, gives you a clean, precise incision. Using scissors is like painting with your fingers, using a scalpel like employing a delicate paintbrush.

Every athlete, every surgeon, and every painter must be prepared for a transient period of awkwardness whenever a new technique is being mastered. Most young surgeons refuse to learn to use their left hand—in contrast to the legions of less-privileged, less-educated young basketball players in this nation. Imagine a lifetime of being a one-handed surgeon when, with practice and patience, you could be a skillful two-handed surgeon!

I also learned the importance of using my eyes fully. Most of us have lazy eyes and settle for visual fields never developed beyond infancy. Dr. David Segal, late professor of medicine at Columbia University College of Physicians and Surgeons, relentlessly drilled a group of selected students in 1945 in the training of our eyes. When we first gathered in the morning, he wanted to know what we had observed the night before and what we had seen on the subway that morning. When you

Detail of *Willis Reed*, 1975

came out of a patient's room, he threw a fifteen-minute Sherlock Holmes interrogation at you. "Was the patient wearing a ring?" "What objects were on the patient's bedside table?" "What design was on the window curtains?" He would suddenly cover his necktie and ask you to describe it. I learned his lessons and teachings well, and to this day in the middle of a lecture I suddenly cover my tie and, parroting Segal's technique, demand that my students describe it in detail.

I also came to know and love anatomy in the classes of another great teacher, Dr. Ernest Lampe, who taught surgical residents at New York Hospital. Anatomy can be a chore and is brutally tough because you have to memorize countless minutiae, but he made it a joy. To this day I return to the anatomy laboratory for dissection.

Detail of *Pool Player—After Milton Robertson*, 1977

I later transferred these two skills—careful observation and knowledge of anatomy—to the world of painting. When I paint a hand, it is not just another image; it is still a wonderment to me. Hands are one of the great miracles of human evolution and remain the most difficult part of the body to paint. As a result, many masters fake them—Cézanne, Manet, and Van Gogh, for example, refused to be bothered. Rembrandt, however, painted them with great beauty and sensitivity.

Detail of *Smalczerz, Flyweight Champion*, 1976

Painting the muscles of athletes always takes me back to the hours spent in the anatomy laboratory as a medical student when I patiently dissected every muscle in the body, tracing their origins, insertions, and relationships to each other. I learned the hundreds of intricate blood vessels and nerves in the human body and all its fascinating anatomical landmarks—the clavicle and patella, the source of the tendons and the nerves, the small bones of the hand and foot. Such knowledge later enabled me to effectively paint the human body.

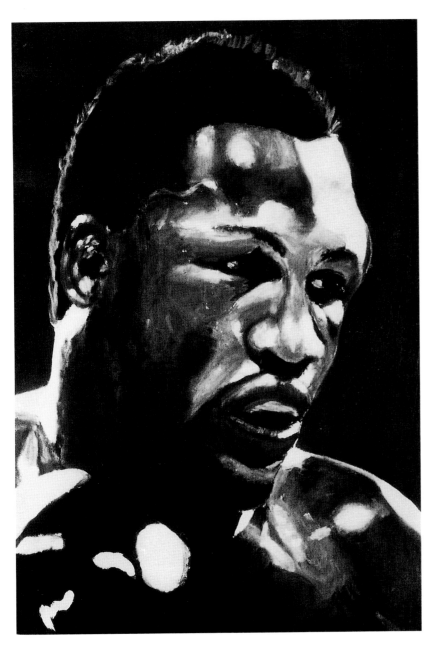

Detail of *Joe Frazier,* 1975

In my painting of former heavyweight champion of the world Joe Frazier, I depicted his throbbing temporal blood vessels during his grueling battle with Muhammad Ali. This pulsating temporal artery was a telltale sign of his stress and high blood pressure, which led to several weeks of hospitalization after the fight. He was never the same great fighter after this bout—nor was Ali.

Painting the various tones of the skin can be extremely difficult. Renoir was a master at this; if you examine one of his paintings closely, you can see how he used

every tone in the color spectrum in his painting of skin. Red skin? Blue, green, yellow, or orange skin? Yes, every color. As a physician who has closely examined thousands of patients, I have gained sureness and familiarity as I paint all manner of skin colors from the palest chalk-white skins to the blue, black, purple, brown, orange, yellow, and green skins of the great black athletes.

On October 7, 1959, I received an urgent phone call from my friend Merle Dubusky. He told me that his close friend Zero Mostel was about to have a leg amputated at the Knickerbocker Hospital after an accident in which he was run over by a bus. Mostel had dramatically halted the elevator on his way to the operating room and requested a second opinion.

My first impression of Mostel was an unforgettable one. Lying on a stretcher was 250 pounds of rotundity topped by the most expressive face I have ever seen. He lay there sweating profusely, in obvious pain, and pleaded with me, between cracking jokes, to save his leg. The leg was definitely salvageable. An intense period of multiple operations and grafts followed, and four months later he walked out of the hospital with a badly scarred but normally functioning leg. Months later he appeared in *Rhinoceros*, then subsequently danced and sang himself to international fame in *A Funny Thing Happened on the Way to the Forum* and *Fiddler on the Roof*. He regained a leg, while I gained one of the richest relationships of my life.

Mostel was a complicated, irascible, moody, bigger-than-life man who, unbeknownst to many people, had started life as a serious painter and teacher of painting. Although his fame was gained in the theater, he never wavered from his claim that the first and true love of his life was painting.

A few days before his discharge from the hospital, in January 1960, he teased me about working too hard and invited me to come to his studio on Saturday afternoons to draw from a model. A week later I walked up three stories to his loft on West 28th Street in the middle of the flower district. This extraordinary man greeted me there wearing an artist's apron in a studio oozing with warmth and fitted with all the trappings of a serious painter.

I was unprepared for the sight of a working artist's studio. The smell of oil paint, one I have since come to love dearly, permeated the air. Half a dozen of Zero's friends were absorbed in sketching a nude model starkly standing in the middle of the room on a platform. Zero found me a chair, a sketchpad, and charcoal and shouted, "Draw, Yushka, draw!" I was overwhelmed—awestruck—confused, but I had a gut feeling that I was beginning a new and important chapter in my life.

From that point on I spent every possible Saturday with Zero's group. I was totally captivated by the challenge of learning to draw as the first step in becoming

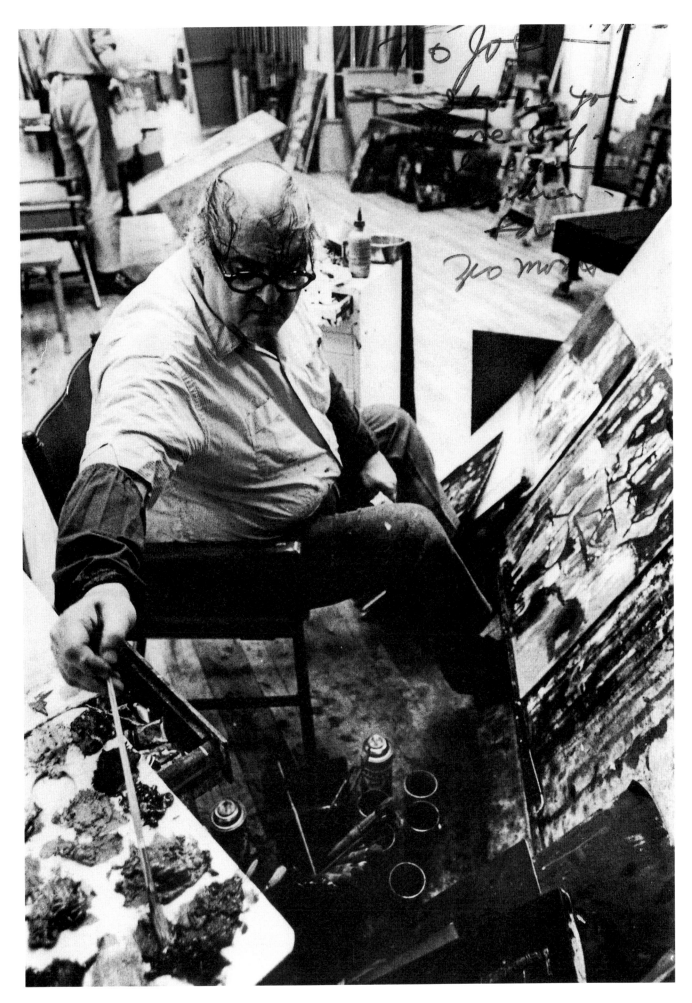

Zero Mostel in his studio, 1976

In my Soho studio, 1965

a painter. In my spare hours, like a man let out of a cage, I read everything I could lay my hands on about the world of art. Over the horizon lay those yet-untried treasures of watercolor, pastel, and oil paint. I rented my first studio, a modest 400-square-foot room in a drafty factory building on lower Broadway.

I also registered at the Art Students League beginner's classes under Will Barnet. At the first class, Barnet declared that the most important task for all painters was training their eyes to see! As Barnet discussed anatomy and arm foreshortening and the importance of learning to see, I realized that I had absorbed these lessons years before at medical school. This insight, along with the distractions caused by fifty students, convinced me that I could best learn to paint by working on my own, and I did just that.

I painted every day and every minute that I could find. I read and spent hours talking to my painter friends. I went to museums. I read into the world of art my knowledge of medicine, and into the world of medicine my new awareness of art. I became my own teacher and student at the same time. The whole secret of painting is eyes—it's all about learning to use your eyes. Once you know how to use them, you realize how blind you've been all your life and how blind the rest of the world is. Above all things, an artist is a seer!

As far back as I could remember, my emotional life had been dominated by discipline, determination, and conscientiousness. Now, with the doors of the world of art open to me, I discovered a whole new freedom in life. Unlike the great demands of surgery, which was my chosen life, art did not impose the awesome task of being responsible to and for others.

In the early years I painted like an animal, completely abandoning the discipline, attention to detail, precision, and thoroughness that dictated my every move as a physician and surgeon. I threw paint on the canvas in big swaths of bold color. I painted animals, flowers, men and women, animate and inanimate objects, and frequently covered myself with as much paint as appeared on the canvas.

After three years of free, indulgent painting, my orgy stopped. I realized that there was more to painting than total freedom of expression. I was deeply impressed by Jasper Johns's encaustic (wax) paintings, and I decided to work in that medium, which is the most difficult in painting and one of the oldest, having first been used by the Egyptians.

The formula is a complicated one that calls for boiling beeswax in a can and then adding varnish, pigment, a resin, and a touch of turpentine. As you move your brush from the can, the hot liquid wax is solidifying by the time it has reached the canvas, and it dries on contact. This limits your ability to work the surface over, as you can in oil paint, and demands great discipline. It took me almost a year to learn

the correct chemical formulas; equally difficult was learning how to prepare the canvas so that it would properly accept the wax. When all is right, wax is a beautiful material, the orchid of painting mediums. I finally learned how to make it and to work it. Gone were my carefree early days: I was now as serious and dedicated about my painting as I was about surgery.

I learned to work with other materials, each permitting its own kind of artistic expression. Watercolor became one of my sweet favorites, requiring little in the way of preparation. You carry a small tin container in your back pocket along with a small pad, and wonderful work can be produced in a matter of moments on a park bench, at the seashore, or in a sports stadium. There is a spontaneity, immediacy, and delicacy to watercolors in contrast to oil paint, which is the big gun in painting.

Watercolor is a delicate Strauss waltz, while oil painting is a powerful Beethoven symphony. There is a permanence about oil paint. It is a complicated medium demanding experience, knowledge, and deftness, and it can be messy. It is definitely the most satisfying and richest of all mediums, with a history dating back to the fourteenth century.

I also began to use pencil, crayon, and pastel for simplicity of statement, ease of execution, and convenience. I have come to love airplane trips; oblivious to the commotion on the plane and happy to be able to utilize those precious, long hours, I do some of my best pastel and crayon drawings on flights.

I make the various art mediums fit my different moods. If I have a few moments I do a quick pencil sketch or watercolor. When tired, I often do my pastels in bed resting after a long day at the hospital. Pastels enable me to work quickly, rendering brilliant colors with a minimum of effort; and when time permits I work with my greatest love, which is oil paint.

A major problem for me was the selection of imagery. At the time I began to paint, Pop Art was skyrocketing to fame and recognition, pushing Abstract Expressionism into history. I was deeply influenced by my friendships with Dine and Johns, and as a result found myself uncomfortably painting all kinds of inanimate objects and doing Pop images of people brushing their teeth and taking showers.

In 1966, Allan Stone put me in my first major group show, and two years later I had my first one-man show at his gallery. Although I was firmly launched into the "serious" art world, I still had a profound desire to capture on canvas a theme of my own. In spite of the hype and the politics of the art world, I finally decided to paint what I wanted to paint, knowing that by doing so I was bucking the powerful art clique.

The decision was simple. I knew sports inside out. I was fascinated and thrilled

Goalie. c. 1970. Watercolor and pastel on paper, 16 x 22″. Collection Nick Wilder

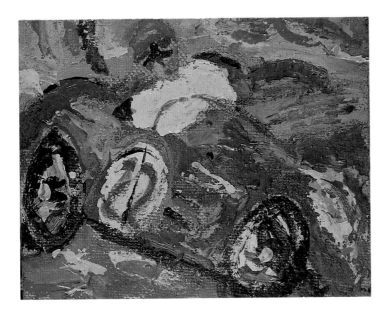

Earle's Car. 1961. Encaustic on burlap, 18 x 24″.
Collection Earle M. Wilder, M.D.

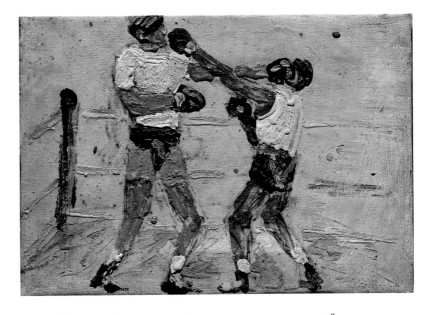

Ali and Sparring Partner. 1965. Encaustic on canvas, 9 x 13″

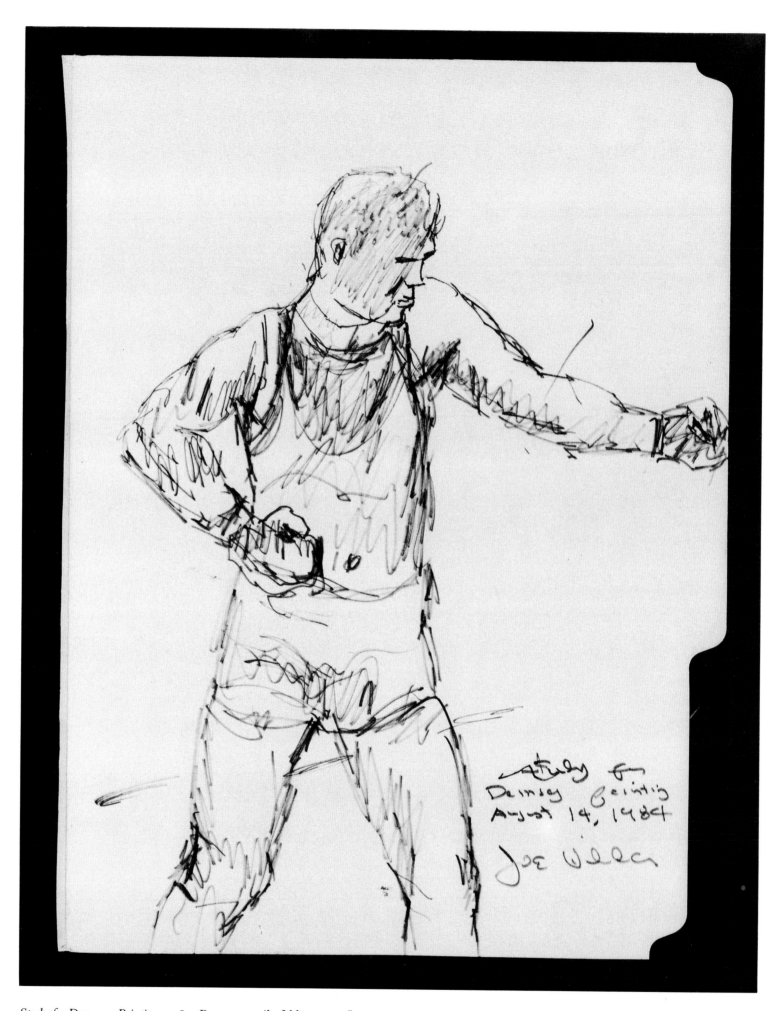

Study for Dempsey Painting. 1984. Pen on manila folder, 12 x 9″

anew each day at the miracles of the body. I loved both sports and painting. It seemed the only natural path to take. I felt a sense of enormous freedom as I embarked on what proved to be twenty years of painting sports images, starting with racing cars and drivers.

I saw my first automobile race in October 1964 at Watkins Glen, New York. That first afternoon I watched the cars flying around and around the track and thought, "What a bore."

I poked around the pits and garages, looking closely at the beautifully painted Formula One cars and the thin, ascetic-looking racing car drivers. I noticed the crews of six to twelve men feverishly working on the cars with a love and a devotion not too different from my experience in the operating room with my teams as we worked on patients. The crews, speaking many different languages, were all amazingly oblivious to each other. I watched and took all of this in with an intensity and a concentration that stamped thousands of images on my unconscious brain.

All my basic animal senses of smell, sight, sound, and touch were aroused. In particular, there is a sensuous smell to the racing car fuel mix of castor oil and gasoline that is unlike any other smell.

I took some two hundred photographs that first afternoon, working furiously to capture every image in sight with my Hasselblad and Nikon cameras. The next morning I woke up exhilarated. I wasn't sure what had taken place in the previous eighteen hours, but I knew I had fallen in love with car racing. For the next ten years I went to dozens of races throughout the United States and in Europe: dirt road races, drag races, the extraordinary Indy 500 races, and the Grand Prix races.

A number of realities of the racing life captured my imagination, as my worlds of painting, sports, and surgery jostled each other for attention.

Racing is a hell of a sport. Its grueling physical demands are awesome: one wrong move can mean death. There is no other sport anywhere in the world with this kind of terrible pressure.

I observed horrible accidents and flirtations with death. Always there was a strange mix of starkness and violence with the beauty of the cars. As a surgeon and painter, I had powerful emotional reactions as I observed drivers whose fingers had been welded together with burn scar tissues, their noses and lips mutilated by burns; then two minutes later, going from man to machine, I saw the beautiful, slick cars in the pits and garages.

The cars were extraordinary sculpted objects like nothing I had seen before. They were painted in gorgeous bright colors and designed with an elegance and a shape that captured my imagination.

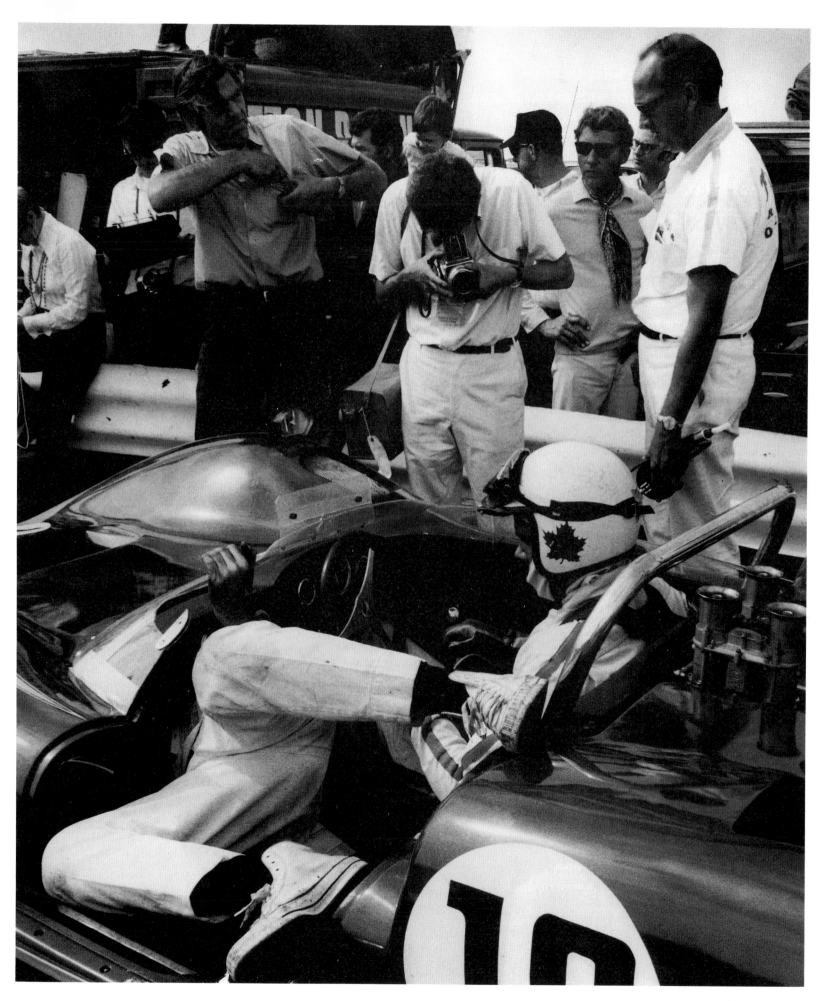

Photographing at Bridgehampton, Long Island, 1971

I sensed a oneness between the drivers and their cars—a unique symbiosis between man and machine—and I tried always to capture this mystique of driver and car. I was fascinated by the drivers' strange combination of poetic introspection and a terrible inner tension. They dared to flirt with death.

These drivers came from all over the world—the dark, black-haired Italian and French drivers, the blond Swedish and German drivers, the small Japanese drivers, the Australians and the English, and the special breed of American dirt road driver, filled with the courage and defiance characteristic of southern manhood.

As I moved in and out of the pits on the racetrack, I looked for the driver and car that instinctively sparked my interest. The drivers had enormous powers of concentration as they sat buried in their cars, like Egyptian mummies, with barely enough space to fit their bodies. They appeared to be in a trance, but they were actually preparing themselves mentally for the forthcoming race, where they put their lives on the line. They cannot afford to be distracted by the bedlam around them.

I made one very interesting observation early on. I looked for drivers who projected a sense of tension and a competitive energy, and I looked for those who were unknown, because the established stars were swamped by photographers. Years later it was clear that an amazing number of the drivers I had photographed were destined to become stars—it was all a question of chemistry. They obviously had the juices of champions early on, and I had sensed this quality.

I tried to convey this energy and sense of urgency in my paintings of racing car drivers. After taking many photographs of each race, I spent months studying the images I had recorded. I pinned 8-by-10 prints on the walls next to my bed, living with them for weeks at a time until one particular image would jump off the wall, practically begging to be painted. Then with enormous excitement I painted on a large canvas all the emotions I had experienced at the track—the drivers' flirtation with death, the beauty of the cars, the excitement of their technology, the vulnerability of man, who could be reduced with the car to ashes in a matter of seconds, and the sometimes tense, sometimes reflective, but always brave drivers. In a way, the whole saga of mankind was out there on the racetrack, and I worked to capture it in my paintings.

On a personal level it was frequently lonely, for I belonged fully to no one group. I became quite adept at photography, but I didn't belong to the photography group. I was a professor of surgery, but going to the races was certainly not part of my surgical education. I was a lover of sports and an athlete, but I never had been exposed to such violence in sports. As a physician trained to save lives, I found this an enigma; as an artist, I was spellbound.

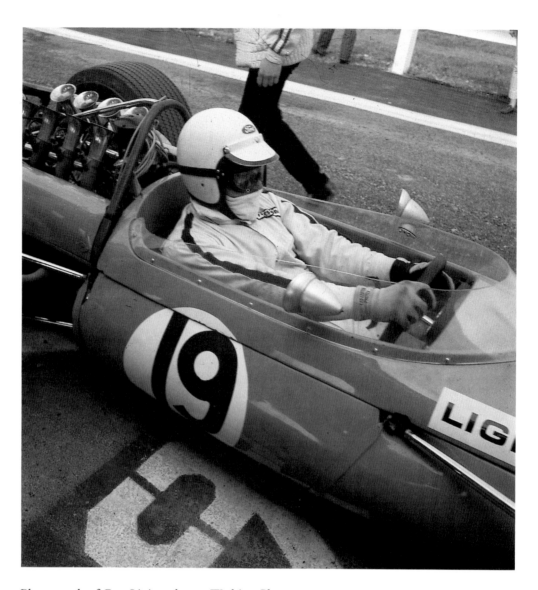

Photograph of Guy Ligier taken at Watkins Glen, 1964

I spent ten years pursuing this challenging imagery before I decided that it was time to set new painting goals and began to explore the world of other athletes. In the years that have followed, I have painted athletes and scenes in almost every conceivable sport, applying the lessons I learned in the exhausting world of auto racing. I use the same technique of taking photographs of those sports and athletes who capture my interest and then studying them month in and month out until one particular image sparks my creative energy.

Photographs are only points of departure for me, however, and serve purely as reminders and reference points. I never copy photographs; that's a bore and reduces the painter to simply being a technician. No, my fulfillment comes from bringing

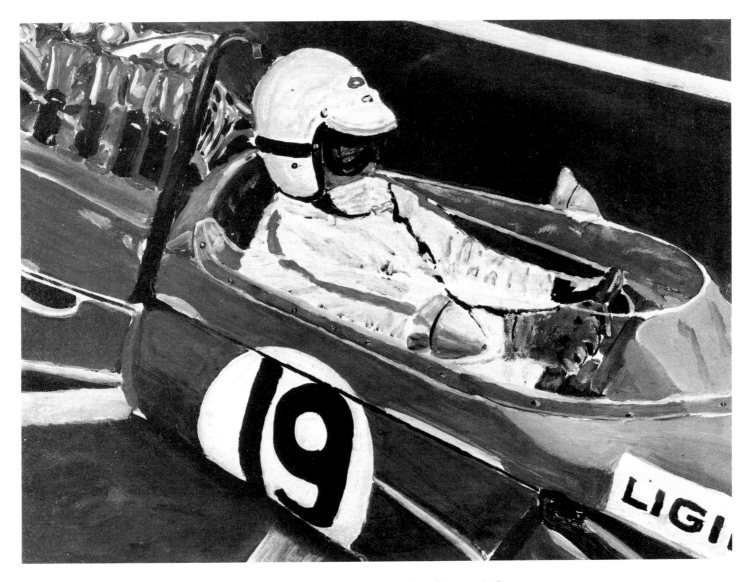

Ligier Number 19. 1966. Acrylic on Masonite, 24 x 30". Collection Daniel and Joanna S. Rose

my own juices to bear as I create an image that is original, unique, and mine.

The essence of my painting comes from something deep inside—the mysterious brain, which stores billions of impulses, recording images from the immediate world around me, from the magical images of the TV screen, from the kaleidoscope of millions of sports images seen in newspapers and magazines, and from my own lifetime of watching athletes and sports. The fusion of all these elements forms the nucleus of my sports paintings.

Certain factors make the painting of athletes especially important to me. After long personal experience as an athlete, I am sensitive to how difficult it is to be a truly great one. Also, the experience of painting the violent, mysterious world of

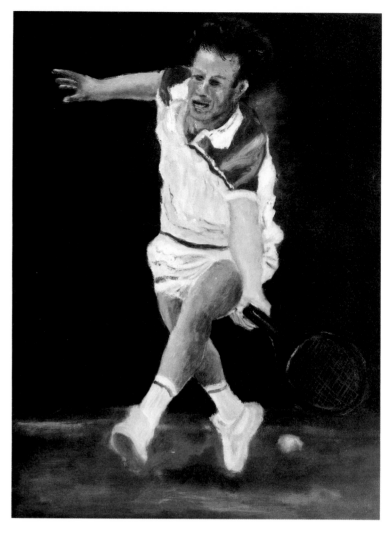

Champion. 1983. Oil on canvas, 16 x 12″

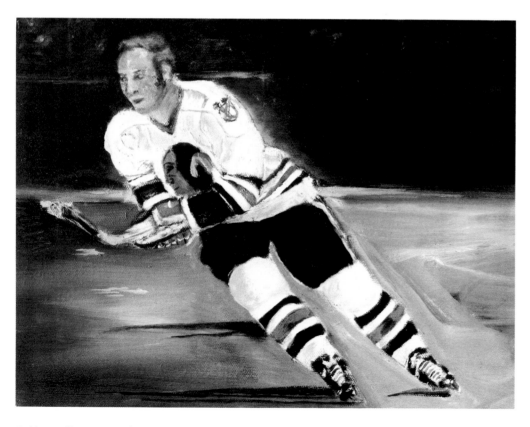

Bobby Hull. 1984. Oil on canvas, 8 x 10″

Connors. 1984. Pastel on paper, 19 x 16″

auto racing brought into sharper focus my fascination with the human body. Above all, I strive in my painting to reflect the grace, tension, energy, and power that mark great athletes in action, to record with paint the athletes' fears, anxieties, insecurities, and pains, along with their ecstasies and exhilaration.

These qualities—grace, power, tension, and energy—are wonderments that painters have tried to capture for centuries. When you see Bobby Hull moving effortlessly across the ice or Babe Ruth swatting a home run, it is a thing of enormous grace. It is a thing of beauty to watch a McEnroe or Connors show devastating power in his tennis serve and, an instant later, loft the ball over the net with the grace of a butterfly floating in the air.

Muhammad Ali—in my judgment the greatest of all American athletes—used to say, "I float like a butterfly and sting like a bee." He was on target. I think of race horses and the great swimmers when I think of grace and power in harmony with

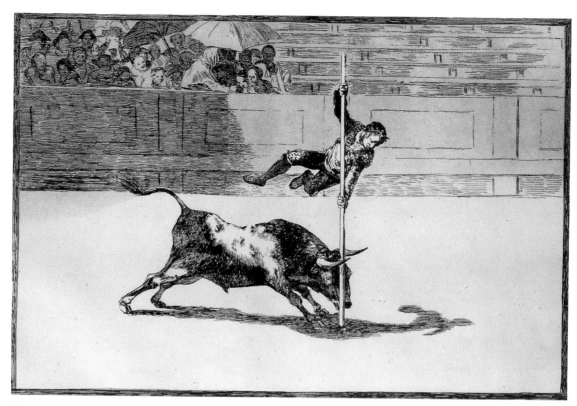

Francisco Goya. "The agility and audacity of Juanito Apinani in the bull ring of Madrid,"
from *La Tauromaquia*, 1816.
Etching, 7⅞ x 12⅛". Collection the Arthur Ross Foundation

each other. All great athletes possess an inner tension and burning fire. You sense that they are ready to explode. Look at a thoroughbred race horse perspiring and prancing nervously before a race. Look at a boxer jumping and cavorting all over the ring before a bout. Oh yes! You can feel that tension.

I try in painting my racing cars, my horse races, indeed all of my athletic scenes, to create a sense of the athlete, car, or horse coming straight at you, flying right off the canvas, for this is how I see sports. I can only do this by climbing inside the athlete's skin—an effort that takes time and a chemical identification with the athlete I paint.

When I paint Tom Seaver pitching, I become Tom Seaver, and into that pitch goes my lifetime as a competitive athlete. As Seaver rears back to pitch, he is for that instant Joe Wilder throwing all of his life energies into Seaver's pitch. When I paint Ali fighting Frazier, I become Ali. It is my juice, my energy, my anger, and my strength transmitted to Ali's fist through my paintbrush.

I translate and pour all my energy into the athlete I am painting. The canvas becomes my sports arena; it is here that I express myself! It is for this reason that I have never been able to successfully paint by commission, for this requires a cal-

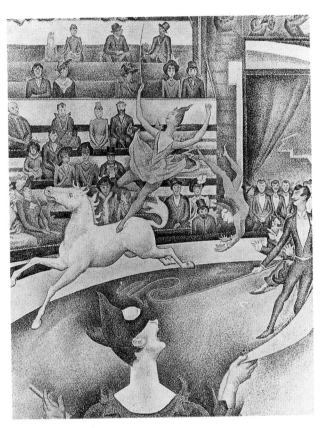

Georges Seurat. *The Circus*. 1891.
Oil on canvas, 73 x 59⅛".
The Louvre, Paris

culated approach; the image is selected by someone else and I am asked to reproduce it. This process stifles me and I cannot do it.

In painting my sports figures, I must first feel a chemistry, excitement, and sense of identity with a particular athlete. I watch the athlete like a hawk, over and over and over, until I know his or her every move. Then I do my painting, confident that what comes out from deep inside me will dominate and take over. That unknown is the heart and essence of my work.

Many of the works of past masters have reflected a fascination with motion. Just to mention a few: Courbet's wrestlers; Rousseau's soccer players; Eakins's boxers, baseball players, swimmers, and rowers; Bellows's boxers; Seurat's circus scenes; the race horses of Degas, Toulouse-Lautrec, and Manet; Goya's bullfights; and Rodin's sculptures.

Millet's paintings of peasants sowing grain in the fields, copied many times by Van Gogh, are beautiful depictions of movement and grace, figures resembling modern Olympic athletes. Van Gogh, in his extraordinary letters to his brother

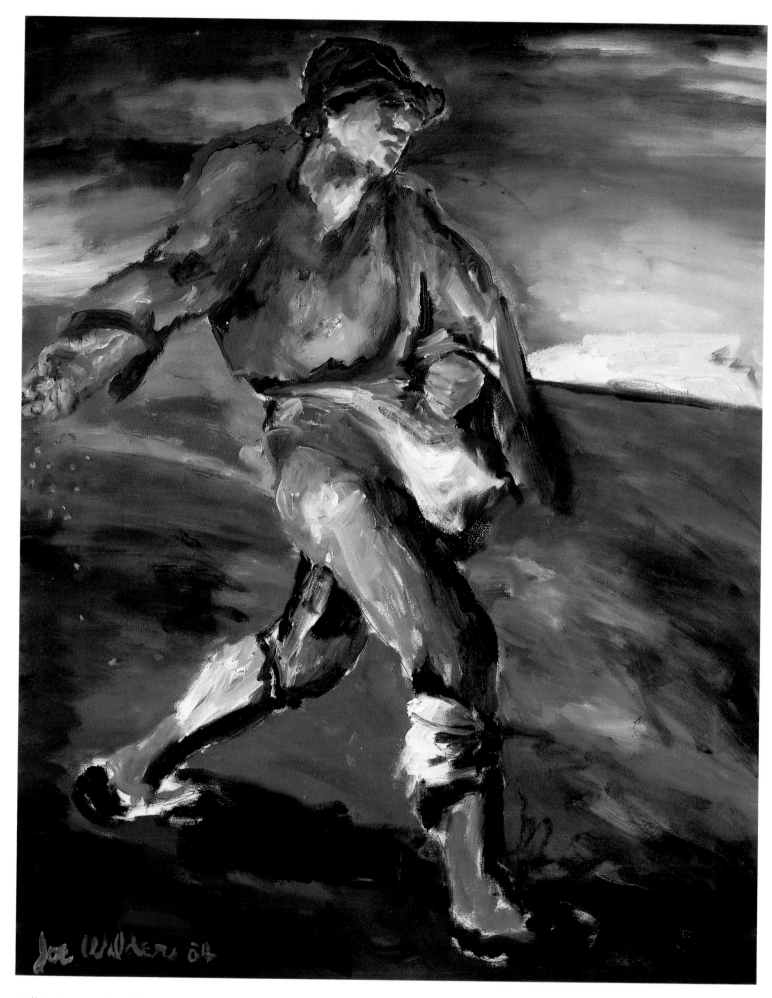

Millet's Sower. 1984. Oil on canvas, 30 x 24″

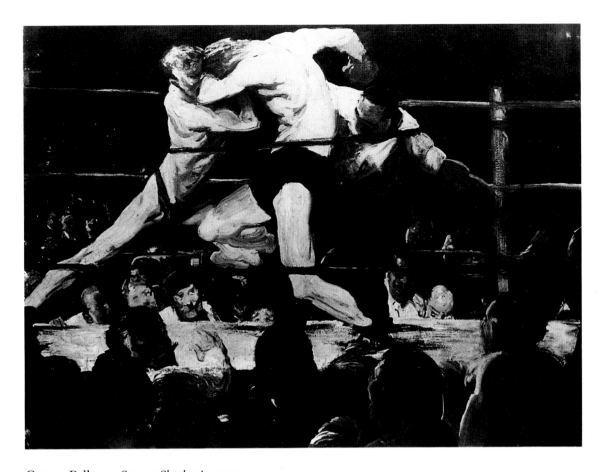

George Bellows. *Stag at Sharkey's.* 1909.
Oil on canvas, 36¼ x 48¼".
The Cleveland Museum of Art. Hinman B. Hurlbut Collection

Theo, repeated again and again his strong conviction that action and motion had to be successfully created in order for an artist to truly depict peasants at work. Van Gogh wrote, "To draw *a peasant's figure in action*, I repeat, that's what an essentially modern figure is, the very core of modern art, which neither the Greeks nor the Renaissance nor the old Dutch school have done" (*The Complete Letters of Vincent Van Gogh* [Boston: Little, Brown, 1958], vol. II, pp. 401–02).

Rodin said, "Now, the illusion of life is obtained in our art by good modeling and by movement. These two qualities are like the blood and breath of all good work. I have always thought to give some indication of movement, I have rarely represented complete repose....I have always endeavored to express the inner feelings by the mobility of the muscles" (Paul Gsell, *Rodin on Art* [New York: Horizons Press, 1971], pp. 66–67).

Thomas Eakins, one of the greatest of all American painters, loved many sports and painted many sports images. He mastered anatomy by studying with

formal medical classes at the Jefferson Medical College. Eakins has been a great inspiration to me, as has Leonardo da Vinci, considered by many the father of anatomy.

The creation of this book has been a project filled with joy. In the process my belief in painting, medicine, and sports has been reaffirmed. Everyone involved in this book has given freely, almost as if each senses something special; and special it is when the three worlds of medicine, art, and sports come together in a single unified effort.

In 1981, the National Portrait Gallery of the Smithsonian Institution gave the first major show of sports art ever mounted in a major museum in this nation. My painting *Willis Reed, Superstar* joined those of Eakins, Bellows, and others on this historic occasion. Referring to the exhibition, Marc Pachter, historian at the museum, wrote in the introduction to his book *Champions of American Sport* (New York: Abrams, 1981, p. 15), "This is the first major sports exhibition ever mounted by the nation. It spotlights the men and women who—just like the politicians, the generals, the artists—have shaped our sense of ourselves and, in a special way, have lent color to our lives and reaffirmed our faith in what the individual can do."

In addition to reproductions of my paintings, this book includes essays by a group of renowned athletes, writers, physicians, and teachers knowledgeable in the workings of the body and the mind in the making of great athletes. In this book we pay tribute to the four-foot-tall jockey, to the seven-foot-tall basketball player, to the black woman Olympic relay champion, to the 300-pound Russian weightlifter, and to athletes from all over the world who again and again remind us of our common origins and common goals. That may be why people love sports so much and why as many as 125 million people have watched a single sports event.

I believe we have created a fresh and original book about humankind's constant struggle to improve upon those achievements etched in stone by previous generations. This book is a salute to those athletes—young and old, male and female, black and white—who develop and use their bodies in a beautiful expression of human behavior transcending race, religion, and origin.

JOE WILDER, M.D.

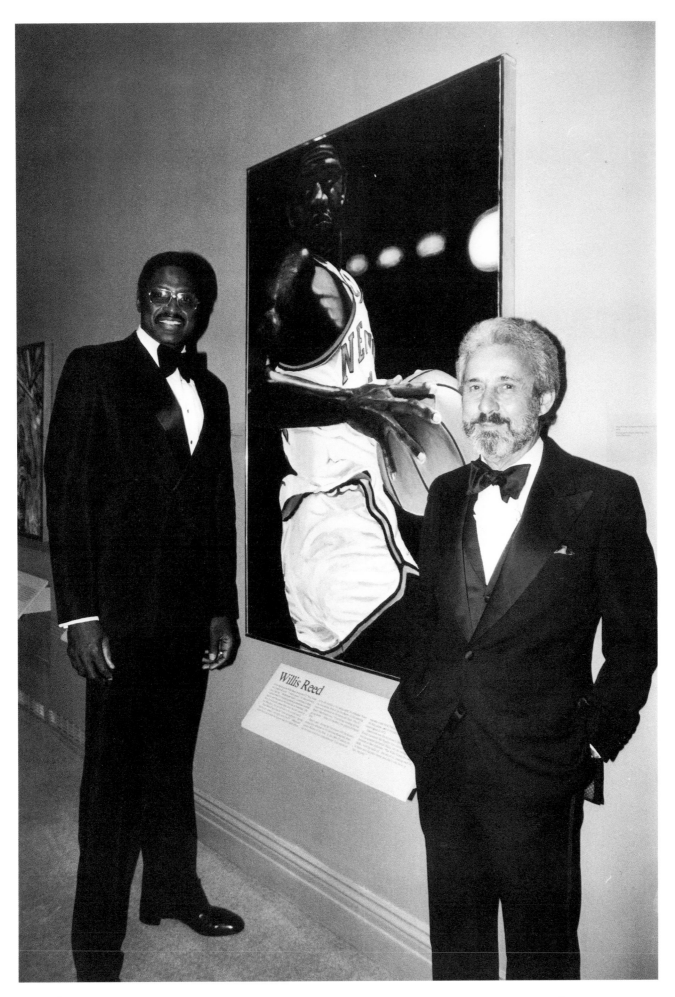

With Willis Reed at the opening of the *Champions of American Sport* exhibition, National Portrait Gallery, 1981

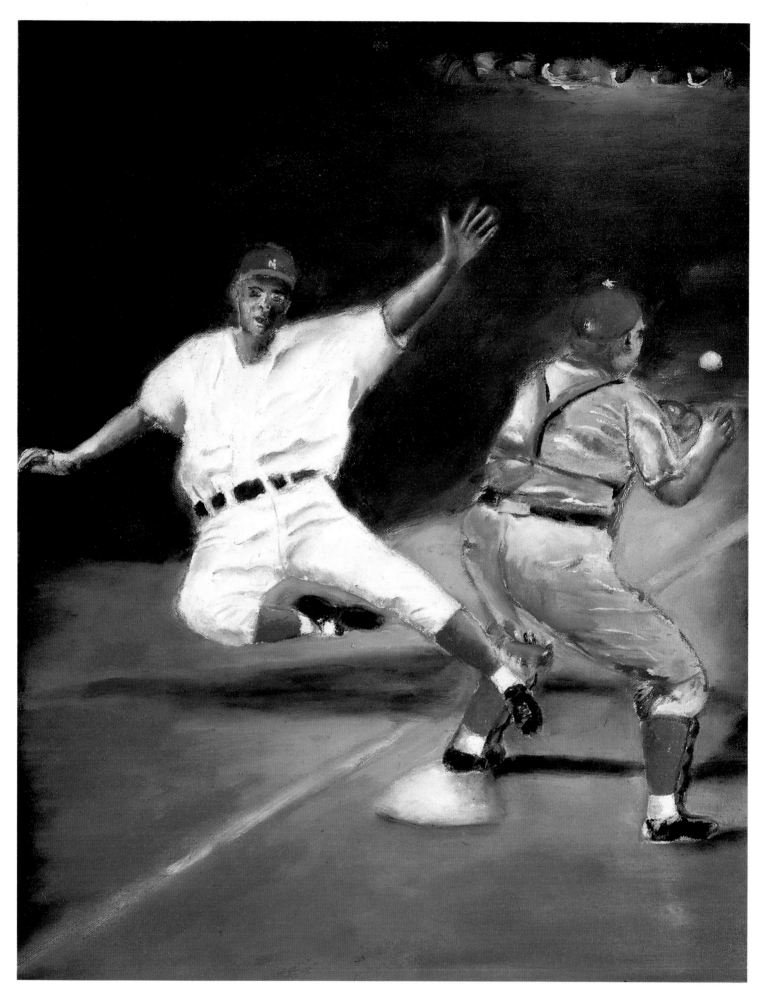

Safe at Home. 1984. Oil on canvas, 18 x 14″

BASEBALL

The Mists of Greatness *Roger Kahn*

On a slow Sunday several years ago, when the television and the stereo and even the children were quiet, I found myself reading a so-called Think Piece composed by a middle-aged Lion of American Journalism. A Think Piece can be defined as one in which the writer sets down his own cogitation and rumination, rather than reportage, and then, to a flourish of sackbuts, announces grand conclusions. (I am not going to say what a non-Think Piece may be. Why make a hundred enemies with a single observation?)

This journalistic Lion wrote with Authority. He understood Vietnam, Washington, and Moscow. He had addressed several Secretaries of State by their first names. He probably, if pressed, could theorize on the copulatory positions most preferred by Masters and Johnson themselves. Humility did not assault this Lion's thought processes.

Now he was stooping to write about the lures of baseball, a mere game. He began with ponderous organ chords, mentioned major league ballplayers and wrote: "I love this game. I've played this game."

My quick and accurate response was to turn on the stereo and turn off the Lion. He had exposed a flaw that was fatal, at least for that particular article. He was confusing his own efforts at Sunday softball—excellent by his own testimony— with what people named DiMaggio and Bench, Rose and Jackson did for a living. Once he had made that staggering mistake, an ineluctable rule of the writer-reader relationship took hold. I could not take seriously anything else he had to say.

If you intend to consider great ballplayers and that elusive combination of co-ordination, attitude, mind and heart and body that creates this particular dimension of greatness, you have to do it from the base of Olympus, not its peak. You had better begin by recognizing that your own baseball career and the baseball career of Reggie Jackson are so disparate that they have nothing to do with one another. I was given a science-study kit once when I was a child. Even then, I did not equate my efforts among the toy test tubes with triumphs and tragedies in the life of Louis Pasteur.

This point, obvious in exaggeration, works more subtly than one might think. Certain fields, like medicine and the law, sell themselves by establishing an aura of

complexity, which can approach medieval mysticism. They build obscure Latin vocabularies for relatively simple conditions, cloak themselves in bewildering work rules, called codes of ethics, and refer to the rest of us as laymen, a word that can be made to sound like "dummy." A lot of medicine and law, like a lot of American life, is the marketing business.

That is one extreme. Major league baseball, at the other, sells itself as a simple game that small boys and even women (ah, there, Gloria) can play and understand. This is egalitarian and commercial as hell. But neither professional baseball nor its finest players remotely resemble softball on the Sheep Meadow in Central Park or the heroes who perform on the Manhattan greensward one or two afternoons a week en route to an evening of beer.

Consider one dialogue with Joe DiMaggio. The professional does not *play* the game. He *works*. He begins spring training on March 1 and from that date until October 1, he has to participate in a game of baseball at least six days out of every seven. He plays despite the minor injuries to which a great star is subject, as you and I. He plays following nights when he has been coddling a sick child; following days when he and his wife have fallen out; following days or nights of wearying travel to distant time zones and indifferent hotels. Fun? There are moments of fun, many moments, but they come within the larger frame of discipline.

"Did you ever get tired of playing ball?" I asked DiMaggio once.

"Sure I did. Every ballplayer who's honest will admit that."

"And what would you do?"

"I'd have a little talk with myself," DiMaggio said. "Just before the Yankees took the field, I'd put a foot on the top step of the dugout"—the pose is remembered by Yankee fans with their childhood saints—"and I'd say something like this: 'There are fifty thousand people here today and a lot of them have come to see you play. Most of them have seen you before and most of them will see you again. But some will only see you on one day of their lives. Today. And all they'll ever know about Joe DiMaggio, all they'll ever tell their kids, is what they see today. Play for *those* people.'"

What an extraordinary act of discipline, across all the days and nights of a dozen major league seasons! DiMaggio was not the fastest ballplayer of his time. He could not hit a ball as far as Jimmy Foxx or Mickey Mantle. He had a strong arm in his youth, but there were better arms than his. Where DiMaggio had no peer was in the world of baseball discipline. No one played harder in his time. Curiously, because of the man's native grace, no one ever made playing hard look so easy.

What forces from within and without shaped this perfectly disciplined son of an immigrant fisherman? He was aggressive, rigid, perfectionist, but these are

symptoms, not explanations. He married a woman who was regarded as *the* most sexual lady in America. Another symptom, this one for the Freudians. As he worked so hard for himself, his pride, his public, so he guarded his privacy, as Cerberus, the three-headed dog, guarded the entrance to Hades. Perhaps he was hiding his driving forces from himself.

Computerize Big Joe. Run a dozen programs on him. Try him on Apple, Coleco, IBM. The machines will tell no more than what we have already told. The man played baseball with superhuman discipline.

DiMaggio's successor as the best centerfielder in New York—and coincidentally the cosmos—was Willie Howard Mays, who first rose briefly in 1951, a morning star of glorious magnitude. The United States Army stole Willie from the Giants after that year, and I did not catch up with Mays again until the spring of 1954.

The Giants had won the 1951 pennant with Mays (and a little help from one Bobby Thomson), then lost the next two pennants while Private Mays assaulted pitchers on behalf of various Army teams. The Giants' spring training camp in Phoenix looked drab as Mays served his last few Army weeks somewhere else. All that would change, insisted Manager Leo Durocher, when Willie came marching home.

Durocher was loud, shrewd, manipulative, and abrasive, and he sold Mays to the press as a Hollywood huckster might sell 112 pounds of hard-driving starlet flesh. Willie could catch any ball in the park, Durocher barked. He fielded ground balls like an infielder. Hit? Well, we were in Phoenix, but they better keep their eyes open in Kingman, Arizona. One of Willie's homers just might end up three counties to the north.

When they tell you a starlet is "coy" in Hollywood, that means she hasn't slept with more than twenty-eight producers in a month. When Durocher pushed Mays, as a combination of Tris Speaker, Jackie Robinson, and God, I found myself backing away, feeling cynical.

"You'll see," Durocher said, smugly. "You'll (three obscenities deleted) see."

Willie flew from an Army base in Virginia on a Constellation, a triple-tailed, four-engine, prop aircraft, sitting up all night. When he arrived—this was early March—the Giants were about to start an intrasquad game. Durocher, who loved drama, assigned him to the bench.

"Ain't you gonna play me, Skip?" Willie asked in a plaintive voice, like an ill-coordinated boy overlooked in a pickup game.

"Maybe later. You must be tired."

"Ain' too tired to play baseball, Skip. Never too tired for that."

Durocher installed Mays in the batting order in the fourth inning, and Willie at once struck out. And then...and then...

47

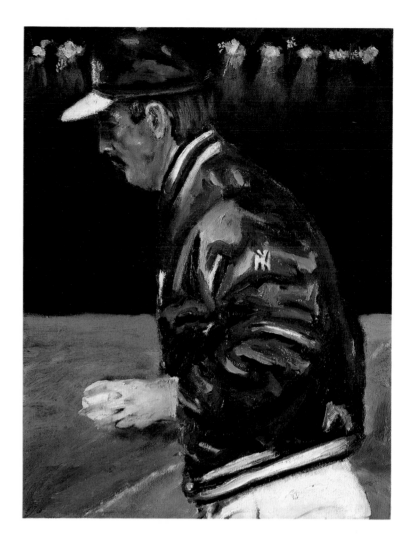

Billy Martin Changes Pitchers. 1983. Oil on canvas, 14 x 11″

Maury Wills, Jr. 1977. Oil on canvas, 10 x 8″

He raced into the deepest reach of centerfield and made a breathtaking over-the-shoulder catch. He hit a 475-foot home run. He sprinted in toward second base, dove and caught a sinking line drive, sprang up and doubled a runner off first base with a throw that split the desert air like a projectile. "And," Durocher reminded me later, with even greater smugness, "that's only how the kid plays after he's missed a whole night's sleep. Wait till you see him when he's rested."

That summer Willie carried the Giants to the pennant, playing with limitless enthusiasm each afternoon at the Polo Grounds, then going to his apartment, changing clothes, and playing stickball with neighborhood urchins. As DiMaggio was discipline, Mays was wild enthusiasm. It did not last forever, of course, and time caught Mays in flight and dragged him down with other mortals. But for that one season, 1954, Willie's love for baseball, for playing baseball brilliantly, was vibrant, tangible, a kind of naked joy that leaped from the ball field into the grandstands.

"Deep down," Mays told me the next winter, "you got to love the game. They say they can teach you a lotta things and maybe they can. I don't know. But nobody can teach you to love the game. That's gotta come from you."

Mays and DiMaggio. A pride of knights. Unforgettable as a dream of glory. Fire and ice.

Those years, the early 1950s, live in the porches of my brain. As a young reporter, roughly the same age as the ballplayers I was paid to cover, I saw major league baseball from within. I befriended a number of great athletes, traveled with them, ate with them, drank with them, and, to a degree, thought with them. Al Rosen. Pee Wee Reese. Whitey Ford. Carl Furillo. Early Wynn. Those are some of the names. They were good fellows all, great fellows, really, and each is still a friend. We sometimes talked about serious issues as equals. Every man bought his round of drinks in turn. They offered me deep respect for my years studying English lit, for my ambition to write works beyond newspaper pieces, but when I talked of playing semipro third base for $2 a game, they grinned a bit and seemed uncomfortable. They respected me as someone who, in Red Smith's phrase, was "a pretty good speller." Indeed, Reese once asked me to explain an essay by Faulkner. But when I let go of self-control and seemed to equate my ballplaying with theirs, they were embarrassed. What could they say? "Hold it, fella. Different leagues."

Rosen, who as I write this is president of the Houston Astros, brought that distinction home most strongly. Three hours before game time one spring morning, I was throwing in a bullpen, showing an accomplice my curve ball, which broke as slowly as a bay wave at low tide.

A policeman appeared behind me. "Sir, you'll have to leave the field."

"What do you mean?"

The cop looked fierce. "Sir, you are making a travesty of the national game. If you don't leave, I'll have to arrest you."

I took my two-cent curve and sat in the stands. Rosen grinned enormously throughout batting practice. Al had bought or rented the cop to make his point.

Play in the schoolyard, kid. This is the Bigs. If I taught journalism, I would require a similar lesson to be imposed on everyone who shows the slightest symptom of becoming a Lion in the craft.

The Lord of Baseball during this era was Stanley Frank Musial of Donora, Pa., and St. Louis, Mo. Beyond his batting average and his unique, uncoiling swing, he was an essence of geniality, more voluble than DiMaggio and more articulate than Mays.

We talked often about hitting in the major leagues and some of the conversation was technical, matters that make the most sense around a batting cage. But by the time I got to know Musial well enough to call him "Stash," I had learned a rule that runs unchanging from Little League on up.

A hitter is required to hit a round ball with a round bat. Very difficult. Very basic. The ball will be traveling at high speed. Have you ever been plunked in the ribs by a fast ball? Air leaves your lungs in a rush, making you grunt. Pain comes as with the tip of a stiletto. It returns for a week, every time you inhale deeply.

So we have an element of fear. It is frightening to bat against a hard-throwing pitcher, but if you dwell on the possibility of pain, you will hit the baseball neither well nor often. As John McGraw probably put it, "You can't double down the line, buster, when mostly you're worried about saving your ass, or your ribs."

Block the potential for pain. Concentrate on clobbering the baseball. You play a mental equation here. The satisfaction of getting a base hit is greater by many parts than the potential of grunting pain. Hanging in, as the ballplayers put it, against a curve ball is, in short, worth the risk.

"Are you ever afraid?" I asked Musial on a night train proceeding from Pittsburgh to New York.

The pointed, aristocratic Polish face showed surprise. "Of what?"

"Of getting hit by a pitch."

"I'm afraid of certain things," Musial said. "Like I don't particularly care for heights. But afraid in baseball? Listen, if you're really afraid, you shouldn't play this game." It may sound trivial, but it is significant, that not Christy Mathewson, Ty Cobb, Ted Williams, Carl Yastrzemski, Steve Garvey was afraid of baseball. For some, this was an example of pure courage. For others, like Musial, confidence in one's reflexes is such that a question about fear sounds downright impertinent.

50

Finally, in this exciting, nebulous, mysterious musing about the psyches of the gifted, there exists the element of fanaticism. Ty Cobb once returned to a hotel and found his roommate humming in the bathtub. Cobb ordered the man to leave the tub, then beat him up, with cold, punishing blows.

When the man was bent, bloodied, on the verge of tears, he asked, "Why did you do this to me, Ty?"

The Georgia Peach snapped an icy answer. "When you room with me, remember, Cobb bathes first."

Jackie Robinson was among the sweetest and most compassionate people I have known. His kindness to my wife, after she had miscarried, and to each of my children as they were growing up, was such that they all remember him as a muscular embodiment of gentleness.

I do myself, but I remember also when the gentleness would flee. We picked up Ping-Pong rackets once in Vero Beach and suddenly Robinson was trying to drive slams through my midsection. He leaped and pounced, grunted and cursed, and ripped me roundly, which does not happen to me often at table tennis.

On another occasion we played gin rummy. Robinson's gentleness vanished. His face changed into a mask of fury. I won a few hands and he looked as though he were about to attack me, à la Cobb.

"Hey," I said. "Wait a minute. What's going on? We're playing a real big game here. A penny a point."

Robinson breathed. His face returned to its normal, pleasing mien. "I can't help myself," he said. "As soon as I play anything, baseball, cards, gin rummy, I've got to win."

"Why?"

"Who the hell knows why? I've got to win."

With such good sense as I possess, I pass up here considerations of Willie Mays's trapezius, Robinson's measured hand-to-eye coordination, and DiMaggio's time for a 40-yard dash. This is not happenstance but my expression of the fact that physical skills tell us little about athletic greatness. I was reminded of this most recently when I bought the controlling interest in a Class A minor league baseball team called the Utica Blue Sox.

Before investing my children's tuition money, I insisted on meeting the manager. Since he had finished second the year before, he would surely be the manager again. Our separate curves converged on Dodger Stadium in Los Angeles.

The manager's name is Jim Gattis and he is both an English major (Santa Barbara State) and a hitter (until one day when a fast ball crashed into his head; he now wears a steel plate inside his head).

We talked in fencing ways. No, I was not going to behave like George Steinbrenner. Look, he appreciated my right to second-guess him. "Baseball is a game of second-guess," Gattis said.

I led him through catacombs under Dodger Stadium into the office occupied by Tom Lasorda.

Tommy and I hugged, this being California, and then the conversation turned stiff.

"Tom," I said. "Jim is going to manage my team in a minor league, far as far can be from the majors. You did that once. Do you have any counsel for Jimmy Gattis?"

"Yeah," Lasorda said. "I wanna tell him something. Okay?" he asked me. "Am I stepping on any toes?"

"We are toeless," I told the Dodger manager.

"Well, look, at that level, the talent is pretty much the same. Jim…it is Jim, isn't it…what you want to do is figure out how hard every manager in the league works, and work just a little harder. Then figure how hard they work their players. Work your guys just a little harder. That's all."

Gattis never forgot what Lasorda told him. We won the pennant. We won the play-off.

Granted good coordination, physical strength, drive, passion, and courage, baseball is a sport in which those who want most to be selected shall be chosen.

In short, it is a ball game named desire.

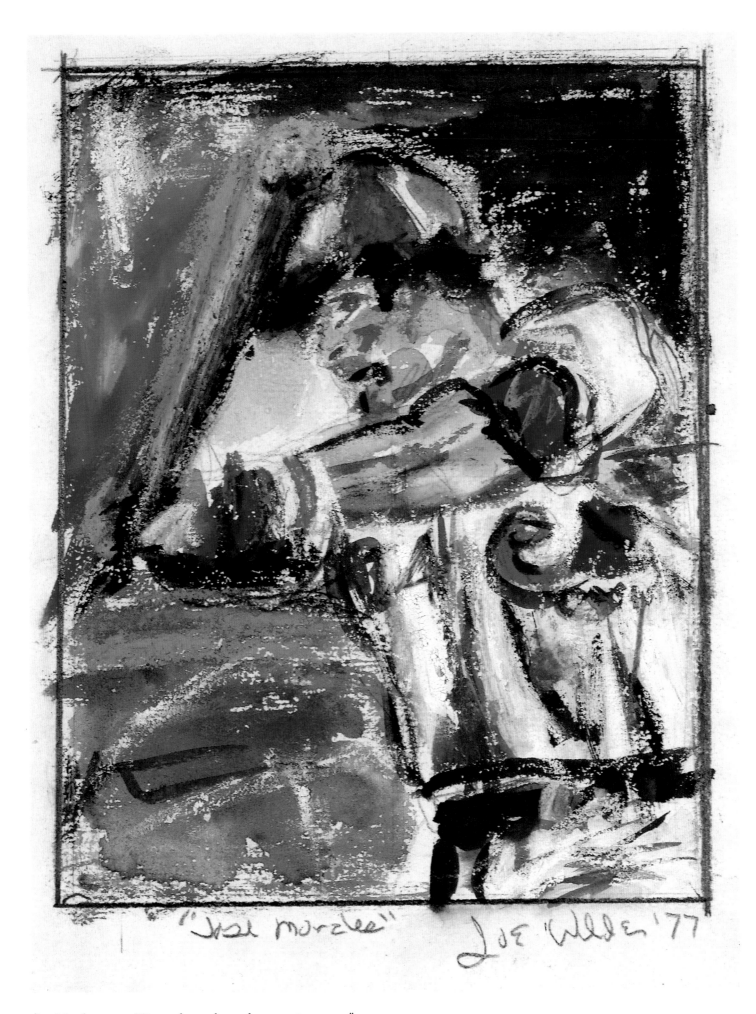

"Jose morales" Joe Wilder '77

Jose Morales. 1977. Watercolor and pastel on paper, 13 x 11″

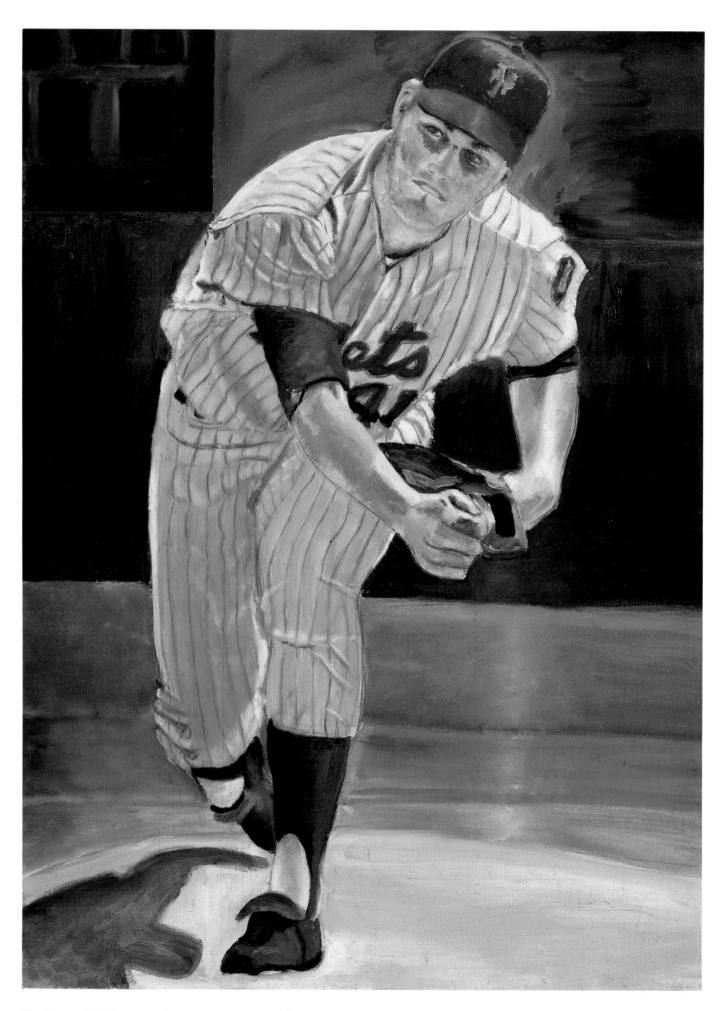

Tom Seaver, Met Star. 1984. Oil on canvas, 30 x 22″

BASEBALL

Pitching *Tom Seaver*

It's the bottom of the fifteenth inning in Anaheim, California. Some fifty thousand people have waited for the outcome of the game, along with millions of others watching on national television.

Tony Perez, the outstanding run producer for the Cincinnati Reds, has hit a home run in the top of the fifteenth and has finally put the National League ahead 2–1 in the annual All Star game of 1967.

Now, Tom Seaver, it's your turn to perform with these players who have been your idols for so long, to compete against those who, only a year and a half ago, lived in a totally different world from yours—the world of big league baseball.

I often look back at that moment in my career and wonder how I withstood the emotion and pressure of it all. Eighteen months before, I had been a student-athlete at the University of Southern California with visions of someday becoming a big league dentist. My opponents were UCLA Bruins, Stanford Indians, and other California collegiate teams. Now, seemingly all of a sudden, I had been picked by Walter Alston, manager of the World Champion Los Angeles Dodgers, to represent the New York Mets in this classic affair. I was competing against Boston Red Sox, Chicago White Sox, and the rest of the stars from the American League.

The one aspect of the experience that still fascinates me—and one I continue to draw on after seventeen years in the major leagues—was my ability to perform in such a situation. As Tom Seaver the person, I felt completely out of place and in over my head. But as Tom Seaver the pitcher, I was totally in control of the situation. I knew that as a professional athlete I could be on the field with any of these stars and hold my own. As a person, I was much younger than my twenty-two years, but now there was no place to hide, no excuses to hold up to the world. How the human psyche advances on different fronts and lags behind on others was finally clear to me, and that moment in Anaheim was the time when Tom Seaver the person caught up with Tom Seaver the professional.

As I stood on the mound and looked around the manicured field, I saw Willie Mays, Pete Rose, Roberto Clemente, and the rest of the National League depending on me to save the game. If ever my confidence was to be solidified, this was it.

Since that exciting moment in 1967, my career has taken me down many fortunate roads, like being on a team of World Champions in 1969 and playing in several more All Star games. But I never lost the respect for what it takes to be one of the best in my profession. The basis of our success does not change with our successes.

The basic theory of my career had been hard work, concentration, and dedication, along with the refinement of the God-given talents with which I have been blessed. That basic theory has not changed in seventeen years, and I doubt it will be altered before the conclusion of my playing career. The same theory is at the core of every outstanding athlete in one form or another.

I recall that, when I was a member of the Cincinnati Reds in 1977, we had played a Sunday doubleheader against the Houston Astros. Pete Rose was playing third base for the Reds and he had had just a miserable day, going 0 for 8 or 0 for 9. As I walked out of the clubhouse after showering, I started for my car to drive home to my family, and then I heard someone taking batting practice. Rose, after the doubleheader and nearly twelve hours at the ball park, had one of the coaches back on the field. He took thirty minutes of hitting, working on his skills with the bat. I know—I stayed the entire time and watched him. It was only one example of the type of dedicated athlete Rose is, the kind who has never given up the basic theory of his profession. He is the hardest-working ballplayer I know.

It has long been my contention that the physical abilities of pitchers on the major league level are nearly equal. Certainly there are exceptions, like the great Dodger left-hander and Hall of Famer Sandy Koufax and the Houston Astros' strikeout artist Nolan Ryan. These two pitchers were blessed with the ability to throw a baseball with tremendous velocity, but, for the most part, the difference in "stuff" from one pitcher to the next is not that great.

Then what accounts for the difference in performance?

I believe the difference is in the mental and emotional application to the job at hand. Simply put, you have to be able to make the right decisions regarding which pitch to select and how to attack a hitter, and to do it consistently. The pitcher who makes the fewest mistakes will, over the long haul, be a winning pitcher. Every pitcher is going to make a certain number of physical mistakes during the course of a game, but it is the control of the number of mental mistakes that makes the real, and in most cases the deciding, difference.

Baseball is a game of emotional and mental stability. There is not the tremendous high experienced by the professional football player on Sunday afternoon, but rather the steady pace of a game today, a game tomorrow, and a game, maybe two, the day after that. Including spring training exhibition games, there are nearly two hundred contests during the course of the year, and control of individual emotional

56

and mental levels is therefore paramount. If every game were played like a Sunday afternoon football conflict, a baseball player would be a basket case by the middle of June. The situation is somewhat different for a starting pitcher in the big leagues because he is working only every four or five days, but a lack of mental and emotional discipline will still lead to unwanted errors on the mound.

When I was with the Mets early in my career, we had a fine young pitcher who would become terribly upset if there was an error made by the defense behind him or if there was a bad call by the umpire. Invariably, the next pitch would be slammed for a base hit, and the young pitcher would still blame the "guilty" infielder or the umpire who made the bad call. This young pitcher never realized that his emotional instability and inability to cope with matters out of his control were his biggest drawbacks. To allow a bad call or an error to affect your next delivery is letting a negative instance hurt you not for one time only but for every succeeding pitch you throw, while you keep thinking about an event that is now history.

Control of the physical aspects of pitching is certainly as important as control of the emotional and mental energies. Consistency of execution is the key to physical efforts, just as it is to the mental aspects of the game.

The biggest change I have seen in my seventeen years in the big leagues, aside from overall team speed, has been the development of highly sophisticated physical-training programs. The trainers employed today are much more knowledgeable regarding the functions of the body as they relate to throwing a ball than they were when I broke in as a rookie back in 1967. Not only the trainers and doctors but the players themselves are much more aware of what makes their bodies tick.

During my first several years in the big leagues, the use of weights (free weights to be more exact) was almost taboo. I remember walking into my first big league spring training camp and hearing the snickers of the veteran players when they saw me carrying my ten-pound dumbbell. Today almost the reverse is true. Those pitchers without a strength and stretching program are in the minority.

An effective physical-training program should combine two aspects, strength and flexibility. Trainers will say it is great to be strong, but it does little good if you do not have the flexibility to go along with the strength.

For the big league player, conditioning used to take place during the six-week period of spring training. Now, because a long career is so important from a financial viewpoint, conditioning is a year-round practice for nearly all players. Nor is it important just to the player from the financial standpoint; the ball clubs themselves have realized the advantage of having their investments at nearly the peak of shape, not just when spring training ends but when it starts. As a result, the clubs recommend their players work out, stressing strength and flexibility, on a regular basis

during the off-season. Many clubs will give their players set routines to use for the off-season and will also provide exercise facilities during the regular season for players who live in the areas in which they play.

For pitching the stress has been on maintaining a healthy rotator cuff. I doubt that seventeen years ago any pitcher had heard the term "strength through the entire range of motion" or the names of muscles like supraspinatus or infraspinatus, but today these elements of the human body are worked on with regularity.

Unlike football, where heavy weights have been used for years, baseball is coming to the realization that the use of light weights is a giant step forward for the prevention of sore arms and a tremendously useful vehicle for the rehabilitation process. On the floor of most training rooms in the big leagues, you can find a set of weights ranging from eight to twenty-five pounds. Most trainers will suggest that the weight of a certain exercise not be increased but rather the number of repetitions an individual can do to the point of fatigue. A dumbbell weighing as little as three pounds can be very effective when used in a rehabilitative program for the conditioning of certain smaller muscles of the rotator cuff.

The beauty of pitching is the blend of the physical and mental energies and talents. One of the worst sights is a young pitcher blessed with all the physical talent in the world but unable to grasp the importance of the mental aspects of pitching. The pitcher who continually makes the same mistakes is a frustrating sight.

On the other hand, watching a gifted pitcher blend the physical and mental elements of pitching is to me as beautiful as watching the performances of the great ballet artists of our time. Pitching is an art form, too, done well by the masters and not so well by the mechanics.

So now there are two outs in the bottom of the fifteenth. Just one more out, and the victory will be ours. Carl Yastrzemski is the hitter for the American League, and I know I'll be criticized if I walk him but there is no way, with nobody on base, that I am going to give him a pitch he can drive into the bleachers and tie the score. The pitcher is the next scheduled hitter, and I know that the only pinch hitter left on the bench is Ken Berry, an outfielder from the White Sox who bats right-handed. Yaz is going to first base so I know he can't hurt me. If I get two strikes on Berry, I know I can strike him out with a slider away.

A fast ball for strike one, another fast ball for strike two, and here I am right where I want to be. I've created the situation as planned. Tim McCarver is the catcher and, almost as if he knows my thought processes, he's calling for a slider. Now just concentrate and execute. The windup, the pitch, and (wow!) strike three. The entire National League team is congratulating me, coming toward me to shake my hand and slap me on the back. If they only knew. If they only knew.

58

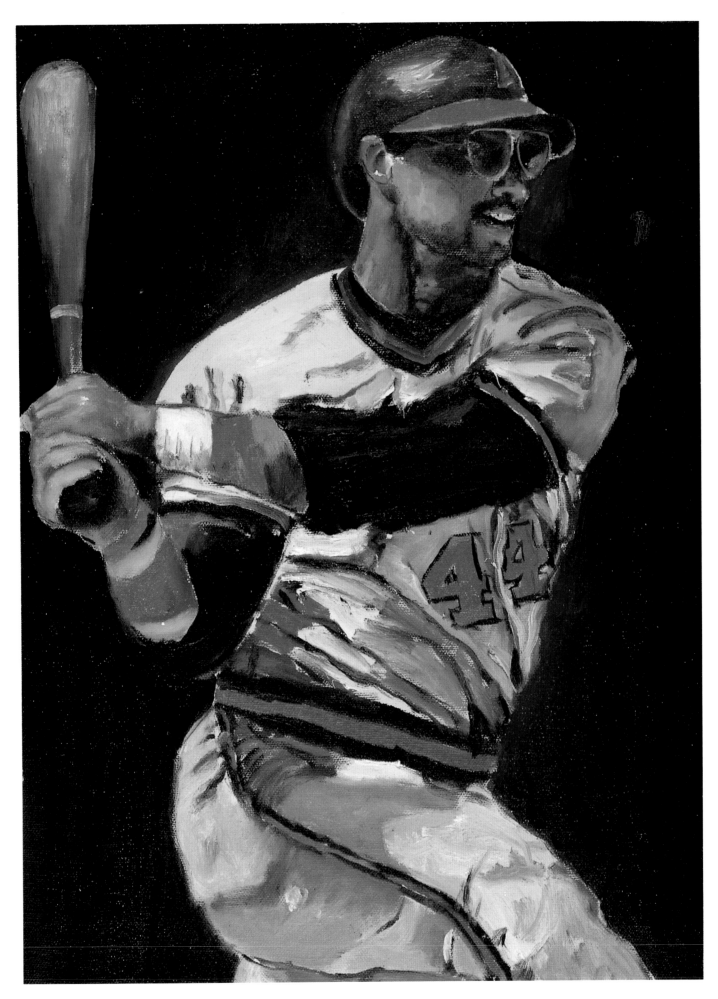

Reggie. 1983. Oil on canvas, 16 x 12"

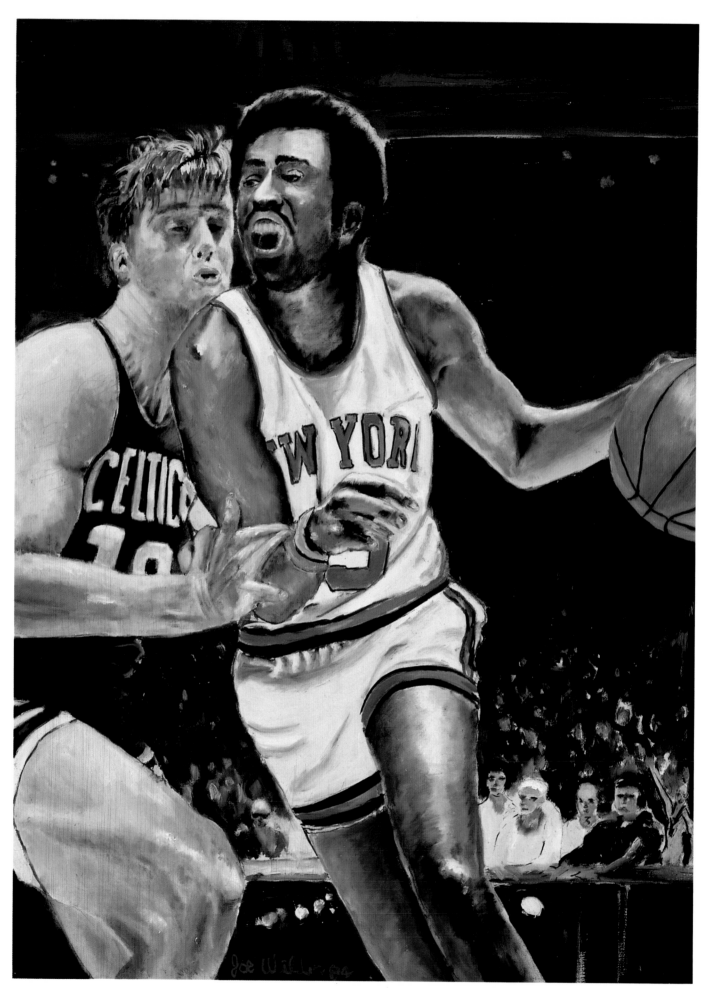

Knicks-Celtics Championship Game—Cowens on Munroe. 1984. Oil on canvas, 30 x 22″

BASKETBALL

What Makes a Pro *Red Auerbach*

I have often been asked, "What makes a basketball player?" Naturally, the player's physical makeup is an important part, but it is not the main factor. There have been thousands of people who have written to me and other coaches saying, "My son is thirteen years old and six feet three. He should be a basketball player. Why don't you sign him?"—or other nonsensical requests. My usual answer to those questions is, "Can he chew gum and walk at the same time?" By that I mean that, although size is of value (even people with a good build have value), the most important element is coordination.

Can he run?...Can he jump?...How does he react?...How is his lateral movement?

When he jumps, how is his timing in relation to the position of the ball? In other words, is he a quick jumper, a reaction jumper, or just a jumper?

What of his hands? Does he have strong hands, sure hands, or what we call "quick" hands?

What kind of peripheral vision does he have? Can he dribble without looking at the ball? Can he pass without being obvious about where he's passing?

What of his judgment? Shooting the ball involves coordination of eyes and muscle reaction. His eyes judge the distance, and the muscle judges the necessary force needed to propel the ball to the basket. The same can be applied to passing.

How does he react to coaching? When you teach him something, does he diligently practice it or does he just forget it and everything else he's been told? So you look for coachable players.

Is he a competitor? Does he like contact? Does he initiate contact or merely retaliate? Is he aggressive?

How does he react in clutch situations? Is he hot or cool under fire, or does he tighten up?

What are his ambitions? How far does he want to go with the game? Is he the hungry type, statistically minded, or a team-oriented player?

These are some of the questions and facts that go through my mind in determining what makes a basketball player. Naturally, all these factors could not be evaluated by merely watching a player work out or play in one game. You should see a

Wilt. 1983. Oil on canvas, 14 x 10″

Jerry Lucas Dribbling. 1984. Oil on canvas, 16 x 12″

Wilt Chamberlain, Los Angeles Lakers. 1975. Oil on canvas, 16 x 12″. Collection David W. Gibbs

player at least three or four times, try to speak not only with his coach but with some of his rival coaches, and many times it helps to speak to the player himself. When you consider all these factors, you finally decide that it is not really easy to find out what makes a basketball player.

There have been many college players who, upon entering the NBA, fizzle out, some of the reasons being that they reached their peak early in life; they did not want to work hard to improve their game, which had to be on a higher level in the NBA; they got paid so much money they thought they would enjoy it and not worry about their future; they were drafted by a team in which their particular position was so competitive that they just quit (when a player does this it is very difficult for him to get picked up by another team); or they had pesky injuries that affected their play. Such players most often get out of basketball entirely, but occasionally a few realize how they contributed to their being cut and they tighten their belts, work hard, and give it another try.

Then there are the players whose abilities are latent and bloom on a professional level. This is often due to coaches playing a stereotyped game of basketball in college and thereby prohibiting the player from expressing himself and showing many of his skills. Oftentimes a player just does not develop at a young age, and if he is given a chance to hang on, he can be a good addition to a ball club.

Then you have the players who work hard right after they graduate from college, before going to the NBA, and they improve so much you don't know it's the same player. A good example of this is Lenny Wilkins, who was a notoriously poor shooter when he graduated and then became a great shooter. Other aspects of his game naturally improved, too.

Then there is the case of Bill Russell. Bill Russell was the greatest rebounder in college, All-American, and so on, but nobody ever thought he would turn out to be the greatest player of the game. He did this through lots of hard work and an intellectual approach to the game.

There are many, many more examples of both: some players got better when they left school and some players got worse when they left school. And, as I have said, it's practically impossible to predict with complete accuracy the course of any individual's career.

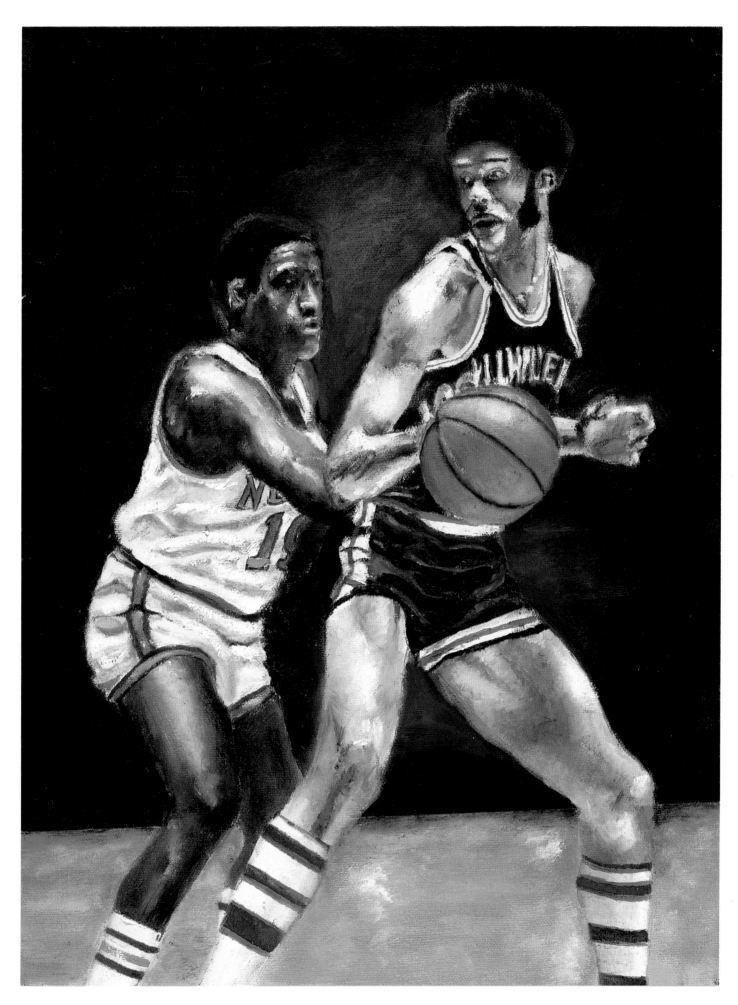

Willis and Kareem, the Two Big Guys. 1983. Oil on canvas, 16 x 12″

Buck Buchanan, Kansas City All Pro. 1975. Acrylic on canvas, 12 x 10″. Collection Frank Bertino

FOOTBALL

The Unknown Player:
No. 65 Replacing No. 63 *Wilfrid Sheed*

Once upon a time, before the age of specialization, there were two kinds of football players: forwards and backs. Or, as I remember them from the old programs, players who needed big necks and players who didn't—but had them anyway.

Of the two, the forwards were slightly heavier and the backs slightly faster. But since everyone had to do so many things—block, tackle, and look lively for sixty minutes—there were few glaring disparities in type. If you saw a team waiting for a bus, you would know they were all in the same line of business.

"We had two guys who weighed 230 pounds," reminisces Irwin Shaw of his Brooklyn College days in the thirties, "but they were just substitutes. Too clumsy." Yesterday, contrariwise, I heard a man of six feet three inches and 246 pounds described on television as "possibly a bit too small for the game."

Too small for *his* game, that is. Specialization has riven the overall game into several quite separate activities, so that walking around the field is like visiting different kingdoms. There is no longer a single football type but a linebacker type or a wide receiver type. Our tiny 246-pound friend was simply caught in no man's land: too small to enter one kingdom, too large, like Alice in Wonderland, to enter another.

Modern players do have one thing in common with their ancestors, which is an uncanny willingness, bordering on exhilaration, to hit and be hit. My own recollection from school days is of one's face constantly crashing toward the ground, so that one developed a special relationship with topsoil, whether hard or mushy. You might not like it, but it was your brother.

I don't know if Astro turf has changed this relationship, but I still imagine your

Author's note: These remarks are based entirely on the professional game, because only there do you find enough talent for such Platonic typecasting. They are based on observations made from some of the worst seats in Shibe Park, the Polo Grounds, and Yankee Stadium, and subsequently my own living room, where the seats can also be pretty bad. During this period, from 1940 to the present, football has undergone an evolution unparalleled in contemporary sports, even basketball, which simply has fewer constituent parts to evolve.

Reggie Williams. 1984. Oil on canvas, 30 x 24″

Herschel Walker. 1984. Pastel on paper, 16 x 12″

basic football player as a man who will hit anything, from a brick wall to a near relative, at the bark of a signal. How much of this sheer "hittingness" is inbred is obviously anybody's guess, but I do know that it can be acquired, as dread of contact gives way to relief and finally to a curious pleasure. And it does not imply violence in one's other pursuits. Although football players are, like most athletes, abysmal practical jokers, their horseplay is not notoriously aggressive—perhaps for the good biological reason that they would all be dead by now if it were. For whatever reason, the last superstar to get hurt in a locker room scuffle was not a football player but a baseball guy.

So much for what f.p.'s have in common: hitting and more hitting. Beyond that, differences in size and assignment dictate differences in temperament. A study reported in *Sports Illustrated* some years ago indicated that our gang are overall the most intelligent of athletes (or, as an announcer might say, "very smart for a big man"), but this again must vary from position to position. Anyone who can memorize any part of a modern playbook has to have some smarts, but some obviously have to memorize more parts than others. Which brings us not to the steely-eyed quarterback—the one player that *everyone* knows about—but the interior offensive lineman, about whom little is known or possibly cared.

These men in fact constitute a fascinating breed, if only because, quite against the American grain, they seem content to remain obscure and relatively poorly paid. Try naming an all-time all-star team, and you will likely come up with twenty-five quarterbacks, fifty running backs, and a great hole up front. If it hadn't been for Jerry Kramer's *Instant Replay,* one might never have heard of any offensive guards or tackles at all.

How content these beasts of burden actually are we'll probably never know, because we hear so little from them; but we do know that your wise superstar like O. J. Simpson never misses an opportunity to praise them. A guard or center may never become a free agent or a household word, but he holds the key for those who can. One doesn't think first of loyalty in terms of the other positions, but here it is everything. When, for instance, the talented quarterback Vince Ferragamo went to Canada and had the most miserable year in history, it seems fair to deduce that he'd forgotten one of his linemen's birthdays; or more seriously, that they didn't cotton to rich Yanks up there.

It would seem too much to ask of these anonymous, brutally overworked citizens that they also be intelligent, but nobody ever said that football was fair. In fact, every play in the book requires of them a different nuance of blocking—whether to make a hole or only appear to, whether to brush block or steamroller or even occasionally to let a man through while appearing not to (the primeval "mousetrap"

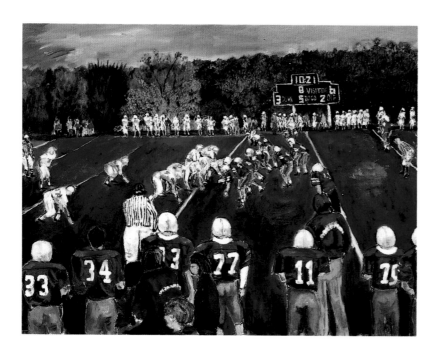

Riverdale Championship Season, 1983. 1984. Oil on canvas, 18 x 24″

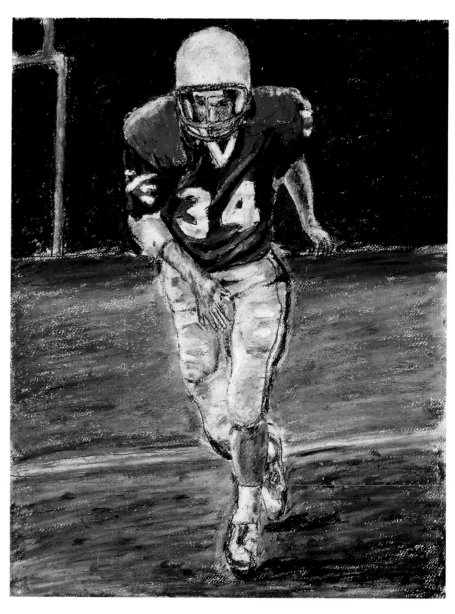

Nick Wilder, Young Warrior. 1984. Pastel and oil on paper, 16 x 12″

play)—and these plays are often changed at the line of scrimmage, while our man is staring at an enraged, hyperactive gorilla a few feet away and trying to decipher the quarterback over the howl of the crowd.

Although, in aggregate, offensive linemen may look like fugitives from a chain gang, they are highly disciplined and intelligent souls—many of them, I would guess by the names, from coal-mining country and grateful to be playing anywhere at all where the sun shines.

They also tend to be slightly smaller (let's say, 260 v. 280), and slightly less good natural athletes, than their opposite numbers on the defense, because coaches like to fill up the defensive line first. These two groups of mastodons are condemned to spend their lives within about five yards of each other, yet they tend to be quite different in type. Where the offense is quasi-military in its planning, the defense must improvise, seize the moment, think on its feet. Defensive signals are only suggestions based on guesswork (unless they come from Tom Landry, who *knows*).

Defensive linemen tend accordingly to be buccaneers and free spirits. There is some glory to be had by them, even if they have to share it with the other People Eaters or the rest of the Fearsome Foursome, and unlike the stolid Palace Guard across the way they have the mouthwatering pleasure of sacking the Rich instead of defending them.

The intensity of this pleasure used to be testified to on Monday Night Football by Alex Karras's cackles of glee every time a passer was hit. Apparently a lineman is never too old to light up over a writhing quarterback. Karras himself was particularly menacing on the field: reveling in the limitations of his position, he actually used to play without his glasses, which was somewhat equivalent to a fastball pitcher working blindfolded.

Behind these marauders lurk perhaps the most vicious creatures in the bestiary, linebackers. Up to now we have been dealing with men who don't look as if they could play any other sport, except maybe the shotput. Karras's bad eyesight is unusual but symbolic—what other athletic work can be found for the blind or near-blind? It is nice of football to provide a home for these large but sometimes limited men, but this ceases abruptly as one leaves the pit, or line of scrimmage.

Linebackers are built closer to the size of heavyweight fighters, which is clearly the optimum size for speed combined with strength (linemen are too big for boxing, as one "Too Tall" Jones of Dallas recently discovered in a brief ring career), and their nervous systems seem to be at some equivalent juncture of aggression. In a world of giants or linemen, they are the little guys, feisty and ferocious; among more normal specimens they are the enforcers, the cops. Either way, they are among the hardest hitters in football. Ray Nitschke, Dick Butkus, Jack Lambert, and

Chuck Bednarik were all bywords in terror: yet each is now quite genial in repose. Action seems to alter personality more radically in their case than most.

The middle linebacker in particular must do his best to cope with the Mack Truck elements, the Jim Browns and Earl Campbells, as they thunder over the tundra, breaking jaws and snapping necks, but he must also cut with the scatbacks as they go out for short passes. His rage is inflamed by concentration. Every play ideally begins for him in thought and ends in violence. Having read the mind and history of the quarterback, the linebacker must decide like a tennis player, or a yo-yo, whether to move in or out, become a forward or a back, for both of which he is half-equipped. His natural rival physically is the offensive tight end, usually a slightly taller version of himself, who must for his part block with the big boys and play catch with the fast ones. A Butkus stalking a Mike Ditka is one of the finest match-ups in nature or anywhere else.

Which brings us at last to the pure athletes who make the game so pretty to watch. The cornerbacks and safeties on defense and the wide receivers and halfbacks on offense look as if they could play any other sport they chose, and they often have. Some have been recruited from track, others from baseball and basketball (has *any* middle lineman ever been offered a baseball contract?), and as they approach other athletes in type, they seem to recede from the football essence: I'll bet there are even some wide receivers who don't like to be hit.

These belong to that special elite which gets to play with the ball and not just with each other. Out in the outback where the receivers roam, far from the noise and urban congestion of the scrimmage, the game becomes pastoral, a bunch of kids fooling around, ducking this way and that, sidestepping, stealing the ball.

For the offense, this randomness is mostly illusion. As usual, whatever can be planned is planned and the receiver had better be where he's supposed to be by the count of three or four, however he elects to get there. The defenders are as usual the gamblers. Play deep and get burned, play close and get incinerated. No one's mistakes are plainer to see, no one gets more egg on his face per season. Yet guess right, and he may find himself strutting down an empty lane with a picture-book interception.

These rangers are often converted running backs, and they thirst to get the ball back one more time, and with it the glory, that was rudely taken away by some coach. They also live on their reflexes and their wits and are the most likely to write sassy books (see Johnny Sample, Jack Tatum, et al.) upon retirement. The fact that they also tend to be black may have something to do with the legendary Negro foot structure and its awesome capacity for leaping. But here, as with other positions, notably quarterback, a lot also depends on how much early coaching is needed and

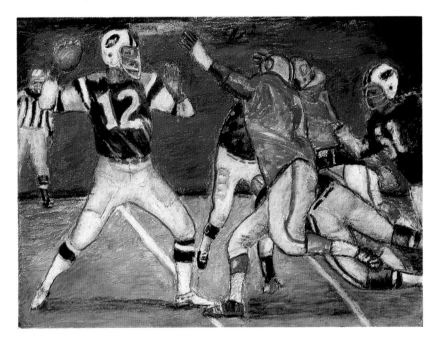

Joe Namath Under Attack. 1984. Pastel on paper, 19 x 26″

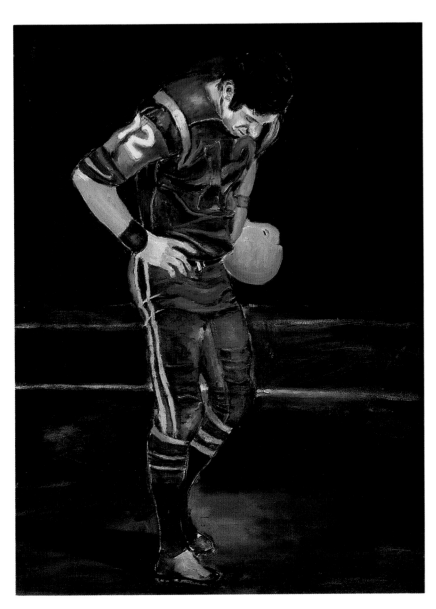

A Dejected Joe Namath. 1984. Oil on canvas, 24 x 18″

how much is available. And you can't coach a reflex.

We are now approaching the high priest himself, the quarterback, and his henchmen, the running backs, who, as far as statistics are concerned, are the only people besides receivers who play the game at all. Middle linemen who put in ten years or so depart the scene without a trace: they leave no records behind, except minutes played, to prove their existence. The only other statistically existent players are not really players at all, but those strange little footnotes who bob up and kick field goals during the intermissions in real life. When I recently saw one of those gnomes give the high sign and scamper round in a tiny circle after a success, I thought, by God, he's *trying* to be a football player. But that's as close as it gets.

Statistics have little to do with football, as one might guess from the sloppiness of the math: a statistical yard is just an estimate (how far has Franco Harris actually run? every yard is raised, as in banking, to the nearest round number); a dropped pass is not recorded, any more than a miraculous catch, in a passer's percentage; and a 5-yard pass followed by an 80-yard run is listed, incredibly, as an 85-yard pass. As for the gnomes, on any given (or withheld) Sunday, incongruous head winds, bad snaps from center, and missed blocking assignments can play the very devil with their precious numbers.

Statistics are designed to hide what every player knows, namely, that football really is a team sport, from the spotter on the roof down to the man shooting the films for next week's game, laboring under a publicity-enforced class system. So let's for once skip the sky pilots throwing their bombs and the solipsists running for eternal daylight, and give the game ball to the man whose name is heard only when he steps offside, the enlisted man who risks his knees and his neck in the trenches every Sunday—the Unknown Lineman.

P.S. A surprising number of linemen have made great coaches, including the likes of Vince Lombardi and the three great pioneers George Halas, Steve Owen, and Curly Lambeau; by contrast, I find it hard to think of a single running back in the top rank. Which supports a belief that running backs know less about the total game than anyone else on the field except the kickers.

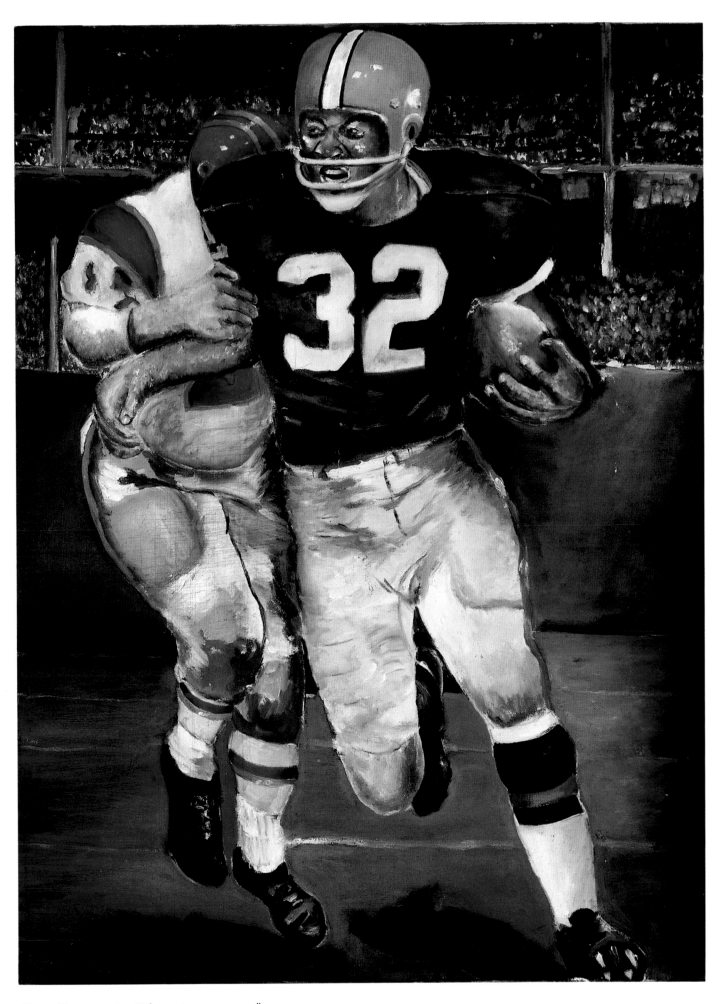

Jimmy Brown. 1984. Oil on canvas, 32 x 24″

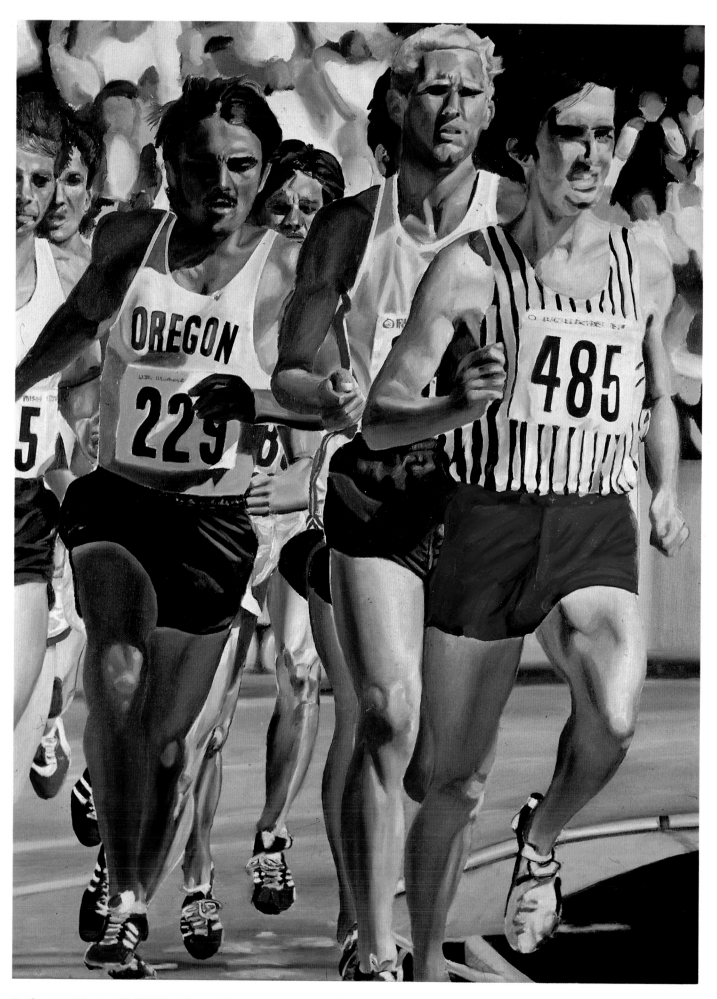

Prefontaine Winning Half Mile, Olympic Tryouts 1972. 1974. Oil on canvas, 35 x 30″. Collection Irwin Ploss

TRACK AND FIELD

No Place to Hide *Frank Litsky*

Q: What makes a great athlete?

Q: Why is one athlete great and another not?

Q: What characteristic or characteristics do great athletes have in common?

A (to all of above): Who knows?

We have romanticized these questions to death. We have Frank Merriwelled them to death. Look, kid, if you want to be a sports hero, you must practice hard and play hard and do your best all the time and never give up even when things look bad and respect your coaches and get eight hours of sleep a night and eat the right food and stay away from booze and funny little pills and white powder. And remember to eat your Wheaties every morning and drink the orange juice that Bruce Jenner thinks is best.

That's fine. Wheaties and orange juice cannot hurt, and if practice does not always make perfect, at least it helps.

To be sure, a study of outstanding athletes would uncover other common threads. Ability never hurts. A gifted physique is a blessing. Cardiovascular capacity is a bonus.

But success does not emerge neatly from a mold. There are all kinds of good athletes with all kinds of gifts and all kinds of deficiencies.

And if we can confuse the issue a bit more, there are team sports and individual sports, and the psychological demands and requirements of the two often differ. In these paragraphs, we are talking mainly about track and field, a highly individual sport, and if we must find a common thread among those who excel in track and field and similar sports, it is something that cannot be coached or taught or acquired or purchased from a Sears catalogue.

It is character.

What is character? Is it a buzzword, a convenient and shallow answer to a complex question?

Not really. But it is easier to illustrate character than define it. Consider the stories of Jay Luck, Bob Giegengack, and Al Oerter.

Jay Luck was the Yale track captain in 1962, Wendell Mottley in 1964. The two friends were honor students who would earn doctorates, and they were the favorites of Bob Giegengack, the Yale coach, who was also coach of the 1964 United States Olympic track team.

The twist here was that Mottley would run in the Olympics not for the United States but for his native Trinidad. People wondered all year whether Giegengack would secretly root for Mottley to beat his American 400-meter runners in the Olympics. Giegengack, a wise man, had a quick answer.

"Until June," he said, "I shall teach Wendell Mottley of Yale all I know about how to beat the Americans. After June, when Mottley graduates, I shall teach the Americans all I know about how to beat Wendell Mottley of Trinidad."

In the Olympic heats, Mottley ran so well that he was favored in the final. He feared only one runner, Ulis Williams, an American.

The day before the final, Williams injured a hamstring muscle. Giegengack knew it. Luck knew it. Mottley did not, and his old coach and his best friend were not about to tell a runner from Trinidad about an injury to an American.

In the final, Mottley gained so much ground on Williams in the first hundred meters that he thought he must have been running too fast. So Mottley, still unaware Williams was hurt, eased off. Meanwhile, Mike Larrabee, another American, started closing ground, and in the last ten meters he caught Mottley and beat him by two feet.

Had Mottley known of the injury to Williams, he would not have eased off, and he probably would have won the gold medal.

"But no one told me anything," said Mottley, "I would not expect anyone to. Jay's obligation was to his teammates, not to me."

Jay Luck allowed his best friend to lose because Jay Luck had character. So did Giegengack, his college and Olympic coach.

The spring before those Olympics, Giegengack took his Yale team to Ithaca, New York, for the indoor Heptagonal Games. This was a conference championship meet involving the eight Ivy League colleges and Army and Navy, none of them a track powerhouse.

But the presence of a runner as good as Mottley made this meet special, and Mottley's performance made it even more special. On a flat board track in an armory where runners had to wear flat shoes instead of spikes, Mottley set a world indoor record of 1 minute 9.2 seconds for 600 yards. Ninety minutes later, he led Yale to victory in the one-mile relay by running the 440-yard anchor leg in 46.7 seconds, the fastest ever to that time.

Yale had one other winner in that meet, Jeff Sidney, who won the two-mile in

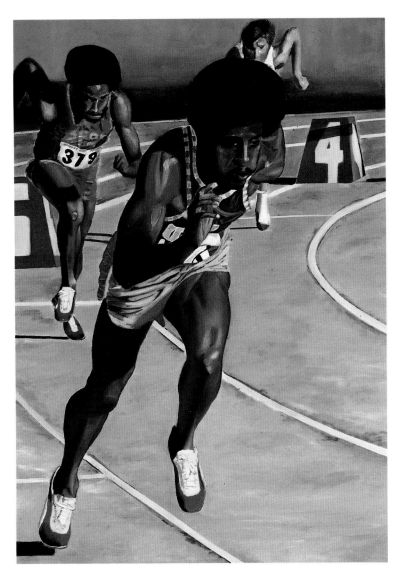

John Smith. 1974. Oil on canvas, 41 x 29".
Collection Mr. and Mrs. Frank Litsky

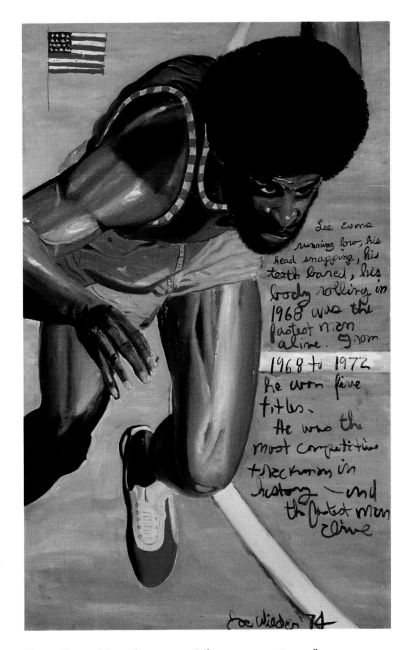

Lee Evans running low, his head snapping, his teeth bared, his body rolling in 1968 was the fastest man alive. From 1968 to 1972 he won five titles.

He was the most competitive trackman in history — and the fastest man alive

Joe Wilder '74

Evans, Fastest Man Alive. 1974. Oil on canvas, 48 x 30"

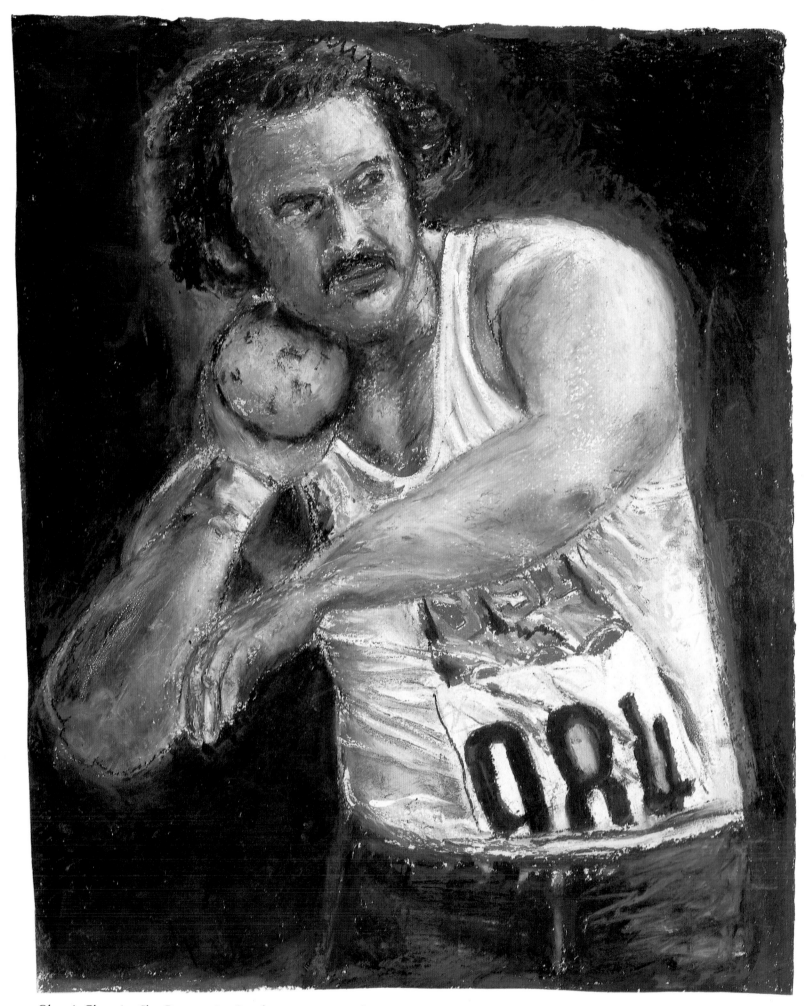

Olympic Champion Shot-Putter. 1984. Pastel on paper, 16 x 13″

Ryun. 1984.
Watercolor, pastel, and oil on paper, 13 x 11″

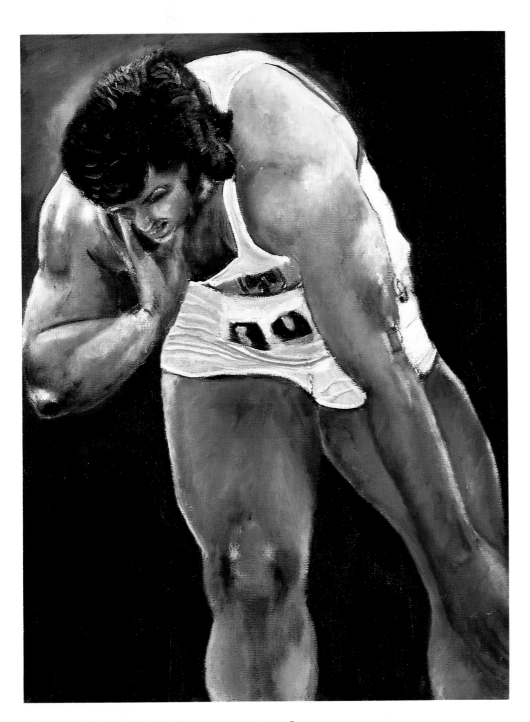

Olympic Shot-Putter. 1984. Oil on canvas, 16 x 12″

the pedestrian time of 9 minutes 26.6 seconds. The fact that Jeff Sidney was even there told something of Giegengack's character.

Jeff Sidney was an obscure distance runner who had never won an important race. Less than a week before this Heptagonal meet, he had placed fifth in a dual meet against Dartmouth. Many coaches would have cut him from the team on the first day of practice. Not Giegengack.

"He came to me," said Giegengack, "and said, 'Coach, I want to run for you.' So I said O.K. I didn't ask him how fast he was. I didn't promise him he could run in meets. I told him he had to come to practice, and he said he would. I told him he had to keep up his studies, and he said he would.

"All I know is that he wanted to run track and I'm the track coach. I don't care if he's as good as Wendell Mottley. That isn't important. The important thing is that he wanted to be part of something and was willing to do the work.

"Wendell Mottley is one of the world's greatest runners and he won a Heptagonal title. Jeff Sidney is not even one of Yale's great runners and he won a Heptagonal title. I'm as proud of one as the other."

Bravo, Bob Giegengack. And bravo, Jeff Sidney, who wanted something and got it.

Jeff Sidney and Al Oerter were both champions. Only the settings were different. Al Oerter is the only athlete to have won a gold medal in the same event in four consecutive Olympics. He won the discus throw in 1956, 1960, 1964, and 1968, each time beating the current world-record holder.

Then he retired to enjoy his growing daughters, but in time he found he missed the challenge of competition. So after almost a decade of inactivity he took up the discus again and, well past the age of forty, threw farther than ever.

He issued no challenges to the stars of the day. He made no brash predictions. He put no demands on himself to win another Olympic gold medal.

Instead, he discarded his outmoded technique and learned a new throwing style. He worked to improve himself as a discus thrower, and he kept the rest of himself free to savor the other things in life.

He said he just wanted to improve and learn and enjoy himself. A fifth gold medal wasn't important, he said. Making another Olympic team would be nice, but that would not make or break his happiness. He had discus throwing and life in perspective, and people everywhere found his low-key approach refreshing.

That acceptance was nowhere more evident than in the 1980 United States Olympic trials in Eugene, Oregon, where track and field is a quasi-religious ritual. The first three finishers would qualify for the Olympic team, though the United States boycott of the Moscow Olympics made the honor somewhat empty.

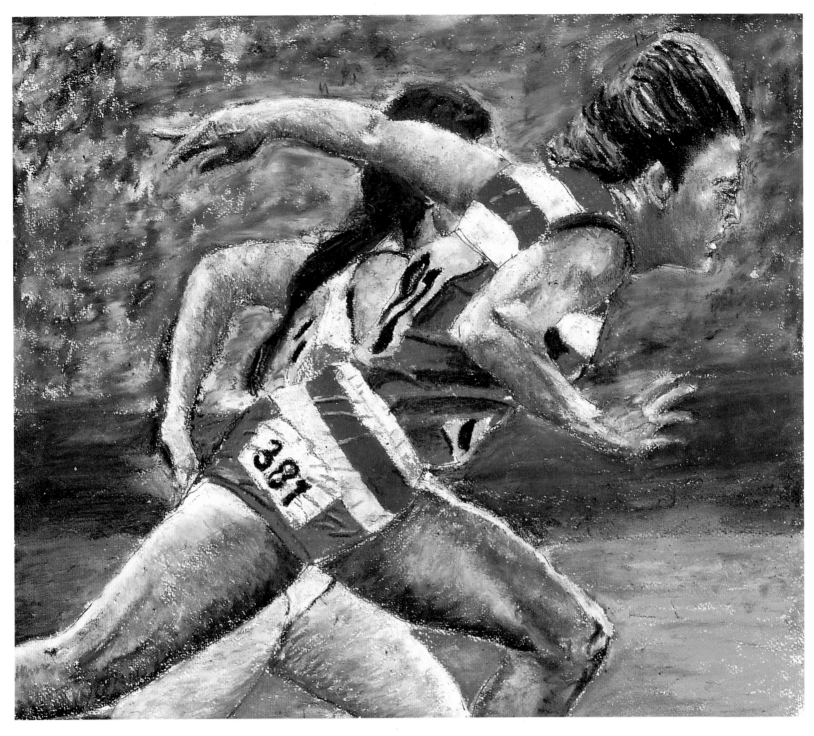

Women's Olympic Relay Race. 1984. Pastel on paper, 12 x 14″

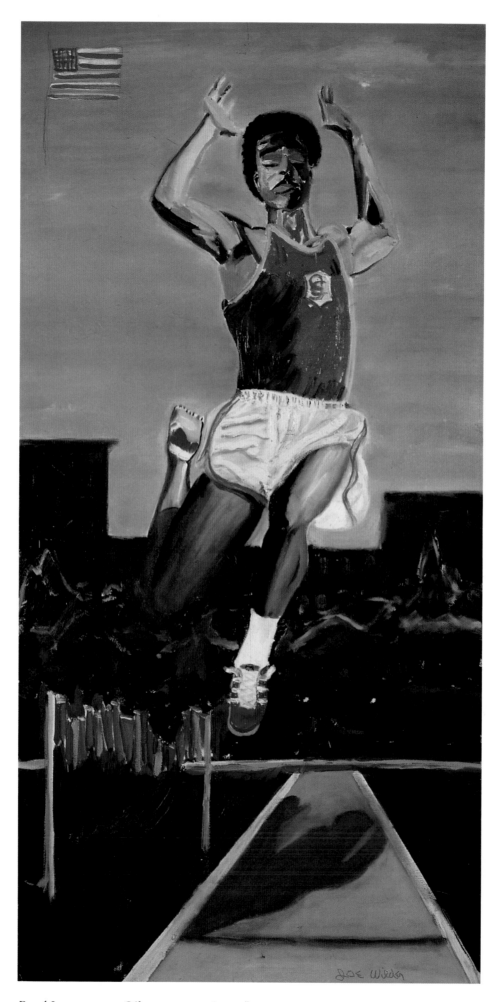

Broad Jumper. 1973. Oil on canvas, 48 x 24″

Mac Wilkins finished first, John Powell second, and Ben Plucknett third, and all made the Olympic team. At age forty-three, Al Oerter finished fourth, thirty-seven inches away from his fifth Olympic team.

After his last throw, the crowd of fourteen thousand gave him a standing ovation. Oerter turned toward the grandstand incredulously and bowed. Another cheer went up, and he bowed again.

"I never got a standing ovation before," he said. "I didn't know what to do."

Now that he had proved he could throw again, Al Oerter obviously was ready to retire for good and settle down into middle age. Hardly.

"It was fun being in with all the other crazies," he said. "It was worth the four-year effort. I have no doubts now. I will try for the Olympic team in 1984." (An injury subsequently stopped him from doing so.)

How about the 1988 Olympics, when he would be fifty-one?

"I'll let you know about that in 1984," he said.

As Oerter left the field, a spectator yelled:

"One more, Al."

Oerter smiled and waved.

"At least one more," he said.

And why not? True, Al Oerter had already achieved more than anyone else. Now he had nothing to prove to anyone, including himself. He was doing what he wanted to do. If he threw poorly, there was always tomorrow. If he lost, so what?

Al Oerter has learned a lot about life. The man has character. He knows how to live and play in a world in which he cannot hide, and that is what track and field and swimming and boxing and wrestling and all nonteam sports are about.

Joe Louis, the late heavyweight boxing champion, was preparing for a 1939 title fight against Bob Pastor, who had once gone the distance with him. Some people thought Pastor could beat Louis by jabbing and then dancing away, but Louis answered with irrefutable logic.

"He can run," said Louis, "but he can't hide."

Beasley Reece, a long-time safetyman in the National Football League, expressed the same idea in another way.

"If a lineman misses a tackle," he said, "a linebacker can make it. If a linebacker misses, the safety is there. But when a safety makes a mistake, there is no one behind him. The safety is naked."

Similarly, the track and field athlete is naked. The runner, the discus thrower, and the long jumper can't hide. They achieve or they don't.

In that sense, there are different mentalities for team and nonteam sports. The athletes who play baseball, football, basketball, hockey, soccer, and other team

sports are prisoners of their peers. If the individual plays well and the rest of the team does not, the team usually loses. If the individual plays poorly and the rest of the team does not, the team usually wins. These individuals are only a part of the puzzle. They contribute to the team's success or failure, but by themselves they seldom control it.

On the other hand, the athlete in the nonteam sport usually controls his destiny. If he takes part in a college or school program, coaches and others may regulate his life. Otherwise, he more or less competes and trains when and how and if he wants to. And that demands a certain self-obligation.

A football player may slacken off one day in practice. A baseball player with a kink in his shoulder may skip batting practice. But a runner seldom can take such liberties. Edwin Moses, the world-record holder in the 400-meter hurdles, says self-discipline is not easy.

"I try to get up early in the morning and train every day," he said. "A lot of days, I don't want to do it, and sometimes I don't work out, but only when I don't feel the need. On those days, I might just run cross-country and sprint up and down hills. Or I might go swimming or stay home and stretch."

In other words, when Edwin Moses doesn't feel like training, he trains.

The tangible rewards in nonteam sports, except for a gifted few, are hardly enough to keep prime beef on the table. A Sugar Ray Leonard can make $10 million for one fight, and Larry Holmes can earn $8 million or $4 million or $3 million for an hour's work, but most boxers struggle on much less and have that carved up by managers, functionaries, and good-time friends. And those boxers are professionals.

Except for college scholarships or training grants, never more than $500 a month, amateur athletes in nonteam sports are fortunate to have someone buy them a Big Mac. Only a few distinguished track and field athletes, such as Moses, Carl Lewis, Alberto Salazar, Bill Rodgers, and Mary Decker, make a sound living from appearances, endorsements, clinics, and the largesse of meet promoters.

But there are no guaranteed contracts for these nominal amateurs. There is no benchwarmer to replace them in the fourth quarter. There is no pinch hitter or relief pitcher to bail them out.

"When I compete," said Moses, "I get no preferred treatment. I still have to go 400 meters and 10 hurdles. That's what it is. I just have to get to the tape first—fast or slow."

That's what it is with track and field and all the other one-on-one sports. There is no place to hide, which is all right, too. Who wants to spend life hiding?

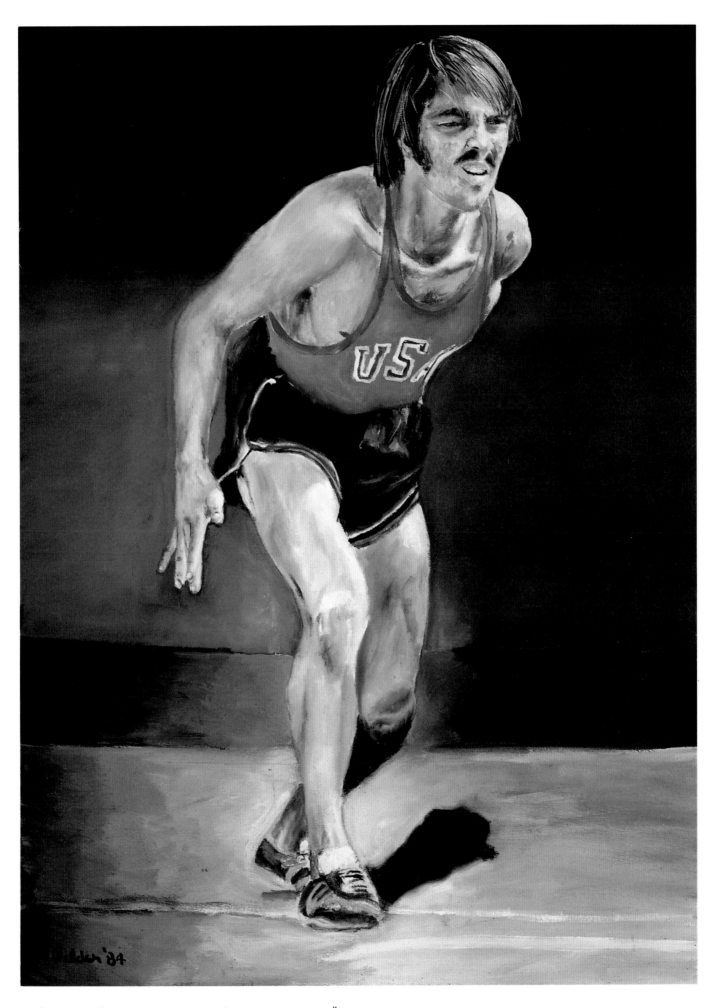

Prefontaine Coiled and Ready. 1984. Oil on canvas, 30 x 22″

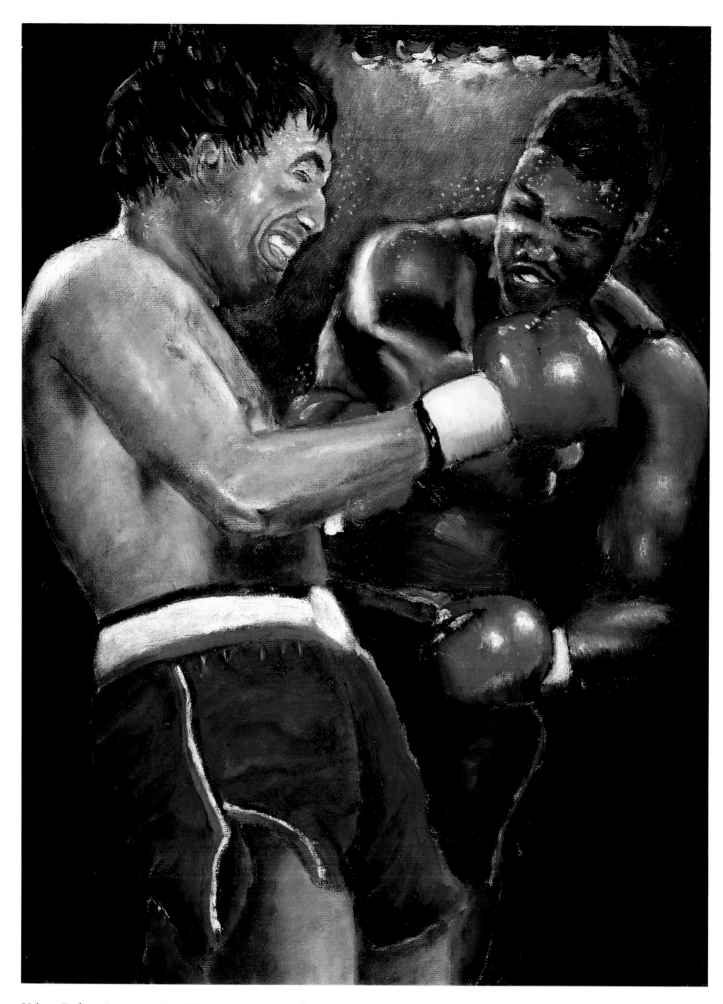

Holmes Defeats Cooney. 1983. Oil on canvas, 16 x 12″

BOXING

The Universal Game *Morton H. Sharnik*

Of all popular sports, boxing is the only one that provides competition for all sizes—little guys fight little guys, medium-size fellows meet other medium-size chaps—unlike, for instance, basketball or football, where only giraffes or water buffaloes need apply. Anyone can identify with boxers; all he has to do is pick out the appropriate size. In that sense, as well as others, boxing can be regarded as the universal game.

Reduced to basics, the sport is a series of contradictions. It appears to be an activity dependent on muscle, but force in the end will not carry a fighter to the championship, or even to the elite status of a contender. Oddly enough, the heavily muscled body types often make poor prospects. "Look for the wiry kid who is flexible and can slip punches" is a boxing truism. "Snap" is the word used to describe the desired punching style, more likely to be found in long-muscled bodies than in ponderous bodybuilder types.

Nor is skill the answer, although it helps. "On a world-class level, boxing is more a matter of will than skill," says the Machiavelli of boxing, Cus D'Amato. The fighter's will is tested even before the fighter steps into the ring for the first time, and every time thereafter. Good sense tells the raw recruit and the old pro, "Don't do it, it hurts." It is not only the daily cuffing but everything about boxing that requires harsh self-discipline. Just taming the blink reflex, the urge to close one's eyes when a punch is thrown to the face, is an accomplishment.

William Saroyan's comment about writing, "There are so many reasons for not writing," also applies to boxing. For fighters there are few role models or peers to set the example. Only self-starters need apply, the kind who do not require the nagging of interested parents or ambitious coaches. And all the time there is the siren song of the streets.

"When I was going to bed my friends were just starting the evening party," says TNT Rodriguez, a lightweight from Spanish Harlem. "And at daybreak when I was getting up to run they were just getting back." Rodriguez's career may have peaked with a win in the semifinals of the Golden Gloves, but he is still around trying. "My friends," he says, "are gone. Many of them are dead, and some are in jail, and most of those who escaped the first two are on drugs."

It is an accepted misconception that good fighters just spring from the streets of the ghetto, poof. Those streets, as Rodriguez describes them, are most often dead ends. In fact, good fighters are universal, come from all over: from the farms of Indiana, the neighborhoods of East L.A., from North Philly, from Big D, from Accra, from Bangkok, and from Belfast—wherever there is a gym and a patient teacher. The prize ring is most democratic. There are no privileged or elite. The routines are the same for the gifted as for the talentless: hard work, struggle, and endless repetition.

It is a spartan's game, a demanding sport. The drill begins early, too early for most, when it is still dark and cold. Travel country roads or city reservoirs at daybreak, and chances are the hooded figures running in heavy work boots will be fighters getting in their roadwork before they report for their jobs. Fighters, after all, have to earn their daily bread, and most often, until they become main eventers, they must hold a job and train, too.

The five miles of roadwork are merely the preamble to serious exercise. It is during the gym workout that the pain and toil become intense. The length of the workout—no more than ninety minutes to two hours—is misleading. Its purpose is to condition the fighter to the three-minute spurt of extreme exertion required by each round of a fight, and generally all the exercises follow the pattern of the round.

The precise schedule will vary with the trainer and fighter. Usually the fighter will loosen up with stretching exercises, shadowbox in front of a mirror for a round or two, and then spar with another fighter for between two and ten rounds. The ring workout is followed by the floor exercises: two rounds on the heavy bag, two rounds on the speed bag, followed by another round of shadowboxing, and, finally, at least two rounds of serious rope jumping. "All the exercises must be performed with careful attention to technique," says Gil Clancy, the trainer-manager of several world champions. "The prize ring doesn't allow for sloppy technique or careless mistakes." Shadowboxing may look like a narcissist's game, but for the fighter it is invaluable. It allows him to watch his form and make certain that he holds his hands up and properly shifts weight as he delivers punches.

In the beginning, the young fighter feels as awkward as when he learned his first dance step. The coordination is complicated—hand-to-eye-to-foot and at the same time move your head—which is why "the manly art" is so difficult to master. Finally the movements fall into place, and he advances in the boxer's shuffle, behind the jab, and learns to get his body into the punches. Meanwhile he must never forget the rule set down by the Marquis of Queensbury, the patron saint of boxing, "Protect yourself at all times." Keep your head up and your chin down.

Ultimately, the successful fighters—those who progress beyond the small

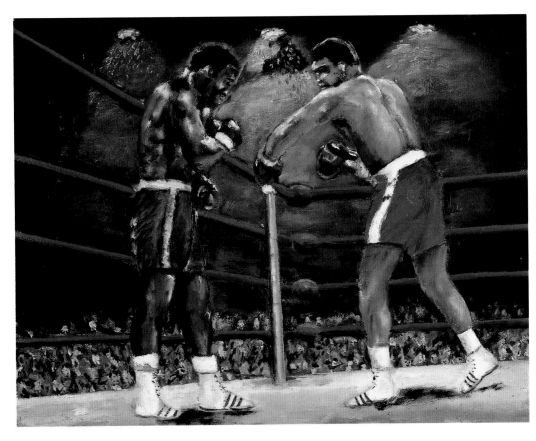

Ali vs. Frazier. 1984. Oil on canvas, 14 x 18″

Punching Bag. 1965. Encaustic on canvas, 10 x 14″

clubs and into the main events—learn to punch in combinations. They seldom throw single blows but volleys of lefts and rights that make defense difficult.

A fighter, driven by ambition, will throw thousands of punches during the daily training regimen. The effort will puddle the floor with sweat and strain his muscles against a wall of fatigue; it will condition the will as well as the body. Still he worries—have I done enough? A fighter has a fundamental fear of punching himself out. Frequently this fear prevents him from following up an apparent advantage and scoring a knockout.

What other traits characterize the true fighter? A few examples may help. Generally thoughtful people, and inordinately introspective, fighters are good at figuring out their own individual techniques and stratagems. In this lonely game, they learn to rely on their instincts and intelligence. In one of the notable fights of the decade, Aaron Pryor defeated the gallant lightweight champion Alexis Arguello. It was the kind of old-fashioned bruising struggle that boxing prizes, and Pryor was justly applauded as a gladiator in the sport's best tradition. Overlooked, or ignored, were a fight plan and preparation that Clausewitz would have been proud to claim. Pryor designed the plan. He reasoned that Arguello was not as effective when he was attacked at an angle. So Pryor had his camp cut the ring into quadrants, using a clothesline, and he practiced positioning himself at an angle to Arguello's powerful punch. The plan, bolstered by intense resolve and solid punching, claimed the fight for the thoughtful Aaron Pryor.

No one was more misunderstood than Muhammad Ali. His unique style, seemingly so effortless, was a deception. The floating and the superb instincts were the results of nearly ten hard years in the gym. As a wide-eyed, spindly ten year old, Cassius Marcellus Clay vowed to become a modern-day "Joe Louey," and he approached the task with extraordinary tunnel vision. "I'd open the gym at six and most times I'd close it around eleven," says Ali, recalling his schedule right through to his Olympic medal. By then the years of commitment and hard work had turned the twenty-foot ring into Ali's personal stage. In the stormy years that followed, Ali was involved in Vietnam war resistance, under seige by the army, and victimized by the sanctioning bodies who would later take his title—but he always could perform in the ring. He shares this quality with many fighters, past and present. Few, of course, had his intensity but then Ali in this regard may stand alone.

The way up was often more arduous for fighters who lacked Ali's skills and innate charm. Dick Tiger, the Nigerian who won the world middleweight title, defended his championship in between trips back to Nigeria, where a civil war was in progress. The war claimed his property, which he had frugally saved to buy, but he refused to be discouraged. Instead, Tiger was a walking advertisement for the work

The Challenger. 1978. Pencil on paper, 12 x 9"

ethic. He looked like an English artisan, dressed in a brown hamburg and long brown coat and carrying his gym clothes in a black bag. In New York, he never did more than look in the Fifth Avenue windows as he made his way first to the gym and then back to his hotel.

Another old graybeard, Archie Moore, fought for thirty years as a vagabond, an itinerant boxer living the most perilous existence. Black fighters during Moore's lengthy career were not favored; they were usually brought in to lose to the local favorite. Moore refused to be obliging and did his best to keep the decision out of the hands of treacherous officials. Thus, he holds the career knockout record (143

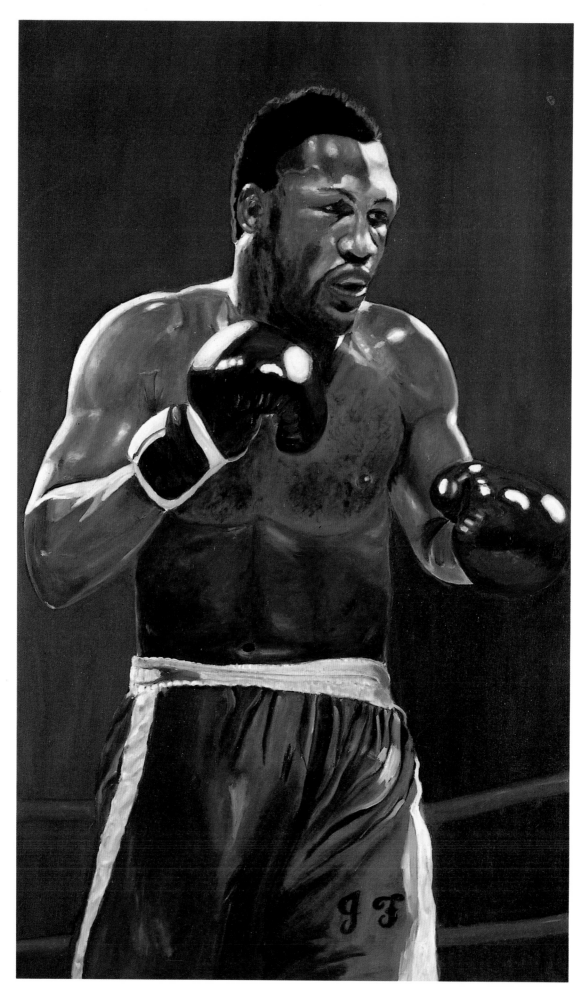

Joe Frazier. 1975. Oil on canvas, 60 x 36″. Collection Carlo and Joanna Grossman

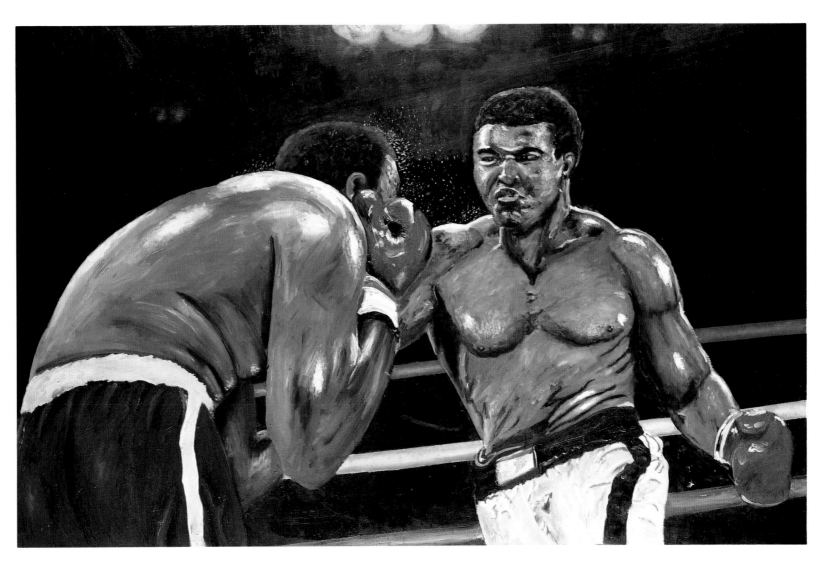

Ali vs. Norton. 1979. Oil on canvas, 54 x 82″

KO's in 231 fights), a fact that he attributes to a lust for life and an acute sense of desperation. All fighters reach a point when they question the need to train and, more important, whether there is a life after boxing. Moore refused to face the issue and resisted middle age and a growing tendency toward fat. He chose to fight on until his fifties, when boxing simply gave up on him.

Mentally, welterweight champion Sugar Ray Leonard never tired of boxing. He was forced by a detached retina into premature retirement. Two years later, his eye problem corrected, Leonard was prompted by a sense of history to return to the prize ring. "I never worked harder and I was in perhaps the best condition of my career, but I didn't have it," explains Leonard. "The very first round, I knew I lacked concentration, that all-important intensity. For once, every punch hurt and I found myself blinking. This won't do, I thought." After escaping with the decision over journeyman Kevin Howard, Leonard did not wait to accommodate his cable employer, HBO, or wonder about his position in boxing history but quickly announced his permanent retirement from the ring.

Roberto Duran, identified with Leonard in two historic fights, made the worst public decision in boxing history. In the New Orleans rematch, Duran turned from an eight-round encounter with Leonard, said "no más," and walked away. For Duran the reasons for fighting had disappeared. He was the welterweight champion, had been named the fighter of the decade, had beaten Leonard once before, and he had $3 or $4 million in the bank. The only motivation left was more money, and *campiones del mundo* do not fight for money alone. They fight to survive, to provide for their families, for glory, or for recognition, but not for money alone.

Duran's act was clearly aberrant. Consider, Ali and Frazier had $3 million apiece banked before they met for the first time in 1971 at Madison Square Garden. They might well have put on a measured performance, left the crowd happy, and gone home and enjoyed their money. Instead they fought as if it were a clash of worlds. It was the best example of why the prize ring is often called theater-on-the-square. This night it was a blinding white light in which both fighters were totally exposed; their grace, their style, their courage were on public view four feet above the craning heads of thousands of spectators, and subject to even closer inspection by millions of viewers seated in front of their televisions. And the public saw a vintage match, filled with intensity. Perhaps boxing's finest hour. Both fighters gave their all, and although they both returned to the ring they were never the same.

Perhaps, then, the most extraordinary thing is the special sense of rectitude that fighters often have. They can tolerate the politics of boxing, as well as the double-dealing, but from themselves they require an ultimately inhuman level of performance.

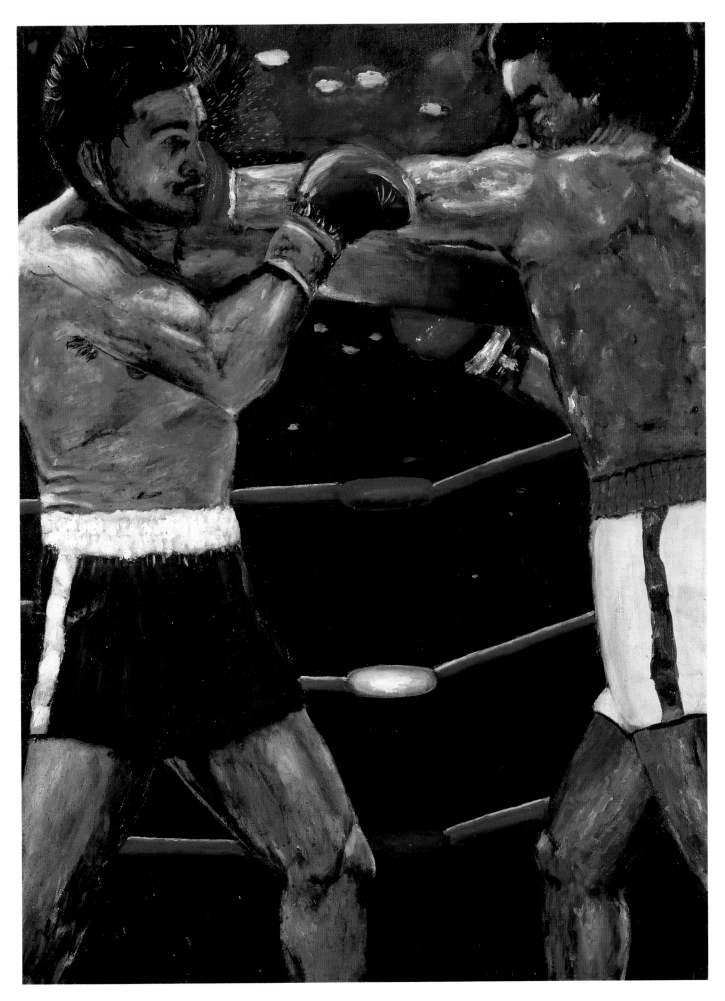

The Great Fight, Duran vs. Leonard. 1980. Oil on canvas, 40 x 18″

Alexeev. 1984. Pastel on paper, 21 x 17"

WEIGHTLIFTING

Strength Training *Ellington Darden*

What is the most successful magazine ad in the history of modern advertising? Hint: it has remained virtually unchanged for more than fifty years.

This famous ad began in the following way: "Hey! Quit kicking sand in our faces!" and pictured Mac, a scrawny teenager, with his girlfriend at the beach. A big bully runs by and kicks sand in the couple's faces. Mac sheepishly tries to stand up to his adversary.

"I'd smash your face," yells the bully, "only you're so skinny you might dry up and blow away."

Thoroughly embarrassed, Mac shrinks away, leaving his girl with the husky bully.

The rest of the story is well known. Mac, a prototypical 97-pound weakling, lets Charles Atlas mold him into a real man. Atlas does the molding by building the teenager's muscles with his Dynamic-Tension Course.

Weeks later, with his new muscular body, Mac returns to the beach, decks the bully, and wins back his old girlfriend.

While many readers may laugh at such comic-book advertisements, there is no doubt that millions of young men have been inspired by Charles Atlas. Building muscle, however, is not quick and easy, as implied by the ads. Many young men who sent off for the Atlas course soon quit in disgust. Even those who stayed with the course frequently did not get the muscle-building results they were after. As the old saying goes, "Great expectations breed great disappointments."

Today, muscles are more respected than they were in Charles Atlas's time. Strength-training programs are reasonably established among all National Football League teams and among most football teams on the university, college, and even high school levels. Because of the great influence football coaches have, other coaches involved in wrestling, basketball, swimming, and ice hockey have gradually begun to recognize the advantages of building bigger, stronger athletes through strength training.

Fifty years ago, a stereotype existed in most people's minds that individuals with large muscles were slow, inflexible, and clumsy. Research since then has proved that such concepts are unfounded. In the light of such evidence, it would be nice to

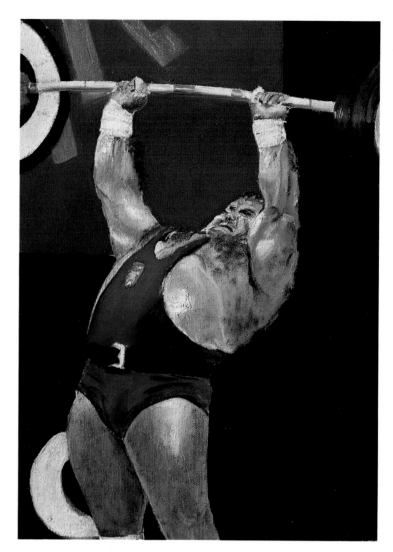

*Serge Reding, Belgian Librarian and Second Strongest
 Man in the World.* 1975.
Oil on canvas, 14 x 10". Collection James Darrell

Serge Reding, Weightlifter from Belgium. 1975. Oil on canvas, 31 x 25"

say that the so-called "muscle-bound" stereotype has been relegated to history, but such is not the case. Although positive strides have been made, many coaches are still fearful of bulky muscles. Sometimes a well-muscled athlete will pull his traditional coach into the modern age, but usually tradition rules.

In the last twenty years, sports-medicine physicians have progressed in their knowledge of strength training and muscle physiology. Furthermore, technological advances in the manufacturing of exercise equipment have allowed much of this knowledge to be put into practice. Strength training has made inroads into sports medicine. Yet, the fact remains that there are still many physicians who are literally afraid of massive muscles, afraid because of a simple lack of understanding.

To combat this fear requires a knowledge of the relationship of strength to functional ability.

Functional ability in sports, or in any endeavor involving human movement, is basically a product of five factors: (1) skill, (2) body proportions, (3) cardiovascular endurance, (4) neurological efficiency, and (5) muscular strength. Only one of the factors, muscular strength, is actually productive. The other factors are certainly important, but they are supportive rather than productive in nature.

Skill is simply the ability to make effective use of the force produced by the muscles. But no amount of skill will produce movement; only the muscles produce movement.

Body proportions, such as the appropriate height, torso length, shoulder width, length of arms and legs, provide an athlete with an enormous advantage. But this advantage is of no value without the strength of the muscles.

Cardiovascular endurance is also important, but only in the sense that it permits work. No amount of cardiovascular ability will perform work; only the muscles perform work.

Neurological efficiency is another factor of great importance but, again, only in the sense that it permits an athlete to use a higher-than-average percentage of whatever muscles he has.

In the final analysis, it is the muscles that produce movement, perform work, and provide force. It is the muscles that run, jump, kick, throw, and, to a great degree, protect an athlete from injury.

No amount of muscle will help an athlete much if he lacks the skill to use it effectively. But no amount of muscle will hurt his skills either. Instead, increasing an athlete's strength will always improve his functional ability, in any sport.

An athlete's muscles can be as strong as those of an elephant, but if his body proportions are bad for a particular sport, he will still not be able to perform well. He will at least, however, perform better than he would with weaker muscles.

101

A sprinter can have muscles like those of Hercules and still fall flat on his face after a 200-meter dash if his cardiovascular endurance is poor. But he should not make the common mistake of assuming that he can only have one or the other: either great strength or great endurance. In fact, it is possible and desirable to have both at the same time.

One of the largest-muscled men in the world (a former Mr. Universe) is actually fairly weak. He is stronger than the average man, but certainly not as strong as one might guess from the size of his muscles. But his lack of strength is not related to his muscular size. As it happens, this individual is very low on the scale of neurological efficiency. He thus lacks the ability to utilize a large part of his actual muscle mass in an all-out effort. Such a lack of neurological efficiency is genetic and is not subject to improvement. Yet even this man, weak as he is, is still far more capable than he would have been with smaller muscles.

An individual with this man's muscular size, plus favorable body proportions, great skill, outstanding neurological efficiency, and excellent cardiovascular endurance, would be a true superman. One day such a superman will exist. Then, when the actual possibilities become evident to a large number of people, we will soon thereafter see many such men.

If all-pro middle linebacker Dick Butkus had ever bothered to train his muscles (and he never did until his football career was over), we would be looking at such a superman now. Dick was probably the best in the world at his particular specialty, but not as a result of great strength. Instead, he was a naturally strong man who also happened to have every possible advantage for a particular activity: great skill, ideal body proportions for a specific function, above-average cardiovascular endurance for the same function, and outstanding neurological efficiency. Given these advantages, he was the best in the world even with nothing in the way of strength training. This might lead many people to believe that he did not need strength training, that it might even have hurt him in some fashion. In fact, Dick had far more to gain from such training than most have; he now realizes this after the fact, too late to be of much help.

Dick Butkus was merely chosen as an example; any one of several hundred other great athletes could have been used—men such as Mickey Mantle, Bill Russell, O. J. Simpson, and Muhammad Ali. Like most outstanding athletes, Dick Butkus was a natural; he appeared to have everything going for him. But he overlooked strength training, a factor that could have made him better than he was, a factor that would have reduced his chances of injury. Like thousands of other athletes, Dick failed to realize the importance of strength training because nobody ever bothered to tell him about it. But a number of people did tell him about the muscle-

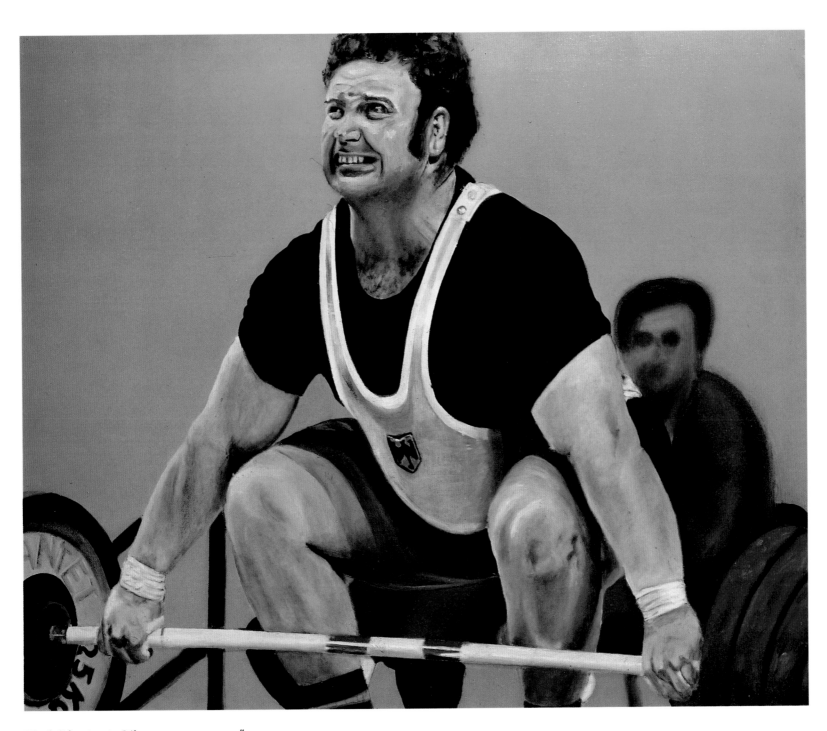

Weightlifter. 1976. Oil on canvas, 37 x 31″

bound myth and the other false beliefs that have helped to keep athletes, coaches, and physicians away from the value of proper strength training until recently.

While observing some of the biggest, strongest athletes in the world for over two decades, the author has never seen a man or a woman who had muscles that were too large. Just the opposite is usually the case: their muscles are too small for maximum performances. Should an athlete ever believe that he was too muscular, he could merely cut back on his exercising, and the extra mass would diminish. Atrophy is all too easy to achieve. Larger and stronger muscles, therefore, are an athlete's foremost ally.

And the great athletes are the ones who have the most to gain from strength training. Proper strength training may improve the functional ability of a below-average athlete by as much as fifty percent, but he may still remain below average in performance and be defeated by untrained athletes who have all the natural advantages that he lacks. Yet, even a two percent improvement in the functional ability of a natural athlete may well be the difference between a good athlete and a world champion.

How much improvement can be produced by proper strength training? Results will vary, depending on such factors as the athlete's age, potential, previous training experience, supervision, and motivation. But in all cases, there will be measurable degrees of improvement. This improvement will produce a level of performance that would not have been reached otherwise.

What degree of protection against injury will be offered by proper strength training? Again, results will vary, but it should be obvious that a strong limb is less likely to be injured than a weak one. It is well established that strength training increases not only the size and strength of the muscles but also the ligaments, tendons, and even the bones. One well-known sports-medicine physician in Georgia has plainly stated that half of all the sports-connected injuries could be prevented by proper strength training.

Proper strength training is thus a tool that can be used for a giant step in the direction toward sports excellence. It is in existence right now and is being used by thousands of people, yet it is still being ignored by millions of others. Over fifty years ago, Charles Atlas recognized the advantages of having larger and stronger muscles, and his exercise methods were nowhere nearly as efficient and effective as those available today. Physicians, armed with modern techniques and equipment, should make strength training an integral part of their exercise prescriptions. They, along with coaches and athletes, have everything to gain and nothing to lose with proper strength training.

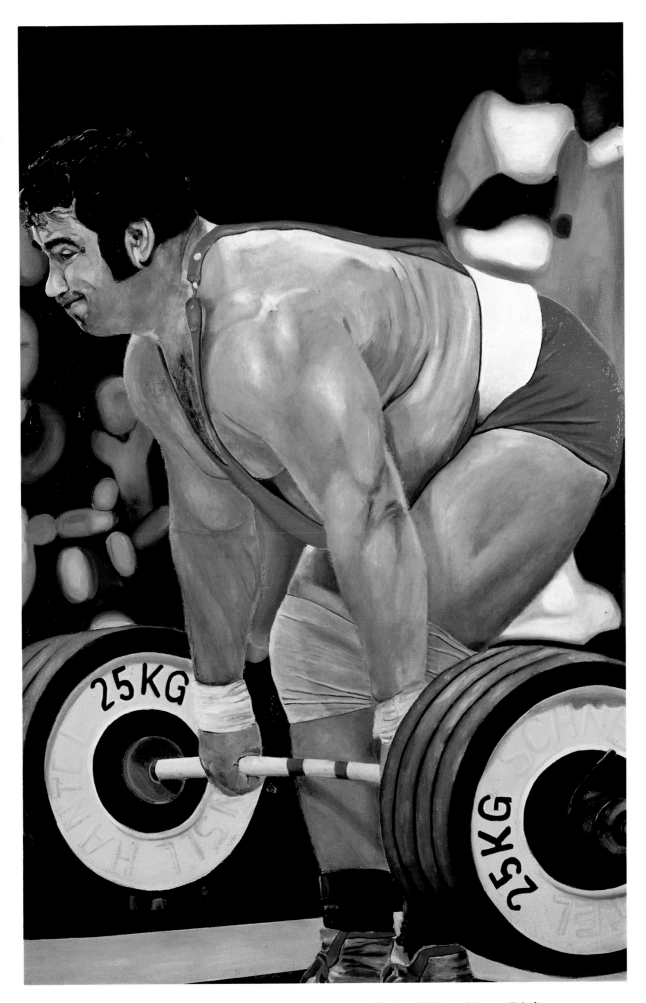

Alexeev, World's Strongest Man. 1975. Oil on canvas, 64 x 42″. Collection Wally and Lynne Friedman

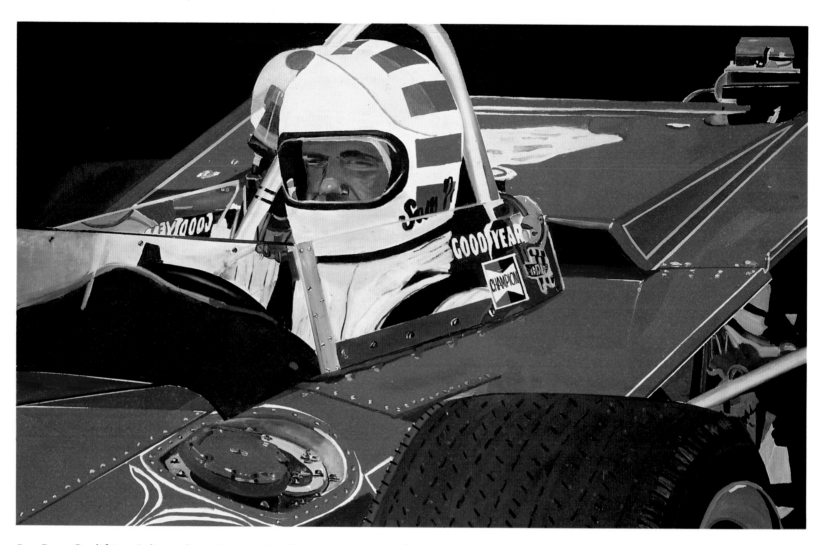

Sam Posey Qualifying, Indianapolis 1976. 1976. Acrylic on canvas, 38 x 61″

AUTO RACING

Driver *Sam Posey*

"Why do you race?"

Every driver has been asked this; you know the question is on its way when the interviewer gets a certain look on his face.

A part of the answer, and the one thing shared by all racers, is the joy in the mastery of the movement of the car. Any kid who has just learned to ride a bike has felt the rudiments of the sensation. So has the student pilot who first takes control of a plane. A driver of a Grand Prix car has felt a control of speed that completely transcends everyday experience.

The racer has much in common with the artist. Racing, like art, is a gratuitous activity—speed for speed's sake. Both artist and racer create a sort of order amid chaos. Both must do what they do entirely on their own.

The difference is that artists—makers of signs and symbols—share with us their understanding of the world. They transcend the world and come back with something—a book, a painting, a piece of music. Racers transcend the world but cannot share what they discover there. A perfectly driven lap, the probing of the outer limits of a new car are achievements of the highest sort, but they are for the driver alone to appreciate. Nevertheless, we can learn from drivers—about our relationship with machines, about the control of speed and movement, and about the worth of something completely sane men will regularly risk their lives to do.

What is a racing driver like? The physical requirements are stringent but few; chief among them is the need for superb hand-to-eye coordination. Twenty-five years ago, eyesight was the racer's ultimate weapon: Stirling Moss was said to be able to read fine print from across a room; Phil Hill tells the story of Dan Gurney reading the name of a boat off its stern at the distance of a mile and a half. Today it is possible that corrected vision may be as good as the real thing. Tom Sneva, an Indy winner, wears glasses. In any case, the driver needs to have not only exceptional distance vision but also exceptional peripheral vision, excellent depth perception, the ability to refocus quickly (from a glance at the instruments back to the track), and a low blink rate. How important is all this? A. J. Foyt says, "When my eyes go, that's when I'll quit."

A driver needs a finely honed sense of spatial relationships—the confidence, for

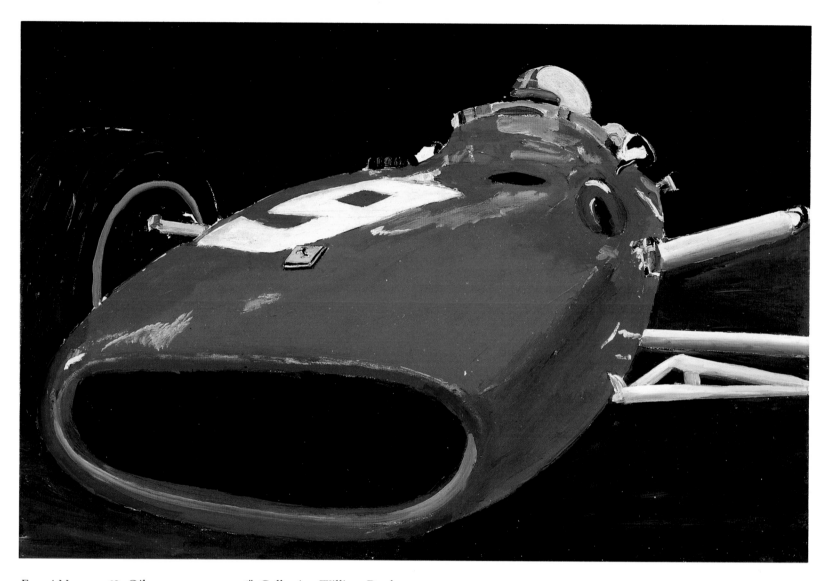

Ferrari No. 9. 1968. Oil on canvas, 24 x 36″. Collection William Burden

example, that he can squeeze his car between a competitor's car and some other object, like a curb, a wall, or another car, at rates of speed that are changing from instant to instant. Reflexes and balance also count, as does a reasonably high degree of aerobic fitness. Tests have shown that the racer's heart rate triples while he is at the wheel. Cockpit temperatures are high (130 degrees or more), and many major races last over three hours. Racers seem to have a perfectly regulated flow of adrenaline: it is there when they need it but not when they do not.

Beyond this there is no prototype. Racers come in every size and shape, from the elfin Tazio Nuvolari to the paunchy, balding Juan Fangio to six-foot-two Dan Gurney.

The mental characteristics of drivers have been researched by California psychologist Dr. Keith Johnsgard, who tested two dozen top drivers in the late 1960s and concluded that they were tough-minded, self-reliant, somewhat unimaginative, and—above all—supremely competitive. Johnsgard had also been involved with the testing of other athletes and, after comparing drivers with men engaged in team sports such as pro football, basketball, and baseball, he said, "In terms of competitiveness, racing drivers are right off the scale—they're in a category all by themselves." The problem can be to leave the competitiveness at the track. Parnelli Jones, for example, could not even tolerate another golfer driving faster in a golf cart.

Drivers also develop the ability to concentrate, hard, for long stretches. In racing there are no time-outs. Stirling Moss said that perfect concentration—going the distance of a race without a single extraneous thought—was the last and most difficult thing for a driver to learn. Paul Newman came to racing late in life (he was forty-seven) but brought to it an actor's ability to concentrate. He found that concentration was often the deciding factor in battles with younger drivers. The driver should also be a perfectionist. Driving lap after lap around the same track would be boring to anyone not fascinated by trying to achieve a perfect lap.

A driver needs to be mature. He must avoid mistakes, pace the car (and himself) correctly, judge the capabilities of the drivers around him. Few drivers are ready to win at the Grand Prix level until their late twenties. There are exceptions: Bruce McLaren won the United States Grand Prix when he was twenty-one.

Can a woman be a racing driver? Nothing has surfaced that says no. So far, however, no woman has made it to the top rung, although several have been close. This is probably a statistical issue: very few women have chosen to be racing drivers.

Can racing be taught? Driving schools have proliferated in the last decade. When Mario Andretti's two sons wanted to become racing drivers, he sent them to a racing school, but he concedes that the best the schools can do is to help you get experience quickly and relatively cheaply. So, beyond the schools, what could Mario

Pescarolo at Indianapolis. 1975. Oil on canvas, 39 x 62″

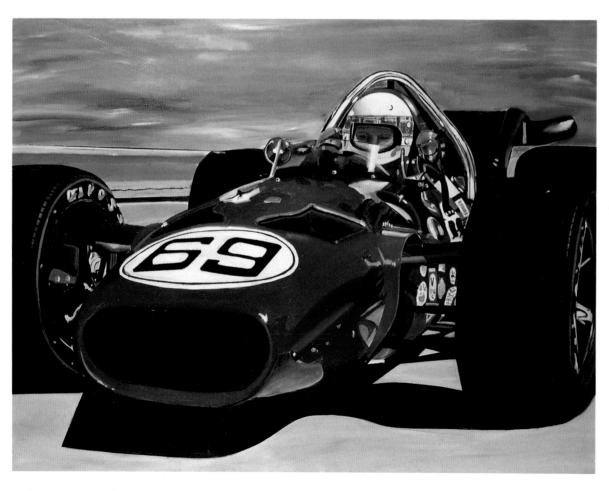

Jackie Stewart at Indy. 1978. Oil on canvas, 55 x 72″. Collection Esther and Jerome V. Ansel

Mario Andretti at Watkins Glen. 1974. Oil on canvas, 20 x 16″

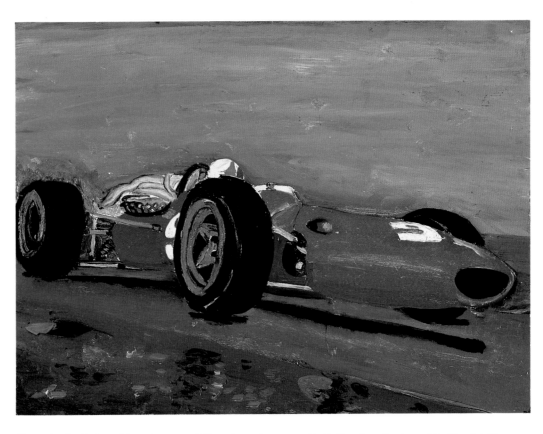

No. 9 in the Rain—Ferrari. 1968. Oil on board, 12 x 16″. Collection Andrew Karlin, M.D.

himself do to help his sons? "Very little. I can help them in areas of safety, and I can help make them aware, sooner, of things they are going to learn anyway. But," and here Andretti hesitated, "there's an area of experience...where I cannot help them at all: it's their ball game. Racing ultimately is a question of psychological control."

The driver is part of a team, but he is not a team player in the conventional sense. The driver is a performer; the other members of the team are not. The racing team functions sequentially, with responsibility moving along from the designers to the fabricators to the mechanics, who prepare the car for the race, and lastly to the driver. When the driver folds himself into the cockpit, he is the recipient of expertise beyond his own knowledge and of man-hours of work beyond any he would be willing to put in himself. Yet it is the nature of the driver that he accepts this responsibility, giving little thought to its weight, and will commit the entire enterprise to highly perilous situations as he strives to cut bits of a second from his lap time, even when to do so is satisfying only to himself and is of no consequence to the outcome of the race.

The driver feels ambivalent about his car. On one hand he wants the best one he can get. On the other hand *too* good a car diminishes his role when success is achieved. One solution is to be closely identified with your car—like Mark Donohue, who was an expert test driver with the ability to "set up" the car. A further step is to form a team and build your own cars. In the 1960s several top drivers went this route; today, with racing so much more expensive, drivers are inclined to stick with driving.

The contemporary racing car is an imposing object (although, unlike the car of the 1920s and 1930s, it no longer represents the cutting edge of worldwide technology). Its turbos spin at 250,000 RPM, its fuel is metered by an onboard computer, its aerodynamics suck it toward the road. No driver (nor any individual member of a team) understands the whole car. Today's driver probably counts for less in the overall equation than yesterday's, and he is not sure he likes it.

Unlike most of today's athletes, the driver has no accurate way of gauging whether or not he is superior to his predecessors. Is the breed improving? The runner can say yes, it is, and records prove he is right. Today's racing speeds are higher than ever before, but it may very well be that the level of skill required to drive these cars is lower. A. J. Foyt thinks so, and his career spans thirty years.

The racing driver is accurately perceived as involved in an extremely dangerous activity. As a result, he is guaranteed certain prerogatives. He is also, in certain aspects, a hero. If you accept the idea that a nation in peacetime needs surrogates for war, then the driver and his violent sport perform a vital function. Do spectators want to see drivers killed? No, but they want to see crashes...from which the driv-

Formula One Car. 1967. Monoprint on newspaper, 23 x 29″

ers escape, thereby reaffirming everyone's dream of immortality. No driver, of course, ever consciously thinks of himself in this sacrificial role; if asked, he will say he races only for the exhilaration it brings to him.

The driver has some blind spots—he has to in order to function. How about the anxieties of those who love him? These he largely ignores. How about the deaths of other racers? A period of genuine distress follows, along with pangs of mortality. But soon he is picking up the phone to see if he can get the ride. Isn't he afraid for himself? Crashes are infrequent (you might have two a year), so in a typical day at the wheel the odds of a crash are negligible. The driver is like a fighter pilot who returns to his base after a mission, has a shower, and heads for a drink in the officers' club; until the day something goes wrong, the danger remains abstract.

But when something does go wrong it is part of the driver's profession to learn to force it, quickly, from his mind. Suppose your suspension breaks, sending you toward the wall. You spend the intervening milliseconds staring at the exact spot you will hit. How soon do you forget this? They have your backup car waiting,

113

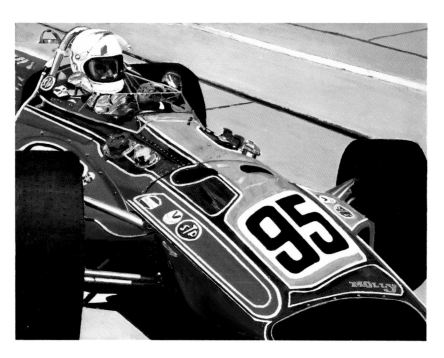

Sam Posey Placing at Indianapolis. 1972. Oil on canvas, 38 x 48″

Jimmy Clark Winning at Watkins Glen Grand Prix. 1971.
Monoprint, 38 x 26″

Racer. 1969. Watercolor, crayon, and oil on paper, 36 x 30″

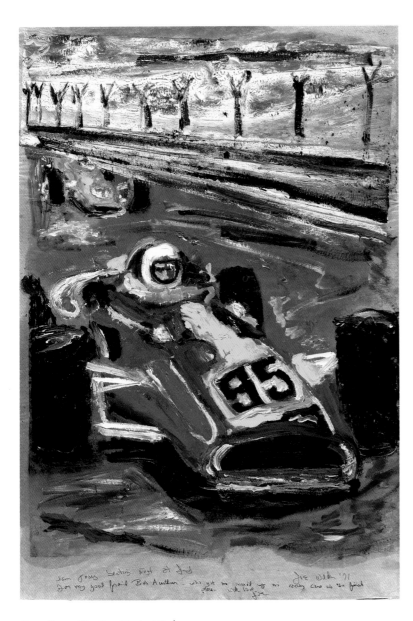

Sam Posey Beating Foyt at Indy. 1971.
Monoprint, 36 x 24″. Collection Robert Alan Aurthur

warmed up, in the pits. You ride back from the crash site in the ambulance and the doctors check you over. You are shaken but O.K. You step in the backup car and now, twenty-five minutes after the crash, you come to the same turn in a car identical to the one that just broke. What are you thinking? Do you see the mark you left on the wall? If you are the stuff champions are made of, you are thinking about the apex and getting the throttle open as soon as possible.

This sublimation of fears and doubts is a driver's stock in trade. In a sense, he lives in a dream world. He travels constantly, so he has little awareness of place and often wakes up in his motel room with no idea where he is. He is interviewed regularly, and he has developed stock answers and a sort of public persona that is different from what he considers himself to be. If he is a top Grand Prix driver, he earns at least $2 million a year to do something he would do for free—a strange distortion of values.

The price for all this is paid, if it is paid at all, at a deeply subconscious level. Few drivers display any outward signs of guilt or distrust. Mostly they are intelligent, funny, interesting—great company. They feel lucky, extremely lucky, to be doing what they do. They are proud of their strong motivation and they are fascinated by the challenges to their sport. They have poise and iron self-control.

In fact, assuming he survives, a driver's biggest problems will come when he tries to retire. Racing has been rewarding to him on many levels, and it is hard for him to imagine anything that could replace it. Being extremely good at something is part of his self-esteem. So is being well known, in the public eye. He suspects he will never be as good at anything again, that his best years are behind him. He is leaving a highly structured world in which he has been comfortable and in which he knows his place. He may have complained about the constant traveling, but now he is afraid of living in one place.

His greatest regret, however, is that he will never again experience the thrill of driving, the mastery of movement. He takes a car out onto the track (for one last time?) intending to savor the feeling, gets caught up in the driving, and doesn't think of his retirement again until he is back in the pits and out of the car.

What no active driver realizes is this: you actually forget, in time, what the driving was like. It is so beyond the experience of everyday life that nothing can keep you in touch with the sensations you once knew as commonplace. The longing becomes unfocused, like the memory of a particularly happy moment from childhood.

But it is always there.

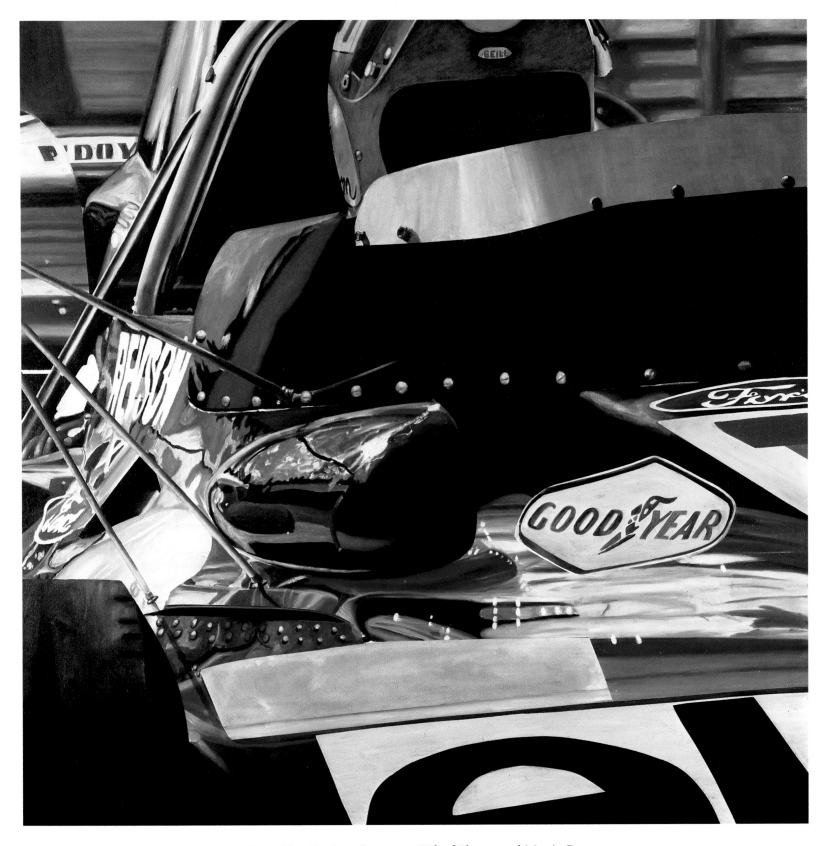

Peter Revson. 1976. Oil on canvas, 72 x 72". Guild Hall of Easthampton. Gift of Eleanor and Martin Revson

Pimlico No. 2. 1984. Pastel on paper, 16 x 12″

HORSE RACING

Where *Little* Is Better *Michael Watchmaker*

"Good things come in small packages" is just a cliché. How many times has this happened to you? You get several presents on your birthday or Christmas, yet the one you want to open first, the one that is the greatest source of anticipation is the one that comes in the biggest box. It holds true for all of us, that common conception or misconception, as the case may be: bigger is better.

That belief has held true not only for inanimate things but for animate things as well. Though the concept may not be cast in stone today, as it was in centuries past, big is still good. It was true way before the period when the ideal woman was a large woman, as depicted by Renaissance artists, through to just a few years ago when a healthy and prosperous man was pictured in the mind's eye as a big man.

In today's world of sports, this idea is magnified. At no other time in the history of football have its players been bigger, heavier, and stronger. In basketball, it wasn't too long ago when a seven-foot man named Wilt Chamberlain dominated the game primarily because of his size; nowadays a team without a seven-footer is the exception rather than the rule. In sports in particular, it seems there is no place for the "little man."

Yet, in the sport of horse racing, the little man—the jockey—is the big man. And therein lies the problem. Outside the sphere of horse racing, jockeys have not been granted the status of athletes, largely because the "sport of kings" does not touch upon as many lives as, say, baseball. How can a person unfamiliar with the sport equate a jockey with an O. J. Simpson or a Pele? Those who know horse racing, though, are fully cognizant of the fact that jockeys are among the best athletes in the world.

Beyond simple physical conditioning and proficiency in one's field, what is the definition of an athlete? That's not an easy question to answer, and perhaps it would be easier to list some necessary requirements. Strength, for certain, is one, and it follows that stamina is another. Touch—the kind a quarterback needs in order to drop a pass to his receiver between two defenders—quick reflexes, and the ability to anticipate and to make quick decisions are all important. And courage is essential. Put all these ingredients together, roll them up into a 100-pound package, and you have yourself a jockey.

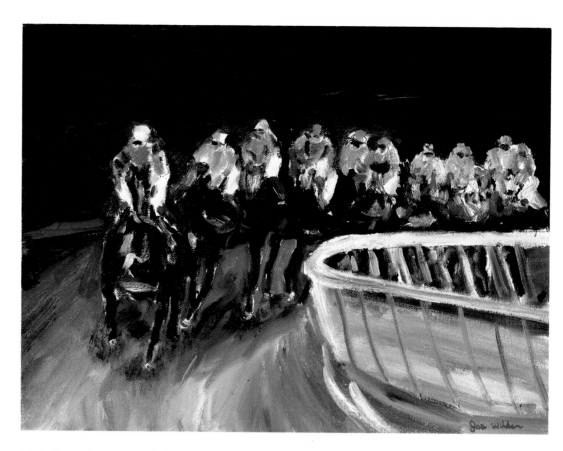

Night Race No. 3. 1984. Oil on canvas, 9 x 12″

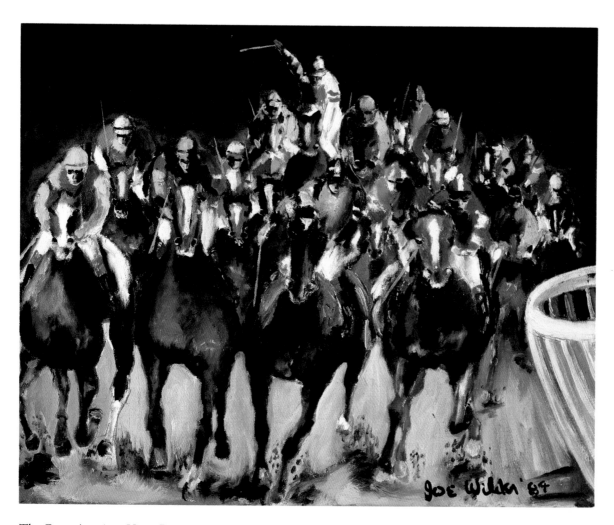

The Great American Horse Race No. 3. 1984. Oil on canvas, 16 x 20″

Being a jockey—and no one in horse racing, including this writer, has not fantasized about the prospect—is not as easy as mounting up, going along for a one- or two-minute ride, and dismounting. In fact, it takes years of training. Often jockeys are bred, born into families involved in some way with horses, whether it be in racing, showing, or even farming. They have an advantage in that they learn the "beast" at a very early age. But they too, like the street kid with stars in his eyes who looks for a job on a racetrack backstretch, must begin at the bottom by raking up horse manure.

"Mucking out stalls" is just the first step, and if a kid shows enough gumption and determination, he or she may be elevated to the lofty position of washing bridle and tack, which must be cleaned daily, or walking horses in endless circles as they cool out from morning exercise. After a youngster spends a while at this, the horse trainer for whom he is employed must make a crucial decision. If the kid is light enough and the trainer sees real potential—enough at least to invest time and money—he will most likely be sent to a farm to "break yearlings." This process of getting a one-year-old horse saddle- and rider-trained is rough, so rough it has broken not only the bones but the spirits of thousands of aspiring race riders. Still, it is just another hurdle in the series of obstacles a jockey must clear.

If that test is indeed passed, the youngster will eventually return to the racetrack. More experienced and more seasoned in the ways of the thoroughbred horse, he will begin galloping horses in the morning, the time for training at the track. This can grow to be monotonous, for once an aspiring jockey has survived the breaking of yearlings he feels as though he can conquer the world. But it is a pivotal period. Not only is he showing trainers, the people who will eventually seek his services, what horse knowledge he has accumulated, but he is also refining his skills by partnering older horses, which have established their own particular quirks and habits.

If this youngster is still light enough in weight and can show he has a little more drive and desire and has absorbed his lessons better than the many others like him, he may then get a chance to ride in a race. It will be unlike anything he has been exposed to before—competing against better, more experienced jockeys, facing a sustained demand on his strength, riding at full speed in a situation that is not as controlled as the ones he has known so far. And, even making it as far as that first ride, there is no guarantee he will get the opportunity to do it again. In most racing jurisdictions, he must show the stewards (the ruling body at racetracks) that he is competent enough under competitive conditions to deserve a license to ply his acquired trade.

In years past, this entire training process may have spanned six, eight, or even

more years. That may seem like an inordinate amount of time, but the discipline and foundation taught and learned prove invaluable. Lamentably, the process has quickened in recent years because of the proliferation of racing activity and racetracks and the subsequent demand for more jockeys to ride the increased population of horses. But there are some fine institutions still in existence, particularly a number of jockey schools in Latin American countries, that carry on this tradition.

Why this foundation is so important to the success of a jockey becomes apparent when one observes a rider at work. Even a person with the most casual acquaintance with horse racing is aware that a 100-pound man riding a horse of some 1,200 pounds is at a risky disadvantage and that courage must be an integral part of a jockey's makeup. True appreciation of a jockey's skills, however, is acquired through exposure to the sport and some understanding of the temperament of the thoroughbred.

The thoroughbred, through careful and selective breeding over hundreds of years, is born to run. Some, of course, turn out to be better than others, but they all share that single purpose, and as a result they all share certain traits. Though they are beautiful, majestic animals, they have a fire coursing through their veins that stems from an inherited lust for competition. And a horse finely tuned from a training regimen obviously becomes even more highstrung. They are nervous, anxious, and eager, all the time.

These are not undesirable qualities in any sense, when viewed from a distance, but centuries of mating within the breed have produced some equally prominent, less than positive traits. The thoroughbred is not a terribly sturdy animal. Each one of its legs, in the span of one stride in a gallop, absorbs pressure far exceeding total body weight. Yet, since each leg is not much wider than an average man's forearm, their soundness is clearly in constant jeopardy. Another result of such strictly controlled inbreeding is that a thoroughbred is not as intelligent as other breeds of horse, and the horse, to begin with, does not rank high on the scale of intelligence in the animal kingdom.

Standing still, a thoroughbred can be likened to a time bomb. To set this time bomb in motion going 40 miles per hour with the purpose of bettering others of its kind is the job of the jockey.

The courage of a jockey begins with just being brave enough to ride, but it does not end there. Simply put, the goal of horse racing is to win and, therefore, a race rider will, during the course of any contest, be called upon to make courageous decisions and then have the guts to follow through on them. It could be to drive his mount through a small opening on the rail, or slip his horse between others on the turf, or compete on a racing strip that is dangerous from rain or winter conditions.

Blue Jockey, June 1983. 1984. Pastel on paper, 17 x 17″

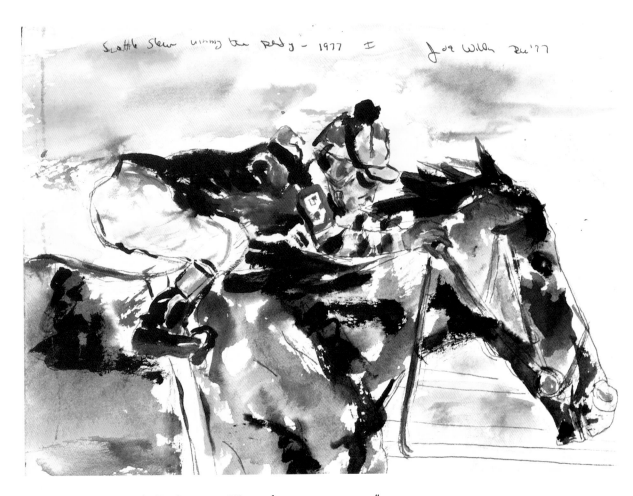

Seattle Slew Winning the Derby. 1977. Watercolor on paper, 9 x 12″

These decisions can often put a jockey's own safety in doubt, but if he doesn't meet these challenges, he will not succeed. In racing, if you don't succeed, you find yourself looking for another line of work.

Strength is, of course, almost as essential a component in a jockey as courage, but not for the reasons one might imagine. A 100-pound jockey will never outmuscle a 1,200-pound horse, but in the drive to the finish line, one of the most exciting spectacles in all of sport, a jockey will use his strength to coerce his mount into giving a maximum effort. The whip, and firm application of it, is one means of achieving that goal. But whipping is merely an alternative method of getting the best out of a thoroughbred, for a horse will not respond to constant punishment and will in fact sulk when it is punished while already giving all it has.

Indeed, use of the whip is not where a jockey's strength comes into play. A much more successful tactic, but one more demanding on a rider's physical resources, is a strong, fluid hand ride involving literally picking up the head of a tiring horse and keeping the animal on a straight course with a solid and even hold on the reins. Then, when the horse strides out, the jockey pushes forward with his arms and gains extra thrust by pushing his legs down and back, leverage there coming from his feet in the stirrups.

While upper body strength is important, a race rider develops extraordinary strength in his legs, through personal training and activity in the saddle. It may look, to a novice observer, that there's not much going on during the early stages of any given horse race and that jockeys are being asked to work least of all. That is not the case. Keeping in mind that most races are won by the horse with the most strength at the finish, a rider tries as much as possible to keep his mount from being taxed during the first part of a contest. If a jockey were to just sit flat in the saddle, his weight would become "dead weight" and tire his horse faster. So, a jockey "stands" in a crouch position in the saddle to cut down wind resistance until he feels it's time to put his mount in a drive; then, as mentioned, a jockey counts on his legs almost as much as his arms and back. Do this six or seven times a day six or seven days a week, and you'll have legs like iron, too.

Any jockey can go out on the track and be fearless and whip and ride the hair off his horse, and if that's all it took to be successful, there would be thousands more in this line of work than there are now. What separates an average rider from a great one, however, are qualities of a different sort—finesse and intelligence, for example. Given the fact that no jockey is going to manhandle a race horse, it is sometimes better to get the desired result by using honey rather than vinegar. Different horses respond in different ways to the same action, but every horse receives signals from the rider through the bit in its mouth, which is manipulated by the reins. Some

horses prefer to run against the bit, that is, with the bit snug in their mouths, while others require a lighter touch. Horses send these signs back to the rider, who "reads" them with sensitive hands and then adjusts his hold accordingly.

A thoroughbred can be described as a running machine, and like any machine it will cease to operate effectively if pushed beyond its limits. Asking a horse to run faster than it can by "overriding" it is fruitless, for all this will do is cause a horse to lose its action and squander whatever energy it has left. In a stretch drive between two top race riders, you'll often see each handling his mount differently. Though they both want to win, they are riding to the individual running styles of their horses. Efficiency is gained when a rider, with a fluid motion, becomes one with his horse. The result is true maximization of the resources at hand.

A horse race is much like a chess game—strategy often affects the outcome. There are, however, some set moves that are already dictated. Certain horses always show early speed, while others prefer to make their moves late. Some horses won't perform on a muddy track, and there are those that will try only on the turf. A wise jockey should make it his business to know both the horse he rides and the opposition. For instance, if a rider is on a horse that shows early speed, and there are others of that kind in the race, he must devise a way to harness that speed and keep out of a speed duel that will surely be suicidal. Conversely, if he is on a strong finisher, he must time his mount's move so as to make its run most effective. Like a good handicapper, a jockey has an edge if he can draw a reasonably accurate picture in his mind of what is about to happen on the racetrack.

Still, there are thousands of unpredictables in any race that will test a rider's reflexes and force him to make quick changes in strategy. A jockey could have his horse perfectly positioned along the rail, only to have a horse in front of him stop suddenly, forcing him to check and take his mount up. A jockey could have a late runner in high gear on the turn, only to find a wall of horses in front of him. He may have no choice but to swing wide and lose precious ground. Or a jockey may find a rival drifting in from fatigue, which could slow the momentum of his own mount.

These are just some of the variables that can occur in a race, and they are not easily avoided. The experience of being there before, though, helps to overcome some of these problems, as do courage, strength, good vision—particularly peripheral vision—and that indefinable quality called anticipation. Anticipation is that seemingly God-given ability to know what is going to happen just before it does; seen only in the greats in other sports, it is a much more common trait in jockeys.

All jockeys possess the positive attributes we have mentioned, but of course not all in the same measure. Even the best in the profession have their strengths and weaknesses. And therein lies the reason why there are different types of riding styles

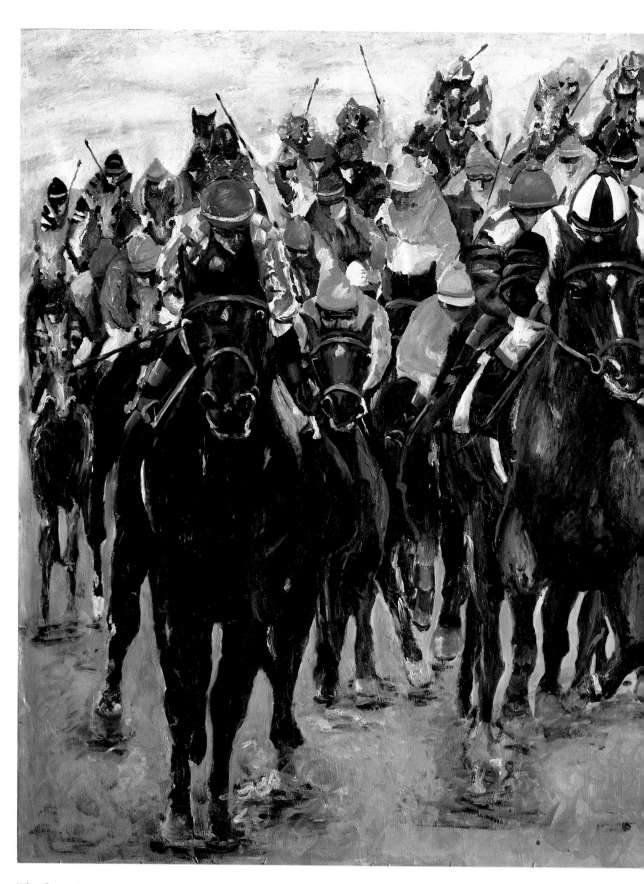

The Great American Horse Race. 1979. Oil on canvas, 72 x 108″. Collection Carlo and Joanna Grossman

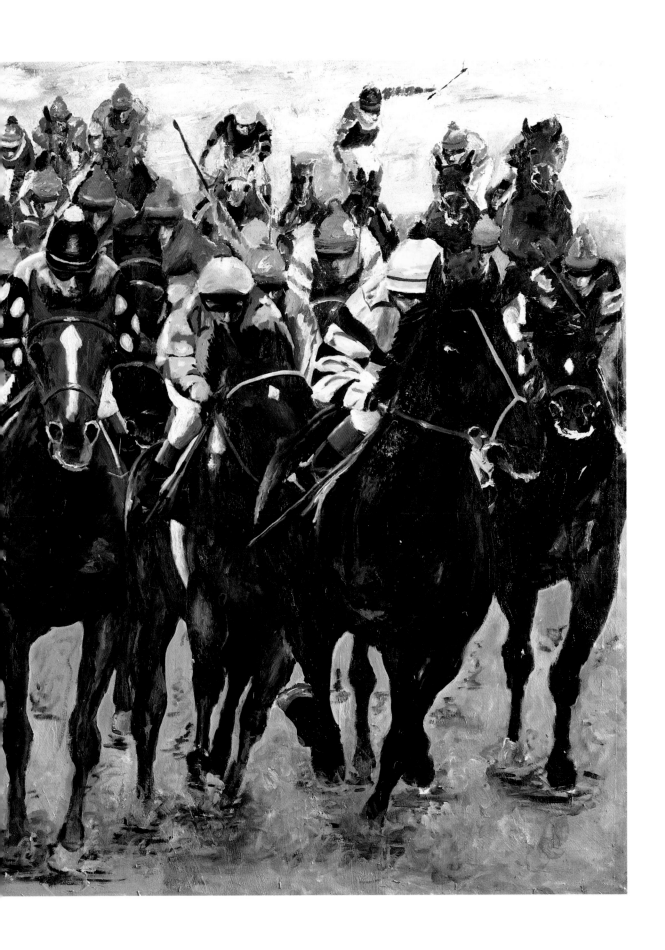

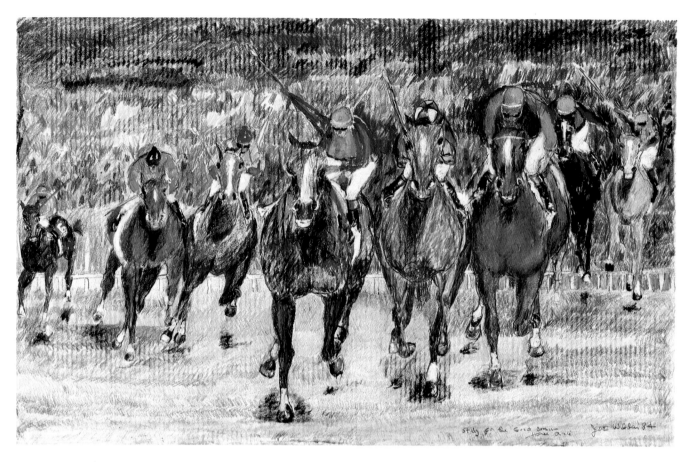

Study for the Great American Horse Race. 1984. Pastel on paper, 22 x 33″

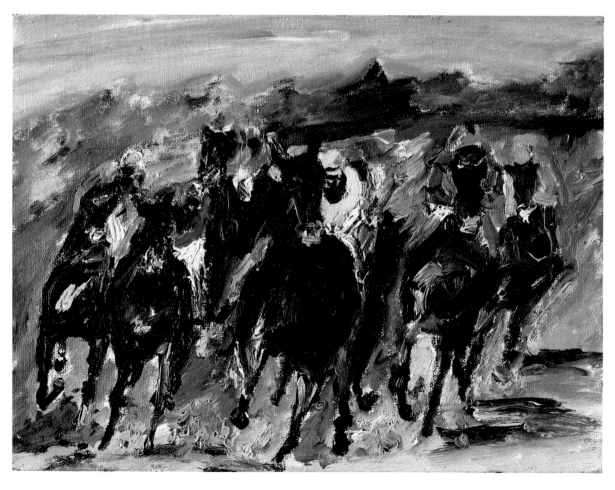

Racing Painting No. 4. 1978. Oil on canvas, 9 x 12″. Collection Virginia Kraft Payson

and why—like different batting stances in baseball—they can be equally successful. Of contemporary jockeys, the great Bill Shoemaker, for instance, is noted for getting horses to run for him because he is a master in the field of finesse and communicates so well with his mounts. He is not as strong, though, as Laffit Pincay, Jr., who can practically pick a tiring horse up and carry him across the finish line. Angel Cordero, Jr., is known for his daring risk-taking, which satiates his consuming desire to win, while Pat Day has earned acclaim and championships by being a genius at strategy.

As jockeys have different riding styles, they also have different methods of keeping fit, as if riding horses alone weren't enough to accomplish that. The need to keep weight off requires some jockeys to engage in extra training to maintain prime physical condition. It wasn't always this way. For a long time, the feeling was that since they worked hard, they had the right to play hard—and play hard they did. It was the race rider's credo. But the emphasis on health and fitness that swept the nation in the 1970s reached the racetrack as well, and now most jockeys have adopted that attitude. Jogging and racquetball are particularly popular, and many follow more health-oriented diets.

One reason for all this healthy activity is to avoid the dreaded "hot box," the little steam compartment that will sweat pounds off but only temporarily. Too much reliance on the hot box can lead to dangerous dehydration—and even to fatalities. But of course, there are those lucky ones we see in every walk of life who can eat anything they want and never have to break a sweat and still remain thin as a rail and fit as a fiddle.

The idea of sport is competition, and thoroughbred racing epitomizes this by pitting horse against horse, with the race to the swiftest. Yet racing also takes competition one step further. Unlike most other athletes, who sign contracts specifying how much they will be paid before they perform, jockeys work first and then, only if they have performed well, will they receive compensation. A journeyman jockey receives a minimal flat fee for each horse he rides; this fee alone is hardly enough to keep him at the poverty level. But, for every winner he rides, he receives ten percent of the winner's share of the purse, and that is where the money lies.

When a jockey wins, he wins at the direct expense of his peers. When he loses, he loses at their direct benefit. He rides against his peers to put bread on his table but, in turn, takes it off theirs. And, if he is to make a living commensurate with the effort he puts in and the risks he takes, he must do that unpleasant deed often.

Still, despite the continual emphasis on bettering their competition, jockeys belong to an unspoken brotherhood of sorts. No one, except for the race riders, can know what it's like to pilot a thoroughbred under competitive circumstances and

cope with the daily dangers they face. They know that, if they take a fall and are unlucky enough to break a leg but fortunate enough to survive, there will be no money coming in until they have regained physical shape and return to the saddle. For that reason, if there is a rider in a dangerous situation during a race, his fellow jockeys will attempt to help him to the point that he does not become seriously injured. After all, it could be one of them next time. All that they have in common keeps the bond among jockeys strong and unshakable.

With everything that is entailed in becoming and being a jockey, one could ask, why bother? Well, there are a number of good reasons. To be a rider, you must love horses and horse racing, and if a person feels that way, he feels that way always. If you become one of the best, it is a lucrative field of endeavor, indeed. In 1983, horses that Angel Cordero, Jr., rode earned in excess of $10 million, of which his cut is estimated to be in the neighborhood of $500,000. And, where else in our large-oriented world would a "little man" be the big man? Finally, just imagine the thrill, winging on the lead on top of a sleek, beautiful thoroughbred...

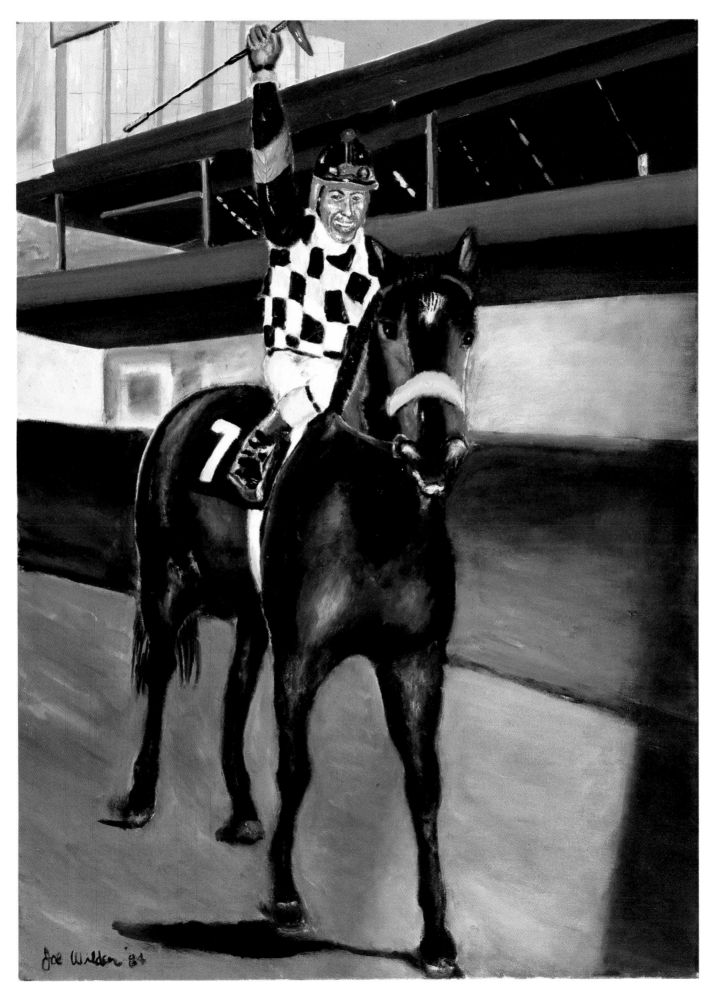

The Great Cordero. 1984. Oil on canvas, 30 x 22″

Champion Swimmer. 1973. Acrylic on canvas, 30 x 40″. Collection Alyssa Wilder

SWIMMING AND CREW

The Ideal Swimmer *James Counsilman*

The ideal swimmer, as pictured by the general public, was epitomized by former Olympian and world-record holder Johnny Weissmuller: tall (six feet four inches), lean but muscular, and having big hands and feet. Mark Spitz would never have made it if these traits were prerequisite for success. Mark is not tall at five feet ten and a half, he is lean but not markedly muscular, and he has small feet—size seven—and relatively small hands. Of all the swimmers I have coached, however, Mark did have the combination of traits that makes for a champion middle-distance swimmer. He was very flexible, particularly in the two segments of his body in which flexibility is desirable for swimming: his shoulders and ankles. Shoulder flexibility facilitates arm recovery, and ankle flexibility enables the feet to push the water backward during the power thrust of the kick. While Mark was not extremely muscular, he was strong for his body weight. His relatively light bone structure made him buoyant in the water and enabled him to maintain a more streamlined body position and, consequently, to create less drag or water resistance.

Mark possessed extremely good general neuromuscular coordination, good hand and eye coordination, plus that intangible quality that swimming coaches refer to as "good feel for the water." This term has been used to describe the ability of some great swimmers to learn to perfect their swimming stroke mechanics with no outside help. It appears that the brains of these swimming geniuses receive input from such sensory organs as the eyes and ears, from the sensory nerve endings that perceive kinesthesia, and from the pressoceptors, located primarily in the hands, arms, and feet. These impulses are fed into the brain, which then without conscious awareness adjusts the stroke mechanics of the swimmer to become more effective.

Every great swimmer must have this "feel for the water." While this trait is probably the single most important factor for success, there are many others that contribute significantly. Surprisingly, lung capacity is not always one of them. For the sprinter, explosive power and strength are more important than endurance and cardiorespiratory efficiency, while the reverse is true for the distance swimmer. Good stroke mechanics have already been mentioned, but even a person with the gift of "good feel for the water" can end up with poor stroke mechanics if improperly coached. Good coaches will give these swimming motor geniuses only as much

Olympic Swimmer. 1984.
Pastel and watercolor on paper, 12½ x 16″

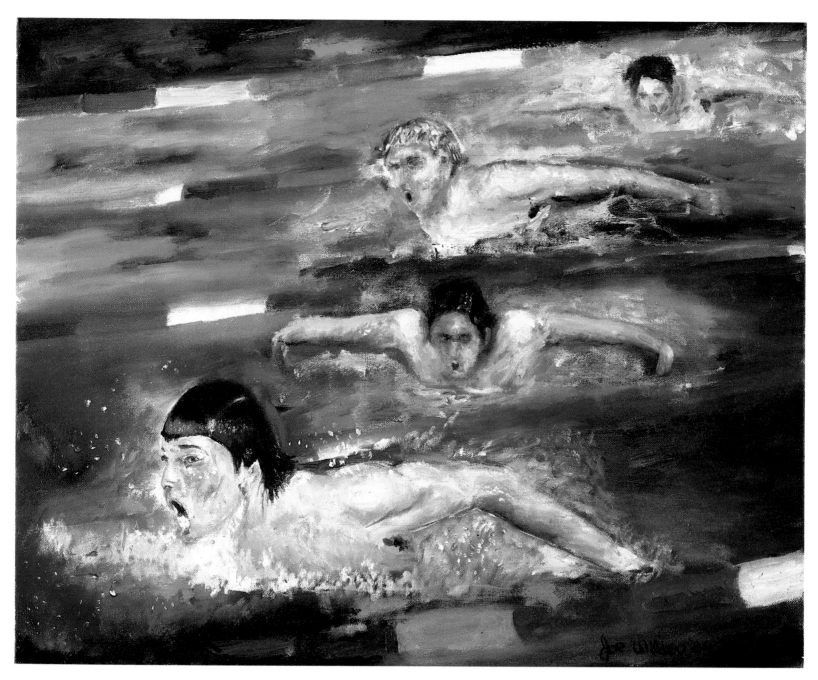

Spitz Wins the Olympic Gold. 1984. Oil on canvas, 16 x 20″. Collection Piper Wilder

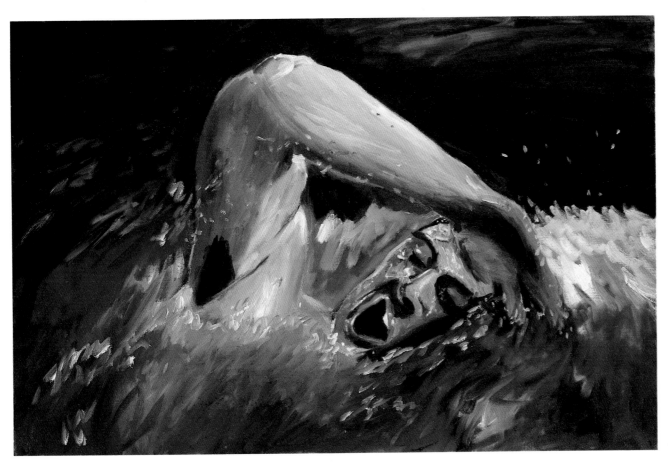

Swimmer. 1977. Oil on canvas, 24 x 36". Collection Virginia and Simon Chilewich

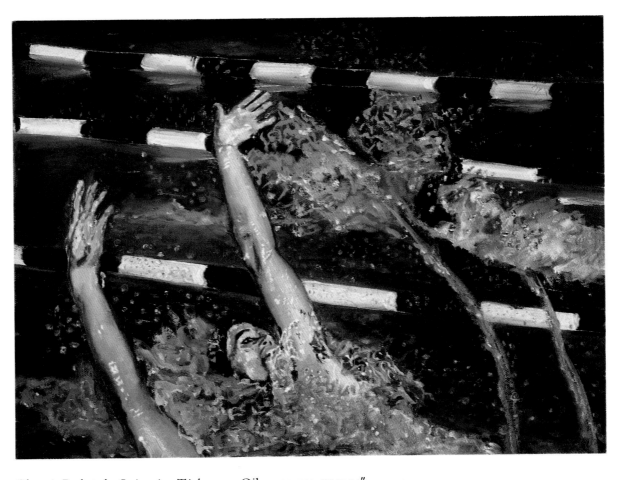

Olympic Backstroke Swimming Trial. 1977. Oil on canvas, 10 x 14"

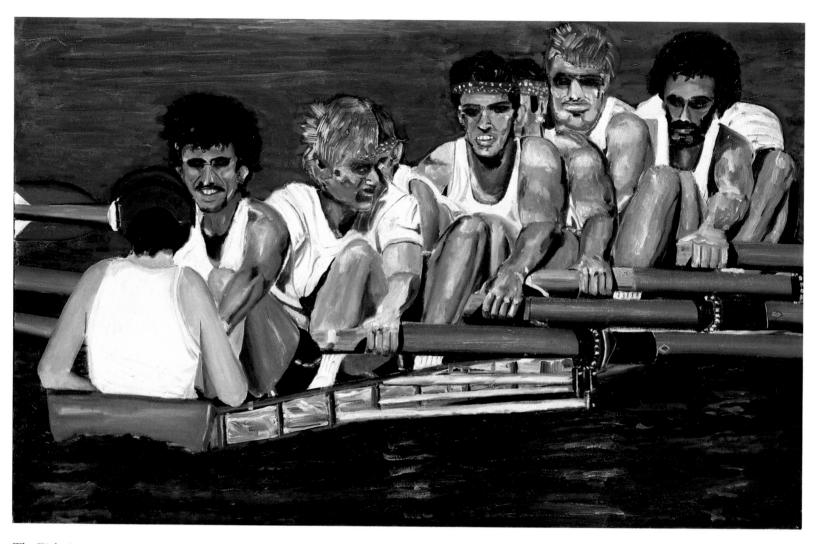

The Eight-Man Crew. 1973. Oil on canvas, 30 x 48″

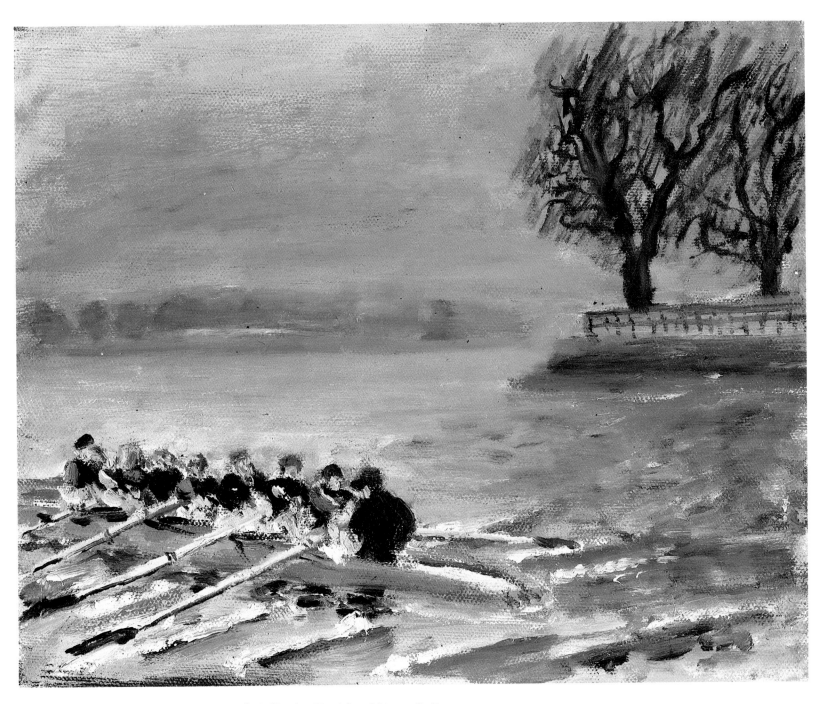

English Crew. 1978. Oil on canvas, 8 x 10″. Collection Daniel and Joanna S. Rose

stroke correction as needed, because they prefer to allow the superior neuromuscular systems of the athletes to sort out the right mechanics.

No single type of personality can be selected as ideal for a champion swimmer to possess. Champion swimmers vary in personality in the same manner as any heterogeneous group. Yet there do appear to be several traits among swimmers that are less often found in the average person. They are usually more agonistic, that is, they don't seem to mind pain as much. They are slightly more self-sufficient and goal-oriented than the average. Of course, these could be traits that have been conditioned by the type of training in which the swimmers are involved.

Most of the Olympic champions I have worked with have been more aggressive and have had more psychological endurance than the unsuccessful swimmers. Some, like Mark Spitz and Jim Montgomery, have been so goal-oriented that they have tunnel vision. Not easily distracted, they are capable of great concentration on their goals and frequently seem obsessive. Once coaches establish rapport with this type of athlete, their job is easy. They must only guard against losing concentration themselves, in which case the athletes will lose respect for them. Such athletes are generally demanding, expecting the coach to "put out" as much as the athlete.

Because the continuity of training should not be frequently broken, a great swimmer must be prepared to swim slowly, even to lose races at times, rather than disturb the training pattern. The athlete can lose minor races and come back, rested and with psyche intact, to win the big meets. Great swimmers "psych up" without "psyching out." They get nervous but don't panic. They believe in their ability to perform well at the proper time, a belief not lost after one setback.

Even the ideal swimmer with all the desirable physical and psychological traits can lose confidence because of a series of failures. This was the case with Mark Spitz in 1968. In the Mexico City Olympic Games he failed to live up to his expectations and lost his confidence. It was my job as his coach to restore this confidence by so arranging his competitions that he had a series of successes with a minimum of failures. For this to occur Mark had to be "coachable." He had to work with the coach and believe in him. Some athletes stubbornly hold onto their own ideas and refuse to acknowledge the coach's expertise. Spitz was ideal to work with. He agreed with the plan we worked out for him, and the rest is athletic history.

Great swimmers are born with a talent for swimming. To develop this talent takes years of hard work, involving sacrifices by swimmer, family, and coach. The physical and psychological attributes each swimmer possesses determine his or her ultimate potential. Few people ever achieve their full potential, yet the future world-record holders will come closer to that goal as we increase our knowledge of training, stroke mechanics, and psychological preparation.

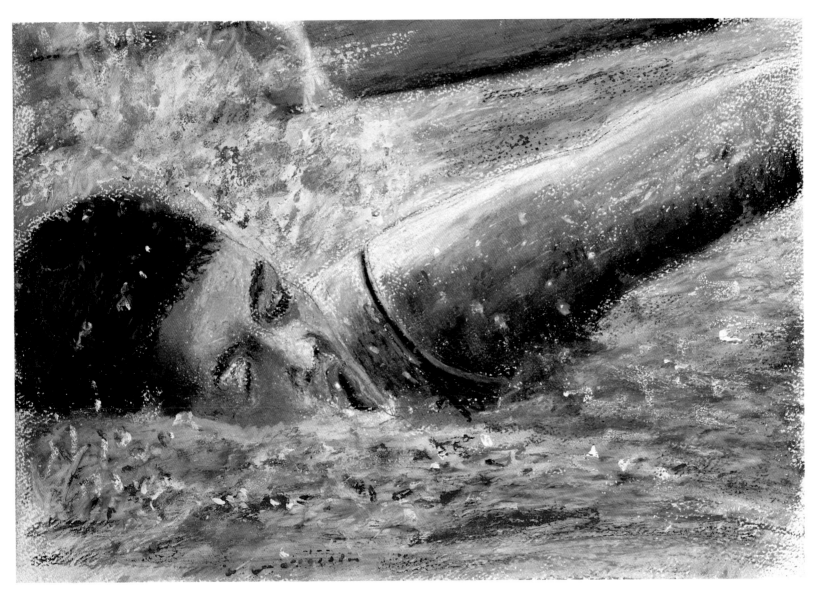

Women's Freestyle Finals, 1980 Olympics. 1984. Watercolor, pastel, and oil on paper, 10 x 14″

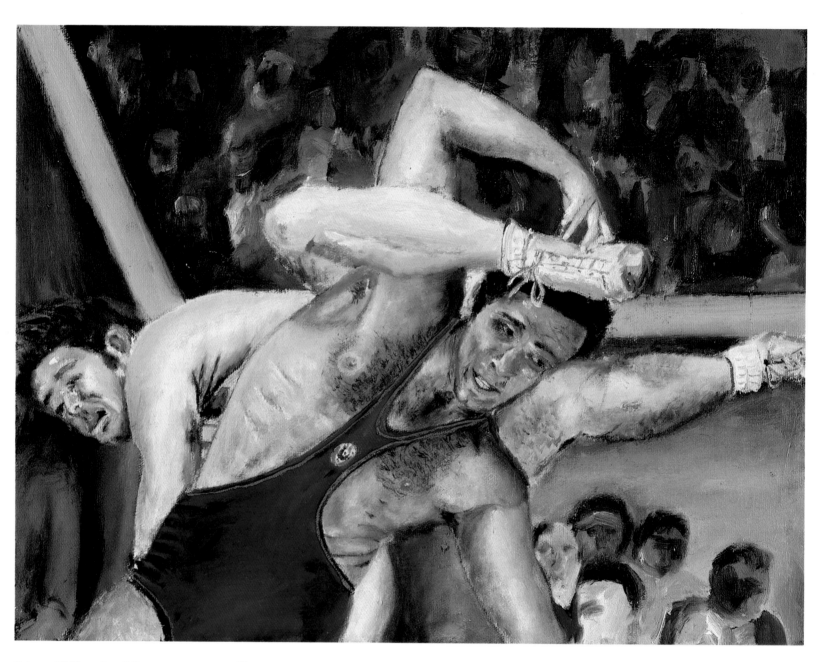

Scissors Hold. 1984. Oil on canvas, 12 x 16″

SPORTS AND YOU

Testing Athletic Potential *James Counsilman*

What qualities or traits must an athlete possess to be outstanding in a particular sport? This question is being asked by many people; certainly it is an important one in terms of channeling the efforts of potential athletes into the sports activities for which they are best suited.

Given our present scientific knowledge of sports medicine and the use of computers to analyze the data our researchers have gathered, determining these qualities would seem to be a relatively easy task. Unfortunately this is not the case. Some of the traits are obvious; even the average sports fan is aware of them. Size is an example of this type of trait. A 285-pound, six-foot-three-inch athlete could never, for instance, be a great high jumper, a pole vaulter, a cross-country runner, a world-class tennis player. Just on the basis of his size, we could say he might make a good shot-putter or a good defensive football lineman. However, he might not be strong enough to excel in those sports, so the quality of his strength would have to be added to the picture. To further improve the testing procedure, such additional physical traits as quickness and speed, reaction time, explosive power, agility, flexibility, visual acuity, peripheral vision, and depth perception would also probably be important.

Assuming all of these traits had been tested in a large group of athletes, each of whom had tried to be a football defensive lineman and some of whom were professional football players, would we be able to separate the professional players from the rest of the group? The answer is no. We could select those who could not be successful, but there would remain a large group of mediocre athletes mixed in with those who had achieved success.

Conversely, some all-pro linemen might have been eliminated because of low scores on a particular trait, such as size. Occasionally an exceptionally strong defensive lineman will come along who weighs only 210 pounds and is five feet ten inches tall. That is to say, a person who is very strong and possesses exceptional explosive power might succeed despite testing below average in the physical trait of size.

We are all familiar with apparent misfits in the various sports. Such a case is Ricardo Prado, once a world-record holder in the 400-meter individual medley. We visualize the ideal swimmer as tall, lean, and muscular. Prado is just the opposite:

short—at five feet eight inches—and relatively stocky. Are these people really misfits; are they the exceptions that prove the rule? No, they are not misfits. They score high in certain important qualities that are not apparent; possibly, these traits have not even been considered, or no test has been devised for them as yet. Some of these are physical and some are psychological.

Physical Traits. Some of these traits have been listed in the foregoing discussion, more are listed below that are generally believed to affect athletic performance. It is by no means a complete list, including only those that are capable of being tested at the present time. They are: age, simple reaction time, balance (both static and dynamic), hearing, body type, muscle and fat distribution, bone structure, general muscular coordination, hand and eye coordination, motor educability (the ability to learn motor skills), cardiovascular endurance, muscular endurance, specific muscular strength, kinesthetic sense, and sensitivity of pressoceptors, particularly those in the hands.

Most of these are innate and, while an athlete can improve many of them somewhat, the degree to which they can be changed is limited. An athlete with an ectomorphic body type (thin, angular, small-boned, and fragile) cannot expect the gains from a strength-building program that an athlete with a mesomorphic body (large-boned, heavily muscled) can. Humans are born with certain limitations as to how much they can improve or change any given trait; they are in many respects locked into certain sports activities.

Good examples of this are the opposing traits of muscular endurance and muscular explosive power. It is impossible for the same athlete to have both excellent muscular endurance and excellent explosive power. Muscle tissue is composed of two types of muscle fibers: fast twitch fibers, which contract rapidly but tire quickly, and slow twitch fibers, which contract slowly but are capable of great endurance. An athlete who has a predominance of fast twitch fibers is capable of the quick movements needed in sprinting, throwing a fast ball, delivering a knockout punch, high jumping, pole vaulting, and all of the sports activities that involve fast, explosive movements. An athlete with a predominance of slow twitch fibers is incapable of developing explosive power but can, with the proper training and inherent traits, develop good muscular endurance and succeed at endurance events, such as marathon or distance running or swimming, bicycling, or cross-country skiing. The relative proportion of slow and fast twitch fibers possessed by an individual is morphological and cannot be changed by training. An athlete can improve explosive power by the proper training, but only within the limitations of muscle-fiber-type proportionality.

While the contribution of certain traits to success in certain sports activities is

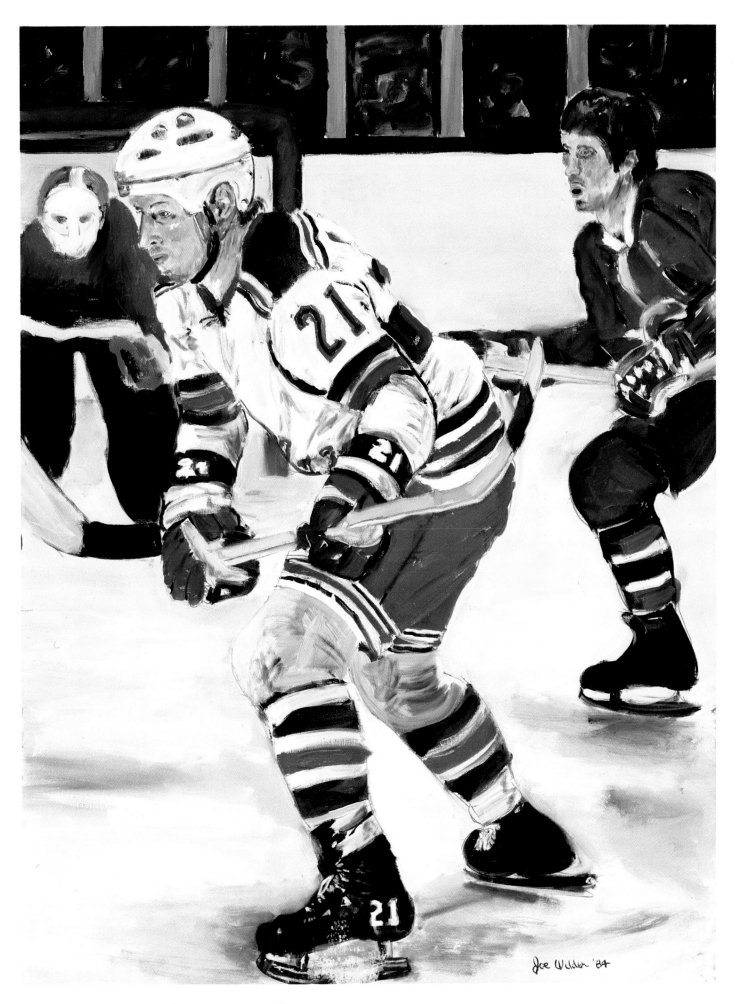

Moving in to Score. 1984. Oil on canvas, 32 x 24″

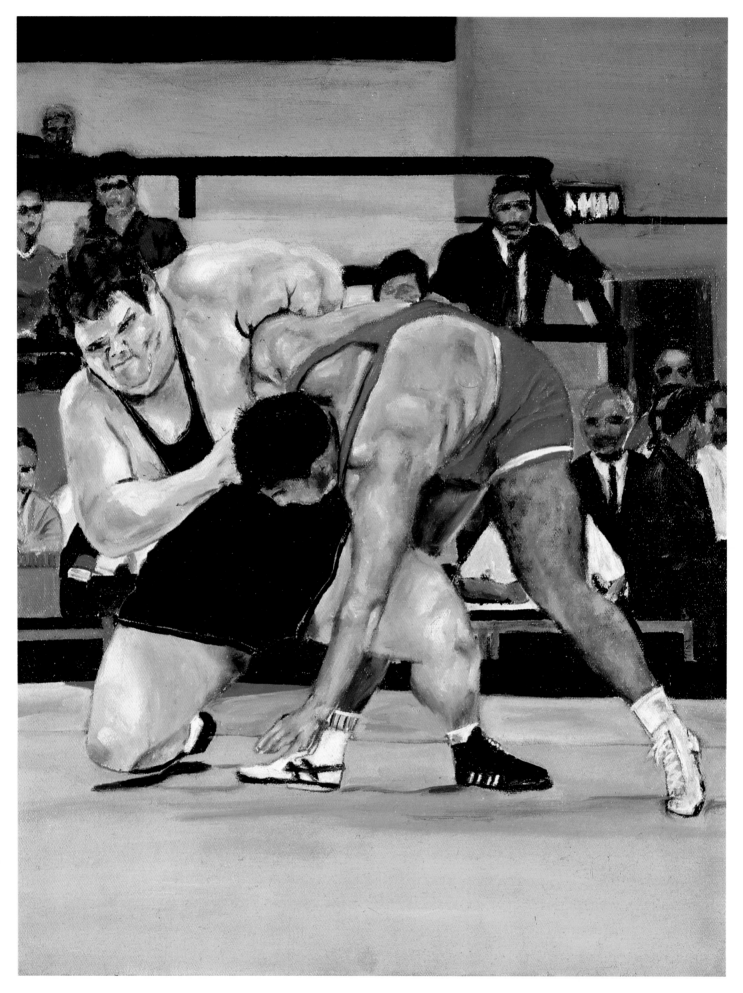

Taylor—Olympic Heavyweight, U.S.A. 1975. Oil on canvas, 18 x 14″

well known, the role of others is yet undetermined. Balance is an example: exactly how important is good static and dynamic balance to achievement in the various sports activities? It would appear to be important in such activities as gymnastics, diving, and broken field running in football and perhaps not as important in distance running or marathon swimming. This is speculative opinion only and requires extensive research, involving thousands of athletes, to shed light on the effect of any single trait such as balance.

Psychological Traits. A basic problem in constructing a profile of the desirable traits for an athlete is that there are so many psychological qualities to be considered. Even an individual with the perfect physique and all the desirable physical traits might lack some important psychological traits for a particular sport. It is probable that the psychological attributes desirable for a football player are different from those needed to be a marathon runner. Some authorities in this area speculate that a good team-sport participant is likely to be more extroverted, aggressive, and group-oriented than a participant in an individual sport. Theoretically, the marathon runner or swimmer should be more agonistic, that is, should not mind, perhaps should even enjoy, the agony of prolonged exertion encountered in competition and in training sessions. There is a theory that persons with mesomorphic body types (predominantly muscular) have a higher pain threshold to the effects of traumatic shock than do ectomorphic body types (thin, light-boned) or endomorphic body types (predominantly soft, small-boned, and tending to overweight).

The personality of an individual is a very complex amalgam of dozens, perhaps even hundreds, of vaguely identifiable traits, all of which affect that individual's likes and dislikes, rate of learning, motivation to work hard at achieving a goal, level of aggression, and so on. If it takes a psychiatrist many years to complete the analysis of a single individual, there is little hope we can fully understand an athlete by administering one or a series of psychological tests. Research in this area is becoming more common, but at this time little credence can be given to the athletic psychological inventories that are available. At Indiana University thousands of athletes have been tested using the Catell 16 PFI Personality Profile. We have found no marked differences in personality traits among swimmers, football players, and track athletes. This does not mean there are no differences; it means only that there were no major differences delineated by the sixteen items evaluated by this particular test.

The matrix of physical traits is complex, but it is probably relatively simple in comparison to the matrix of psychological traits that should be considered. The effect of the two types of traits and how they interact to limit or heighten athletic achievement are certainly not known factors at this time.

To illustrate this point, let us develop a hypothetical assumption. Joe Smith

apparently has all the desirable physical traits and most of the desirable psychological traits to become a great football quarterback. However, he lacks psychological endurance, becomes bored with skill drills, and loses his concentration easily. Much to the disappointment of his coach, who sees all of the apparent physical equipment required to become a great player, Joe does not achieve his full potential. The coach finally gives up on him and trades him to another professional team. There the coach is able to motivate Joe to concentrate and thus be able to use his physical skills enough to achieve at least a major part of his athletic potential. We see this happen so frequently that we can introduce another factor—acquired physical skills—into the success or failure syndrome that comprises the already complex question of what traits are needed for success.

The acquired skill level of the athlete varies with the amount of time the individual spends in learning the necessary skills and the quality of the instruction received. Athletic skills are acquired either by individual trial and error or by guided trial-and-error learning. In the former, the athlete has no external guidance—from another person, a book of instruction, a film, or such—while in the latter the athlete does. Many potentially great athletes who have desirable traits are never permitted to achieve that potential because of lack of opportunity or poor guidance. A swimmer of average ability and limited potential who has been practicing eight hundred hours a year for ten years will probably outperform a more talented swimmer who has only been training eighty hours a year for two years. If the data from these two swimmers were included in the statistical search for desirable traits for swimming, some very misleading results would be obtained.

In summary, then, there are a few easily recognized traits that serve as rough guides in helping individuals choose the sports activities for which they are best adapted. These traits are size, strength, body type, explosive power, and endurance. They provide a general idea of where to channel one's efforts. There are a large number of traits that are difficult to test and probably many more of which we are not aware or have little knowledge. At this time it is impossible to evaluate a person's ultimate level of athletic achievement on the basis of testing.

Both of the categories concerned—the physical and the psychological—contain a multiplicity of components that make it difficult to try to isolate the most crucial factors. It is the hope of coaches and athletes that future research will indicate with greater certainty where an individual's strengths and weaknesses lie. Physiological and psychological research will doubtless eventually reveal the remedies that can counteract the weaknesses and exploit the strengths. That day is not yet here.

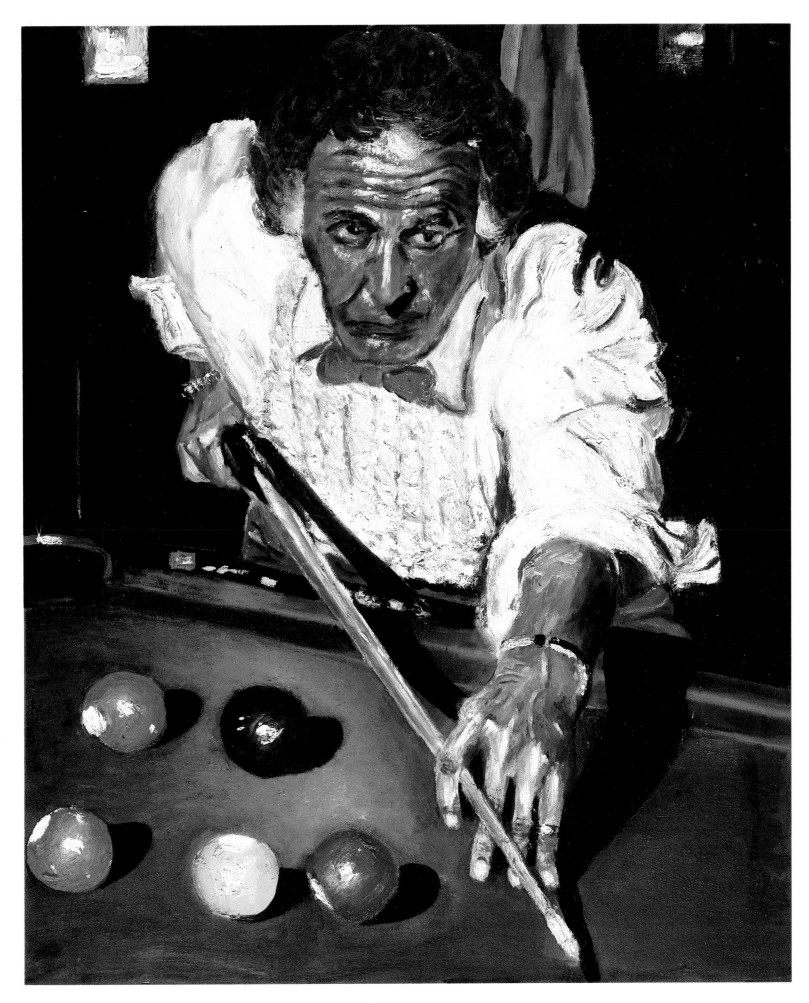

Pool Player—After Milton Robertson. 1977. Oil on canvas, 24 x 20″

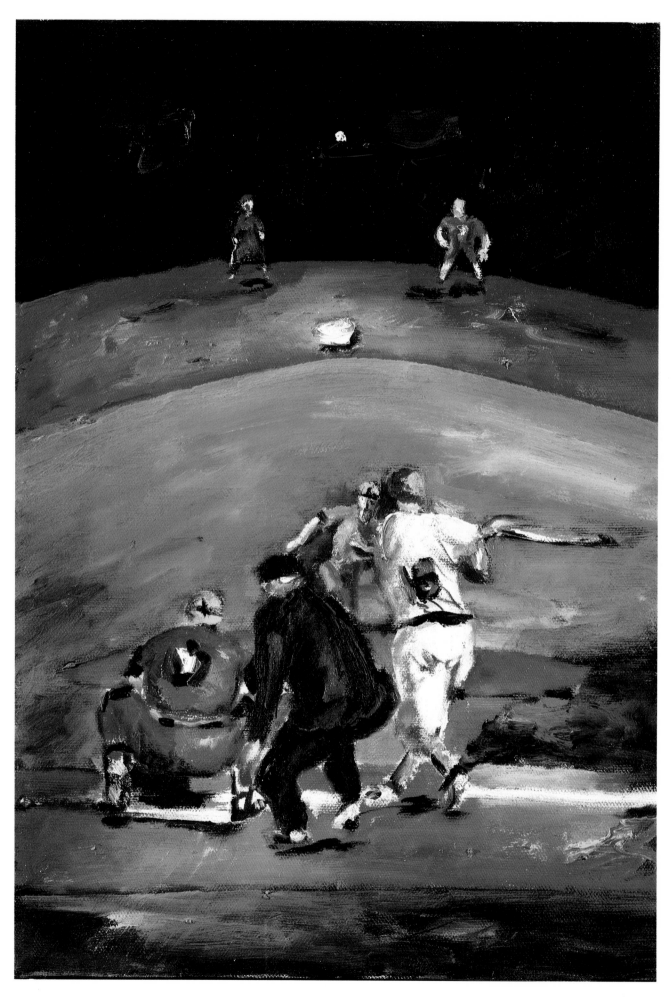

Middle of the Lineup. 1984. Oil on canvas, 14 x 10″

SPORTS AND YOU

Sportswriter at the Bat *Ira Berkow*

In some circles, sportswriters have a reputation as frustrated athletes. In similar circles, theater critics are seen as frustrated mummers and political writers as thwarted potentates.

I can only speak about sportswriters, however, having been one for nearly two decades. And I can only speak for me, having been me —or a reasonable facsimile— for better than four decades.

In this vein, I'm reminded of a call I once put in to the humorist Goodman Ace. I dialed the *Saturday Review* magazine, where he had an office, and asked the receptionist for Goodman Ace. I was put through and a man's voice answered.

"Hello," it said.

"I'd like to speak to Goodman Ace, please," I said.

"What do you want to speak to Mr. Ace about?"

"I have a question I'd like to ask him."

"Go ahead," said the voice.

"Are you Goodman Ace?" I asked.

"I try to be," said the voice.

Well, as a professional sportswriter I tried to be just that, and not a professional athlete nor to think of myself as one—and so I have not sat in the press box and ruminated, "Hey, I can do better than that clown," or, "If only I hadn't wasted my precious hours in English classes, that could be me out there on the mound instead of Wooden Arm Williams."

Growing up, I was like a lot of kids and had my own little dreams of athletic stardom, most of which centered around playing for the Cubs in Wrigley Field; I was born and raised in Chicago and grew up with the unfortunate Cubs as my favorite team. Andy Pafko was my favorite player. To understand the depths of such a dream, one must recall that from the time I was eight until I was twenty-eight, the Cubs finished in the second division each year, an all-time record.

As for Pafko, well, he was a very good player, and a well-meaning one. I'll never forget the play, for example, in which he ran in from center field for a sinking line drive. The bases were loaded and he dived for the ball. Pafko tumbled and came up with the ball held aloft in his glove to indicate he had caught it. The umpire,

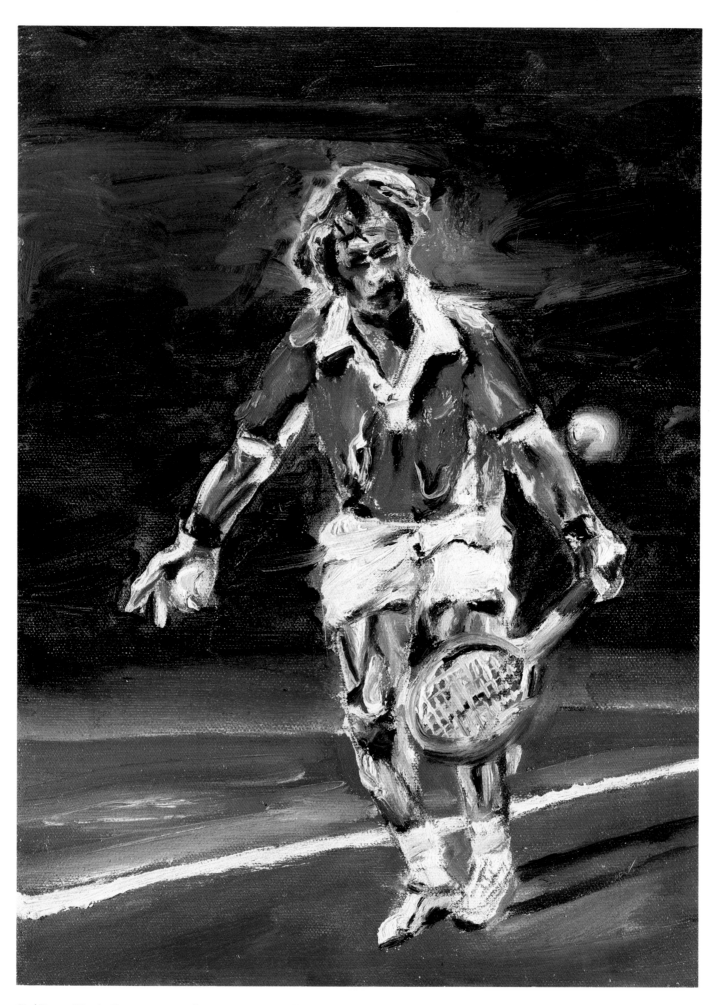

Rod Laver, Tennis Great. 1977. Oil on canvas, 12 x 9″

though, indicated that he had trapped it. Enraged, Pafko ran in to the infield to argue with the umpire. Meanwhile, all four runs crossed the plate.

As I grew older, I began to put away childish thoughts about playing for the Cubs, but I stayed active in sports and played baseball and basketball in high school, and basketball in college, and I still am active in basketball pickup games.

Many, if not most, of the sportswriters of my acquaintance are not and have never wished, beyond adolescence, to be athletes. They may enjoy watching and reporting about people who earn a living by the sweat of their brow, but from a distant place, preferably a heated one for football and a shaded one for baseball. To these sportswriters, simply crawling out of bed in the morning—or afternoon—is more than enough exercise for the day.

Others simply accept their limitations. "As a young man," wrote Red Smith, the late, incomparable sports columnist, "I suffered grave disadvantages, being under-sized, myopic, with poor reflexes and yellow. So I wasn't much good at competitive sports. But I am and always will be an utterly unreconstructed trout fisherman. I am inept but enthusiastic. The competition between the fish and me, the effort to prove that I am as intelligent as the fish, is just about as great a challenge as I care to undertake."

But just as a doctor doesn't have to have contracted impetigo to treat it, so the sportswriter, as Smith so eloquently proved, needn't have pole-vaulted eighteen feet to describe it.

As a sportswriter, I've had the temerity on occasion to attempt athletic endeavors, sometimes with topflight athletes, in order to report on them. This is not to say that I am an heir to Paul Gallico or George Plimpton, both of whom spent more time than I wished being knocked out by Jack Dempsey for the sake of a newspaper story (that was Mr. Gallico) or being sacked by a nasty horde of defensive linemen for a book (that was Mr. Plimpton).

I'm not one for danger, and so I moved cautiously—no, grudgingly—into my first attempt at participatory sports journalism. There was an opening of the ski resort, Snowmass-at-Aspen, in Colorado, in December of 1967, and an editor thought it was a good idea for me to write about going skiing for the first time. I've always hated the idea of skiing because I thought it would take me six months to walk again after the experience. I was new on the job in New York, and, well, I was soon being fitted for skis in Colorado. A ski parka was thrown over me. Heavy boots were snapped tight about my ankles. I left the ski shop toting skis and walking as stiff-legged as Frankenstein.

I was assigned an instructor named Lisa Smith, a kindly blonde, and we rode chair lifts to nearly the top of this huge mountain. I put on skis and the lesson began

along a pathway. The first thing you have to learn is to fall down, said my instructor. I couldn't fall down. Through no fault of the instructor. My heart just wasn't in it. All I wanted to do was get off the mountain. After what seemed a very long time, the lesson ended. I asked how I get down. She advised that I take the chair lift.

Under a bright sun, a long line of colorfully clothed skiers rode up the lift. A long line of empty red chairs, except for one, rode down. I clutched skis and poles in my lap. Little girls, matrons, college boys, old men, under stocking caps and behind sparkling sunglasses, pointed at me, some smiling and some, I thought, snickering. I was embarrassed.

"What happened?" asked a man sympathetically as we passed in the sky. "Broken binding?"

"Broken binding," I agreed.

I lifted my head and puffed out my chest. "Broken binding," I repeated to skier after skier, all the way down the mountain.

The next time I was actively involved in sports while on the job, it was my idea. I was sitting on the sidelines at an indoor tennis club and waiting for Rod Laver to finish a workout so that I could interview him. Laver was then the best tennis player in the world.

I've played tennis infrequently, but after his workout I asked Laver if he'd hit a couple of serves to me. I was curious to know what it was like to be at the other end of a Rocket Rod Laver serve. He smiled and said, "Sure." In sport jacket and loafers I walked to the other side of the court and stood there, racket in hand, waiting. He bounced the ball a couple of times, then tossed it into the air and swung his racket through. The ball cracked into the net.

I smiled. "Don't be nervous," I called to him. It was my idea of a joke, of course. I'm not sure Laver heard; if he did, he ignored it. He served again. This one shot over the net. I barely had time to stick out my arm but somehow the racket hit the ball, or, rather, the ball happened to hit the racket. It felt like a brick had banged against it. The ball spun to the side and dribbled away.

Laver had got over his nervousness. What I'll never forget, though, was the look in Laver's eyes on the second serve. It was cool, it was unblinking, it was deadly. And we left the court on, as I refer to it, The Day I Hit with Rod Laver.

Another time, I suggested going into the ring with Smokin' Joe Frazier, then the heavyweight boxing champion of the world. This was in 1970 at Frazier's training camp at the Concord Resort Hotel in the Catskill Mountains. He was training for a title defense against Jimmy Ellis.

I approached Smokin' Joe's manager, Yank Durham, and asked if it would be all right for me to spar a round with the champ, just to get a feel for his moves and

the sense of the ring. I wasn't out for blood and I wouldn't expect him to be, either.

"Ever box before?" asked Durham, a white-haired, thick-voiced black man. He looked at me seriously.

"In college," I said. "I had a course in boxing one semester."

"You in shape?" Durham asked. He was looking me over, and not with what I took to be profound appreciation.

"I've been playing some basketball," I said, "and I've been riding a bicycle a few miles every week."

"In that case," said Durham, "the champ will only break two or three of your ribs. My man," he said, letting the words sink in, "he don't know how to play."

I thought about this for a moment, and about Frazier, whose left hook could make very large and very mean people collapse helplessly to the canvas. And I wasn't nearly as large or as mean as some of those supine gentlemen. "I think I'll take a rain check," I said to the trainer. Neither Durham nor I brought it up again.

I did, however, go head-to-head with another Frazier—this one was Walt, or "Clyde," the star guard for the New York Knicks during their championship years of the 1970s. Clyde won the first game, 11-7. When subsequently asked in an interview how I managed to get seven points off Clyde, I said, "I'm a good shot," and Clyde said, "You made me hustle." He mentioned that he particularly liked my driving, left-handed, double-pump hook shot. Throwing humility to the winds, I include the above strictly for the sake of reportorial integrity, you understand.

I'm not certain that I told the interviewer about the next game Frazier and I played. I mean, the conversation took place at a book party and maybe in all the hubbub I neglected it. An oversight. It happens. The second game? Clyde beat me. The score? Well, 11–0.

Clyde seemed suddenly to transform. There appeared in his eyes a sobriety, a seriousness of purpose that I compare to the look—the glare—in Laver's orbs. And Clyde's left hand, the one he held up and out on defense, grew larger. You can tell me it was my imagination. But I saw it! His palm grew wider, his fingers longer. And there was no doubt whatsoever that he grew more intense. If he would go all out to try to stop Earl the Pearl or The Big O, he would certainly get up to stop a rank amateur.

As I would later learn, he analyzed my moves in the first game. He saw that I liked to go right, and so he forced me left. He noticed that I stood a half-step too far back from him on defense, and so he opted for the jump shot instead of the drive. I didn't understand that one, since he drove on me with unsettling frequency, anyway.

No sense dwelling on this, though. As for my driving, left-handed, double-

pump hook shot in the first game (I'm right-handed, which is what made it so special), it may have been the only one I made in my life. But who's counting?

Baseball was my first love and it was with a certain leap of the heart that I took the opportunity to play in a baseball game against a star major-league pitcher. Denny McLain had been a thirty-one-game winner for the Tigers in 1968. Now, in June, 1970, I was in Lakeland, Florida, to do a story on him. He had been suspended from baseball for the first half of the season for involvement with gambling and was preparing to return to the big leagues in July.

Every evening, with the warm sun down, but still a couple hours left before nightfall, McLain pitched a nine-inning "Piggy Move-up" game with a ragtag collection of local high school and college players. The catcher was Jim Handley, the local high school baseball coach, who had caught in the New York Met and Detroit Tiger farm systems. The rest of the positions were taken by the kids. McLain stayed on the mound, throwing about three-quarters speed as the rotation continued. When I learned of the games, I asked McLain if I might play. "Why not?" he said with a shrug.

In my first time up at bat, I felt nervous to be facing McLain. I stood at the plate with batting helmet and sneakers and soft knees. I waggled the bat as I looked out at the mound. McLain, in Bermuda shorts, stooped in that classic pose to get the sign, gloved hand on left knee. I gripped the bat tightly. McLain appeared chunky from sixty feet six inches away but became formidable as he kicked and whirled and came around with a graceful, smooth delivery. The ball popped into Handley's mitt. Strike one.

That was followed by a breaking ball low and away. McLain had hid the ball magnificently and I never saw the white of it until it was traveling plateward. I fouled off a ball to the right that bounced down a hill and almost rolled into a lake fringed by mossy pines. The count went to 3–2 and then, staring and frozen, I struck out on a called outside fast ball. I trotted head down to right field.

Next time up, on the second pitch, I hit the ball up the middle, past McLain's right, and I ran like hell. I knew I shouldn't watch where the ball was going, but I had to. The shortstop charged in and toward second, scooped up the ball, and threw. But too late! I had beaten out a hit!

The inning ended with me stranded on first. I would come to bat one more time in the game. I was up second in the inning, and I was concerned. McLain's pride might be hurt. He told me once that he wants to win at everything, that if he played his mother at Monopoly he'd do everything he could to whip her decisively.

In the darkening evening, the fielders seemed far away as I came to bat, while McLain loomed close. His tan face and arms were dark with sweat and so was his

Tennis on the Grass. 1983. Watercolor on paper, 11 x 14"

gray T-shirt with "Detroit Tigers" lettered across the chest. Quickly, the count came to 2–2. A high fast ball came close to my head—at least, I thought it was close—and I fell back and onto the seat of my pants. "Oh gee," said McLain, with feigned anxiety, "I wouldn't want to hit *him*." Meaning a sportswriter. Handley's laugh echoed from behind his mask. I swallowed. At the time, I was only faintly aware that I had just experienced an authentic brushback pitch.

Three-and-two now. McLain wound up and—my God!—he was coming in *sidearm*. "Where you goin'?" asked Handley, as I strode into the bucket. The ball came in and, as I swung, awkwardly, helplessly, the ball kept coming in. A change-up! By the time it had reached the plate, I had crumpled to one knee.

McLain's smiling white teeth looked very bright against the dark of his face. Yes, I had struck out ignobly, but as I went to right field in the warm haze of the Florida evening, I was absorbed in the details of my hit. "A hit?" McLain would say later. "You call that thing a hit! It took twelve bounces." His competitive fires burned bright. But so did mine. I was batting .333 against Denny McLain. I still am, and will be, forever.

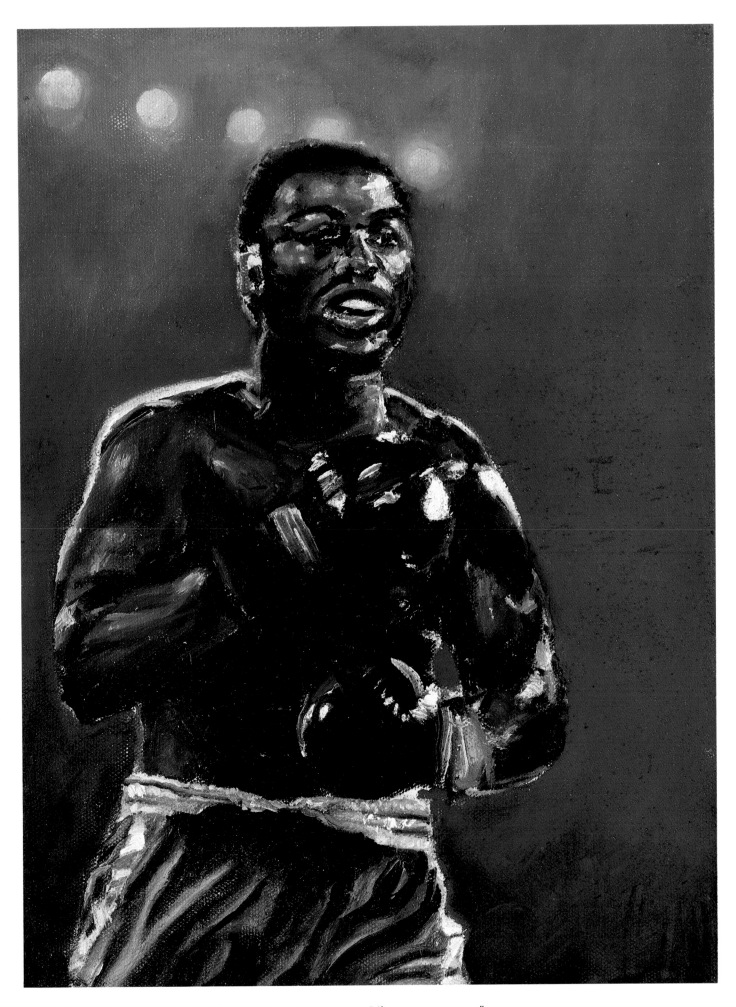

Joe Frazier Losing World Championship to Muhammad Ali. 1975. Oil on canvas, 12 x 9″

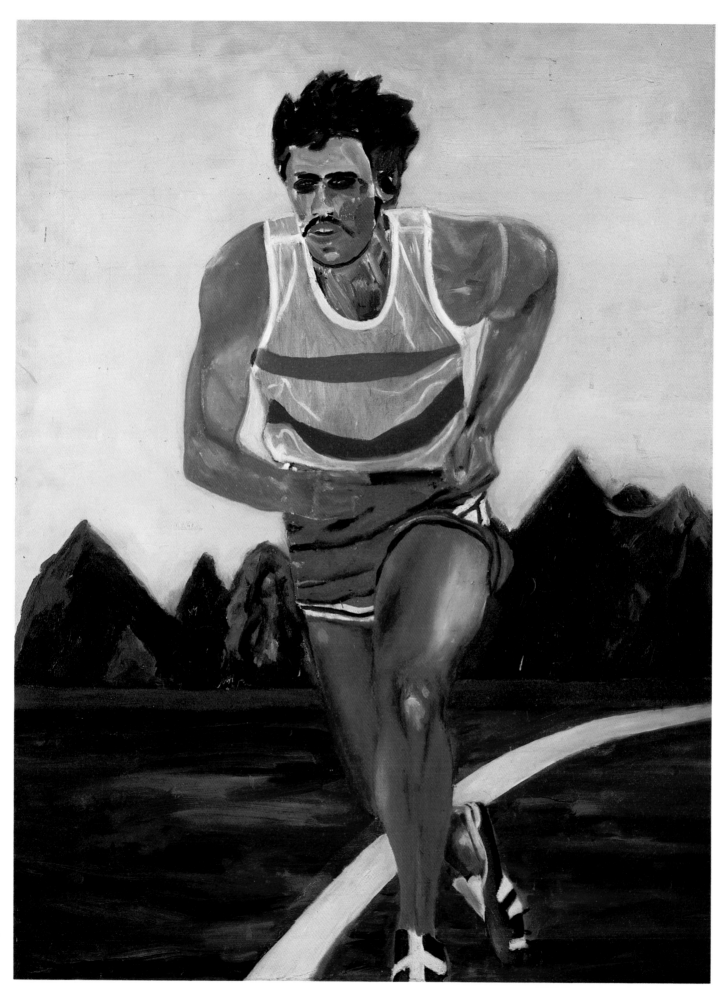

The Runner. 1973–74. Oil on canvas, 40 x 30″

SPORTS AND YOU

The Athlete from Eight to Eighty:
The Joy of Mediocrity *John H. Bland, M.D.*

I am in my sixty-seventh year and the best is yet to come. I am an athlete, have always been an athlete by my definition: a person who enjoys being— indeed is compelled to be—physically active, to run around, jump, jog, sprint, or play some game, in multiple ways to engage heart, lungs, muscles, bones, joints, ligaments, tendons in doing a lot of what they are paid to do. The Greek root *athlos* (a contest) implies that there is always a competition involved in being an athlete. Such may or may not be a part of it; it happens to be very important to me. The competitive spirit does not die with increasing chronologic age.

I remember as a little boy feeling the need to do a lot of running around, to jump, to run, first fast, then slowly, to play for hours at a time. Real play is a random activity, free-flowing, no goals, somehow just enjoying and reveling in feelings of animal vigor, motion, and a sense of overwellness. My running then was very in- efficient, moving up, down, and sideways much more than forward—the pre- sumptive direction to go! I had no need to "look good," or look cool! I was not comparing myself to any other athlete, and there were no rules or score. While play is associated with childhood, as something to give up as adults, I believe it essential. An hour a day of play should be, but rarely is, characteristic of maturity.

In high school and college I was a polyathlete and not much good at any of it— much more enthusiasm than ability. I did occasionally score a touchdown, or suc- cessfully field a ball and throw someone out at first, or place fourth in the low hur- dles, but by and large I was the guy who made up the last member of the team. I gradually learned that I could never practice inertia and would always require vig- orous physical as well as intellectual activity, found that I could always alter a de- pressed, frustrated, or angry mood by going out alone and running with no hurry to get anywhere, with no goal other than to free and clear my mind. I learned that I could unlock wells of mental energy and creativity through exercise.

During career development, new jobs, and increasing responsibility, my prior- ities rapidly changed, and play, sports, and competition took a "way back" seat. There was always another book to write, a patient to see, a lecture to give, but very rarely a race to run, a marathon to finish, cross-country skiing to do. I could never

get really free of the guilt that accompanies a doctor's work, always the feeling of not being as good as the work demanded. Nevertheless, I remained physically active as a weekend warrior, perfectly willing to go out and ski a 50-kilometer race with no preparation at all in the way of sufficient training to warrant such activity. I did not formulate a philosophy of fitness until much later, though I was always a student of the physiology, biochemistry, biomechanics, and metabolism of fitness. I never dreamed of the great joy I was building for myself in my fifties, sixties, and on during that long period of hardly acceptable athletic performance.

In my fifty-ninth year, in the middle of a 50-kilometer ski race, I had a heart attack. At about 10 kilometers out, the sick, faint feeling appeared with a tightness in the chest. Racers were streaming by me shouting "out of the way" as I tried to decide what to do. Since the first part of the course was generally uphill, I decided to let my skis run downhill wherever I could and started the trip back. Two kilometers from the starting line, I met the snowmobile and rescue crew and was taken to a cottage hospital. During the trip back I remember cautioning myself, "Take it easy, boy, suppress fear and adrenaline, you are having no arrhythmia and you really don't feel that bad, do you? If you can ski back it must not be a really bad heart attack." I took my pulse often, found it small volume but normal rhythm.

After an uneventful convalescence I was back at work in two months. During that time I did a lot of thinking and planning. I learned from a friend whose research career was studying experimental atherosclerosis that there were four species of animals in which the disease had been first produced and then reversed—produced by immobilization and overfeeding and reversed by diet and forced exercise.

There are two things in this life that I am absolutely secure about: one, I shall be dead someday and, two, I am not dead now. The issue is what to do in between to postpone the time of dying. With great joy and anticipation, I decided that I was going to become an athlete again, play an hour a day (a religion), develop a fitness program, perhaps with, perhaps without, goal and purpose. While I knew that the experimental studies in animals could not apply to human atherosclerosis, I decided that reinitiating my athletic days was the best possible gamble for survival.

I had not really lost the emotional aspect, the playful enjoyment of exercise; and all went very well indeed. I again could clear my mind, change my mood, think and plan "on the run." My early program was that of simply walking at a leisurely pace a half hour every other day. After two months, I began walking fast for the same period and progressed to jogging 100 yards, then walking 100 yards, and ultimately to running daily. What a glad discovery of what I could do!

I decided to run a five-mile race, having run as much as ten miles without any symptoms. I did so and won a prize, a lovely, glass-bottomed pewter mug! Thus came the notion that a fitness program need not be all play, that a challenge was safe

and sound. I soon began to enjoy the hurting of exercise and effort, the shortness of breath, the fatigue, always knowing that when I crossed the finish line I would be fine in a few minutes. I have now successfully and joyfully crossed the finish line in ten marathon road races and countless cross-country ski races and marathons.

I continue to run and to compete in both running and cross-country skiing and have had no perceivable symptoms of cardiovascular disease. I play basketball and touch football, in fact any sport, all playfully, except running and cross-country skiing. When I get a bib on, I seem to grow fangs! This year, I was named to the United States Ski Association National Team in my age group, an unexpected and joyful event, earned in competition with my peers. I am winning and never did before, although of course, the competition has thinned out some!

Am I old? I've never felt old. Still, the enthusiasm I show for being high sixties is often perceived by others as a denial of reality, some overcompensation out of fear of dying—I perceive a certain condescension. I suppose that old age is identified with death—and few are prepared for that. But death comes at all ages! Every one of my previous years has laid the foundation on which my present enthusiasm and skills as a doctor, writer, educator, and speaker depend. I am much more rewarded now for performance than I ever was before, and I thrill and exult in taking risks and being bold—things I would not have done in my twenties, thirties, or forties. This is because I've been there, I've paid my dues. Having lived so long with uncertainties, I have a few certainties now—not many but some! I feel I can play most any role because I have played them all in various degrees at one time or another.

What is oldness? What is growing old? When you stop growing, you are old; that about defines it. I know people of thirty who are old and of eighty who are young; the years allow you to become well schooled in the rigors and rewards of self-reliance.[1] Our dread of aging is largely the fear of decrepitude.[2] One visualizes the "old guy" who finds the act of urination absorbing most of his time and attention, the spritely older woman who suddenly shrivels and becomes slow of gait, suspicious and whining. However, these are exceptions. Instead of the "head stop" program our society imposes on the aged, why not the same "head start" it gives children? In that way, the best physical, emotional, and intellectual performance day-by-day will assure that loss of function will be kept to the minimum.

There is a large body of evidence, increasing all the time, that the maintenance of physical fitness can postpone the onset of decrepitude. The following matters concerning athletics and the aging are well documented scientifically. First, memory loss in the aging is not nearly the troublesome problem it is commonly thought to be. In a study that examined one hundred people sixty-five and older, only the minority really had functional memory loss. There is good evidence that much of the functional change in memory is attitudinal, a consequence of expecting what is

going to happen rather than a reflection of what actually exists.[3] (I sometimes think that many Americans begin rehearsing for their retirement at about thirty, so that by age sixty-five they are very good at it!) Depression in old age is mainly caused by the same mechanisms that cause it in younger people: isolation, loss of loved ones, money problems, nutritional depletions, general attitude.[4] If all that can be done is done, the mental health of the elderly can be successfully managed.

The older athlete responds with the training effect just as surely as the younger one does in all the measures of fitness.[5] Bone in the older person can increase in density, and in fact compressive and tensile strength will increase by gradually increasing the load.[6] Osteoarthritis can be postponed in older people by exercise, and old athletes actually have less osteoarthritis than younger ones. Don't pity the aging athlete.[7] The oxygen-transporting system will increase favorably at any age upon training.[8] A decrease in total body water is characteristic of aging but can be managed by a doctor sensitive to the issues. Similarly, while it is true that aging is associated with decreased immunologic competence, in general the immunological system functions very serviceably indeed.[9] The reflexes can clearly be positively influenced by training in the aging. Muscle, ligament, tendon, bone, joint all respond with the training effect: tendon, for instance, becomes higher in tensile strength and increases in volume; muscles become more efficient and enlarge. Ligaments and capsules likewise increase tensile strength according to very reliable measurements.[10]

Even the weakest of us can be some kind of athlete, for athletic achievement is thoroughly relative. An eighty-two-year-old man in congestive cardiac failure, pulmonary emphysema, osteoarthritis, and osteoporosis of disuse, who leads a bed and chair existence, may have as his athletic goal to walk around his house twice a day. Since he has not been exercising at all, he can begin by exercising in bed. He too can very gradually increase the load, can experience and induce the training effect on heart, lung, ligament, muscle, bone, joint, tendon. When he does achieve his goal, it will be relatively equivalent to Alberto Salazar's world-record-breaking marathon in Boston in 1982. Only the strongest can survive as a spectator.

Doctors must deal with older people as they do with people at any other age. An eighty-five-year-old man came to see me because of a sore knee, swollen, hot, and red of six-months duration. His doctor had told him that he had arthritis and that everyone his age had it, and he should take some aspirin, rub the knee with liniment, avoid using it, and get a cane. In my interview with him, he said the thing that puzzled him most was that his other knee was the same age and it didn't hurt. How could it really be due to his age? A wise man! He turned out to have a torn cartilage just as a football player might, and the same management healed it! Not at all related to his eighty-five years, though his doctor assumed it was.

Sprinter. 1984. Pastel on paper, 16 x 12″

With specialization in medicine have come categories of doctors who deal with one organ, and their narrow view of biology very frequently prevents their patients from ever being athletes. The nephrologist, for instance, tends strongly to think only of the kidney disease; the patient on dialysis surely cannot exercise, he thinks. This simply is not so. In fact, such a person may suffer more from the consequences of lack of exercise than from the kidney failure itself. Surely major physical and psychological improvements can occur by realizing, within the constraints of the particular disease, the benefits of exercise. Among these are enhanced feelings of self-esteem, optimism, and confidence, an actual increase in muscle power, and an alleviation of the aching and generalized stiffness of immobilization—not age!

We older people are really only human beings who one day find ourselves inhabiting old bodies and confronting physical problems of reduced vigor, changing appearance, and disabilities affecting such things as sight and agility. Avoid retirement: it is just another name for dismissal and unemployment. Aging has no effect on you as a person. Your memory, sexuality, physical activity and exercise, capacity for relationships and fun normally last as long as you do. As an old person you will need four things: dignity, money, proper medical services, and useful work. Aren't these the things you have always needed?[11]

1. Aring, C. D. 1972. On aging, senescence and senility. *Ann. Int. Med.* 77:137–40.

2. Schwartz, T. B. 1978. The specter of decrepitude. *New Eng. J. Med.* 299:1248–49.

3. Katzman, R. 1981. Early detection of senile dementia. *Hospital Practice* 16,6:61–76; Smith, J. S., and Kiloh, L. G. 1981. The investigation of dementia; results of 200 consecutive admissions. *Lancet* 1,8226:824–27; Weingartner, H., Grafman, J., Bontelle, W., Kaye, W., Martin, P. R. 1983. Forms of memory failure. *Science* 221:380–82.

4. Millard, P. H. 1983. Depression in old age. *Brit. Med. J.* 287:375–76.

5. Astrand, P. O. 1968. Physical performance as a function of age. *JAMA* 205:105–09; Shephard, R. J., and Kavanaugh, T. 1978. The effects of training on the aging process. *Physician and Sports Med.* 6:33–40; Sidney, K. H., and Shephard, R. J. 1976. Attitudes toward health and physical activity in the elderly. Effects of a physical training program. *Med. Sci. in Sports* 8:246–52.

6. Aloia, J. F., Cohn, S. H., Ostuni, J. A., Cane, R., and Ellis, K. 1978. Prevention of involutional bone loss. *Ann. Int. Med.* 89:356–58; Smith, E. L., Reddan, W., and Smith, P. E. 1981. Physical activity and calcium modalities for bone mineral increase in aged women. *Med. Sci. in Sports* 13:60–64.

7. Holden, G. 1982. Age and arthritis. *J. Roy. Soc. Med.* 75:389–93; Pollock, M. L., Miller, H. S., and Wilmore, J. 1974. Physiologic characteristics of champion American track athletes 40 to 75 years of age. *J. Gerontol.* 29:645–49; Sherwood, D. E., and Selder, D. J. 1979. Cardiorespiratory health, reaction time and aging. *Med. Sci. in Sports* 11:186–89.

8. Davies, C. T. M. 1972. The oxygen transporting system in relation to age. *Clinical Science* 42:1–13.

9. Gillis, S., Kozok, R., Durante, M., and Weksler, M. E. 1981. Immunological studies of aging, *J. Clin. Invest.* 67:937–42; Yunis, E. J., and Greenberg, L. J. 1974. Immunopathology of aging. *Fed. Proc.* 33:2017–19.

10. Bates, C. J. 1977. Proline and hydroxyproline excretion and Vitamin C status in elderly human subjects. *Clin. Science and Molec. Med.* 52: 535–43; Young, J. C., Chen, M., and Holloszy, J. O. 1983. Maintenance of the adaptation of skeletal muscle mitochondria to exercise in old rats. *Med. Sci. in Sports* 15:243–46.

11. Comfort, A. 1977. *A good age*. London: Mitchell Beasley; Harris, R. F., and Frankel, L. J. 1977. *Guide to fitness after 50*. New York: Plenum Press.

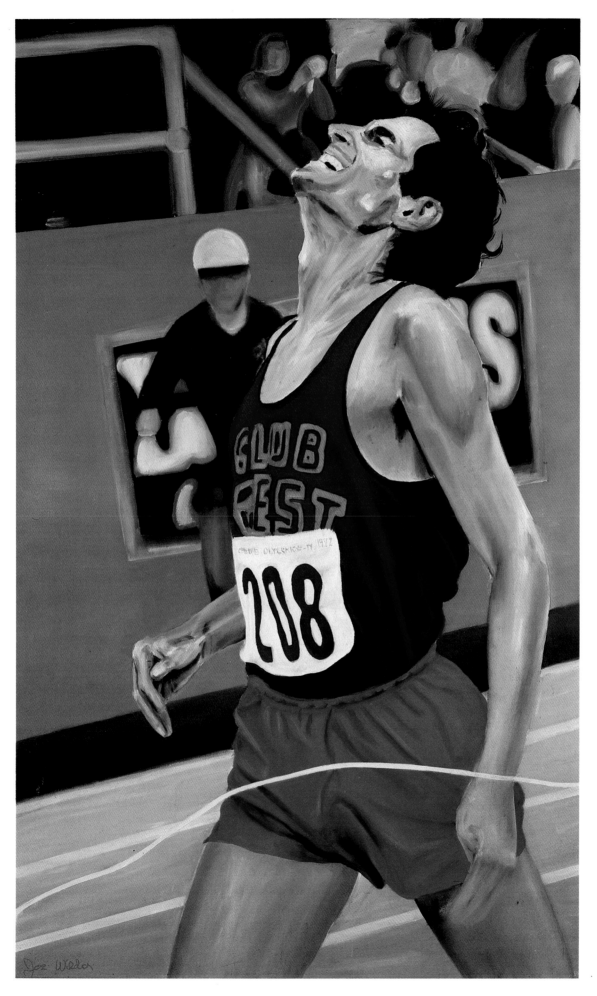

Jim Ryun—Mile Champion. 1975. Oil on canvas, 34 x 24″

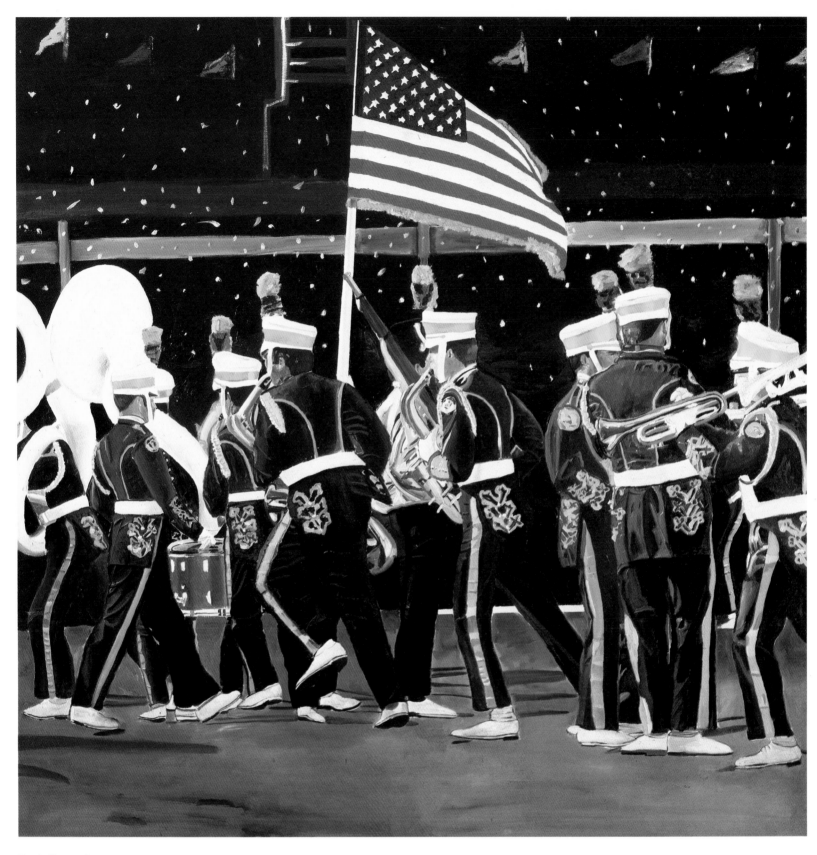

Football Marching Band: Shea Stadium. 1972–74. Oil on canvas, 60 x 60″

SPORTS AND YOU

Seeking Excellence in Sport and in Life
Steven J. Danish

Each year a number of players and teams reach the pinnacle of success in sport. In 1983, for example, the New York Islanders won their fourth straight Stanley Cup and were proclaimed the best team in hockey history. Carl Lewis won the 100- and 200-meter sprints and the long jump at the United States Track and Field Championships to become the first person to win three individual events at a national championship since 1886. Martina Navratilova and Chris Evert Lloyd have dominated women's tennis for the last several years, as Mary Decker has women's track, breaking numerous United States and world distance records.

These several examples of individuals and teams attaining excellence in sports are only the more publicized ones. Monthly, perhaps even weekly, individuals and teams at every age level and in every city and state reach their goals after an extended period of hard work and sacrifice. While the notoriety they sometimes receive is nice, more important is the feeling of satisfaction and pride, of meeting and conquering a challenge, that accompanies their success. The chance to attain excellence is present in sport because sport provides participants with immediate and specific feedback about their performance. There is a clear beginning and end, and an opportunity to evaluate progress toward a goal. While we may seek excellence in all areas of our lives, rarely do we have the criteria to evaluate our performance as clearly as we do in sport. Perhaps this is why sport has taken on such meaning for many of us.

Unfortunately, when we see examples of athletic excellence, we are too focused on the physical skills of the athletes. We see how strong they are, or how quick they are, or how high they jump and we say, "This isn't us." We do not see the dedication, time, and effort involved in achieving their athletic goals. Consequently, it may be hard for us to understand what the attainment of athletic excellence has to do with us except that, as fans, we rejoice in the success of our favorites.

In fact, the difference between an outstanding athletic performance and a good one really has very little to do with the athlete's physical skills. It is mostly related to mental skills. For example, if a baseball player bats 560 times during the season, the difference between batting .300 and .250 is twenty-eight hits, a little more than one hit per week for the season. The difference, then, between being in the All Star

game and being in the minor leagues is less than two hits per week. Very little of this difference can be attributed to physical skills; it is much more likely to be the result of a player's mental skills.

As athletes approach what appears to be the limits of their physical potential, they and their coaches search for something to give them the "winning edge." What they seek is a magic potion that will transform the athletes from good performers into great ones. The search has included the development of new equipment to help them run faster, jump higher, or hit the ball longer or harder. It has involved altering diets to consume more of one food group or less of another. It has even involved taking drugs to make them stronger, more relaxed, or more "keyed-up." Each new discovery quickens the search for the next miracle potion.

What has been lost in the quest for a magic elixir is the athlete. How the athlete prepares mentally for competition may constitute the difference between an average and an excellent performance. Thus, the development of mental skills in athletes—what has become known as sport psychology—may become the next frontier for enhancing athletic performance.

Developing mental skills includes learning to: set goals, relax, use imagery, and increase the ability to concentrate and to talk positively to oneself. The most important thing to recognize is that mental preparation involves learning mental *skills*, which are learned in the same way as other skills such as driving a car, speaking a foreign language, or playing tennis. It requires knowing what to do, seeing others do it, and practicing consistently and extensively. As opposed to many other psychological approaches, sport psychology is learned less through talk than through concerted actions. Thus, the effective use of sport psychology skills cannot be learned the day of the competition.

The importance of goals. Perhaps the most important aspect of one's mental preparation is the ability to set and attain goals. For only when athletes are goal-directed can they reach athletic excellence. Goals are not the same as dreams; they are dreams acted upon. As the folksinger Si Kahn has written:

> *It's not just what you're born with,*
> *It's what you choose to bear.*
> *It's not how large your share is,*
> *But how much you can share.*
> *It's not the fights you dream of,*
> *But those you've really fought.*
> *It's not just what you're given,*
> *But what you do with what you've got.*

168

Julius Erving, when asked how he had achieved so much in basketball, responded with, "Because I dared to be great. Take a look at those you consider to be great and label them your limit. Choose to explore the boundaries of your gift, and feel the light of true creative exploration just as all artists do."

An athlete without a goal is like a computer without a program. Prior to the 1984 Olympics, Rosalynn Summers, the nineteen-year-old world figure skating champion, was asked what she believed was her greatest asset as an athlete. Her answer was, "It would be the determination, and the want. I want this and I'm going to do everything I can to get it—nothing's going to stop me. I feel that I also have great will power and drive. The desire in me to win and always be the best is so strong. That's what keeps me pushing."

However, setting a goal and attaining it are two different things. Even when an athlete is committed to a goal and works hard to attain it, energy may be expended uselessly if the goal is not developed carefully. What follows are some guidelines for effective goal-setting.

Selecting goals under your control. We need targets and directions upon which to focus our efforts. "Winning" is one such target, but it is an impractical one for several reasons. First, winning is not totally under our control. For example, most, if not all, of us would lose to Jack Nicklaus in golf no matter how well we played. Instead of setting goals based on outcomes, we should set goals that focus on our performance, such as hitting 80 percent of our drives in the fairway. By setting goals that we can control, we will not be as influenced by such factors as the opponent, the weather, the problems we may be having at home or on the job, or even luck. Second, focusing on winning may interfere with the pursuit of excellence. I have worked with athletes in a number of sports who have performed at a level equal or close to their personal best but who have been disappointed because they did not win. Should athletes feel like failures because they did not win even though their performance is a personal best? Perhaps they should be more upset when they win the next week with a much poorer performance. Tamara McKinney, an Alpine skier on the 1984 United States Olympic Team, stated the following belief, "Actually, I'm at my strongest when I don't think about who I have to beat. If I can just make it a competition within myself, I know I'm all right."

Even professional athletes who make their living by winning recognize the problems of choosing winning as *the* goal. As Julius Erving observed, "Even though winning has to be a goal, there is too much emphasis on [it] as the end result. And as a result, too many [athletes] take as many shortcuts as they can, such as cheating. Amidst all the games being played, the meat of the matter is often overlooked—that without disappointments, hard work, and sacrifice, there can be

no gain." Focusing on winning creates a reward separate from the activity itself. Focusing on attaining performance goals results in feelings of self-determination and competence.

Setting positive goals. This is an especially difficult task. Athletes often set goals such as "I don't want to be nervous before I compete," or "I don't want to double-fault as much." When the focus is on a negative goal like "not being nervous" or "not double-faulting," what eventually is emphasized is the nervousness or the double fault. Setting a negative goal almost always ensures a negative outcome. Try, for example, not to think of a piece of chocolate for thirty seconds. It is very difficult, isn't it? Now, instead of not trying to think of a piece of chocolate, concentrate on something else you want, such as an ice cream cone. It is much easier. When the focus is on something you want, the outcome is more likely to be positive.

Understanding that setting negative goals is not helpful and being able to change negative goals to positive ones are two different steps. We rarely focus on what we *want to do*. For instance, when athletes learn that they are constantly talking to themselves and are often saying things about themselves they would never let anyone else say about them, they immediately set a goal to stop talking to themselves. This is, in itself, a negative goal. Instead, the athlete should focus on talking positively and identifying what part of the performance he or she wishes to change.

Knowing what to do to reach the goal. Once the goal has been clarified, it is important to identify what actions have to be taken to reach the goal. Four specific sets of actions are possible: the athlete may need additional knowledge or information (for instance, a runner may need nutritional information to be better prepared); the athlete may need to learn additional physical and/or mental skills (a swimmer may need to improve his stroke or his ability to relax and concentrate); the athlete who fears failure may have to learn how to take the risks involved in reaching the goal (a tennis player may have to give up practicing and playing against easy opponents and face tougher competition); and the athlete may need additional support from friends and relatives to work toward the goal (a basketball player may not feel she has the support of her immediate family; they would prefer she engage in more "feminine" activities).

It is my experience that the most common roadblocks to goal attainment are athletes' lack of *mental* skills. When athletes are asked what percentage of their sport is mental, they usually answer at least 50 percent. The percentage reported seems to go up the more physically skilled the athlete is. Yet few athletes spend 10 percent, let alone 50, of their preparation time enhancing their mental skills. Many athletes create a mind-body dichotomy as far as their sports performance is concerned and concentrate only on physical practice. I often find coaches and the athletes them-

One on One. 1985. Pastel, crayon, and acrylic on paper, 18 x 22″

selves labeling an athlete's failure to achieve a particular goal as a lack of motivation or laziness. While this may be true in some cases, it is often a result of lack of concentration or self-control, both of which are mental skills.

Once it is known what must be done to reach the goal—acquire new knowledge, learn new skills, take risks, or create social support systems—a plan can be developed.

Developing a plan to attain the goal. Setting goals does not necessarily mean they will be attained. Breaking them down into small, manageable steps is essential. As an African proverb states, "The best way to eat the elephant standing in your path is to cut it up in little pieces." John Naber, a 1976 Olympic gold medal winner in swimming, described how he developed his plan to win the 100-yard backstroke while watching the 1972 Olympics. He determined that to win he would need to lower his time four seconds in four years—a formidable task. However, by careful planning he realized that if he trained ten months or so per year, he would need to lower his time a tenth of a second per month, and by training six days a week, it would be only 1/300th of a second per day. He then figured out that he would need to improve only a 1,200th of a second per hour of practice. A 1,200th of a second is less than the blink of an eye. Consequently, Naber realized that if he could improve the equivalent of one eye blink per workout, he could win the 100-yard backstroke in 1976, and he did.

Goals that provide step-by-step processes are easier to work toward since we can evaluate our progress. Goals that include specific behaviors upon which to work, and not just time criteria, provide even more clarity on what is needed for goal attainment.

What we learn from athletes. The mental skills described here are not exclusively for elite athletes. They are equally appropriate for the everyday athlete or, for that matter, the nonathlete. They are life skills. All of us have a limited amount of time and energy to invest in life activities. After evaluating our environment, motivation, skills, and biological capacities, we select a pathway for our focus. It may be athletics, school, music, some aspect of business, politics, or another career. Alternatively, we may choose to focus on improving our health, being a better spouse, or being a better parent. We can seek excellence in a number of different areas; however, the number of areas we can pursue simultaneously are limited.

We begin our pursuit by setting goals. Next time you watch athletes perform their magic, instead of wishing it were you or being in awe of their physical capabilities, consider the drive and determination involved in their achievement. You may not dunk like Dr. J. or hit a slice backhand like Martina, but you can dedicate yourself to excellence as they have. What's your game and are you ready?

172

Olympic Champion. 1984. Oil on canvas, 30 x 22″

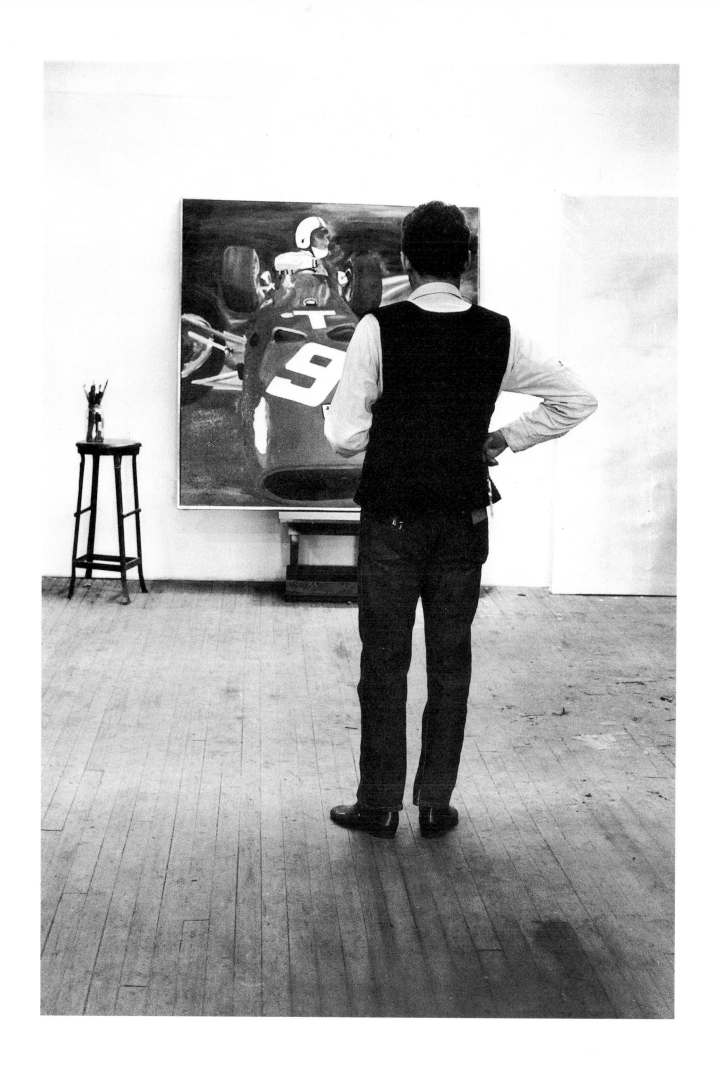

AFTERWORD

Dore Ashton

The history of art does not lack for representations of athletes, from the lithe bull throwers of Cretan murals to the jockeys of nineteenth-century French painting. The human body, or rather the *trained* human body in movement, has always attracted artists, who are themselves deeply aware of the mysterious nexus of anatomical forces that sponsors their own activity. Eye and hand, governed by the indefinably complex activity of the brain, are the source of the arts (and, as Plato made clear, the art of the equestrian as well as that of the sculptor). Appreciative visions of disciplined movements of the body were not only common in antiquity but were shared by the moderns. When Kandinsky sketched his plan for the ideal art school, he envisioned having trained circus performers, particularly acrobats, on the staff to teach the students the art of bodily coordination and the lessons of intense discipline.

Basic to all the arts, and to the art of the great athlete, is the act of attention. Poussin used to say there were two ways of looking at things: one was to look, and the other to look with attention. Dr. Joseph Wilder has spent his life looking with attention. His paintings, whether of boxers or baseball players or jockeys, show him attending to the peculiar gesture that lifts his athlete into the realm of perfection. His excitement, expressed through color and line, is the excitement of the connoisseur, and to some degree, his work is best appreciated by those who understand the beauty of an elegantly performed sport.

By an odd group of coincidences, I found myself attracted to Dr. Wilder's work: I am the daughter of a doctor who was an outstanding athlete, whose parents came to America from Russia and ran a grocery store, as did Dr. Wilder's, who practiced sports all his life and taught me most of them, and who started to paint when he was in his late thirties. As I was collecting swimming medals in my childhood and learning from my father that a "carry-through" was the essence of sport, and even of life itself, I was also noticing the qualitative differences among my cohorts. I came to understand that when my father spoke of the old French notion of *pour le sport*, it was an aesthetic notion, and it was not difficult for me to transpose it to art—for its own sake. When I look at Dr. Wilder's paintings, I respond to his unerring eye for the perfected movement, for the *characteristic* movement of the good athlete, and I think of him as an heir to all those artists in history who marveled at the myriad uses to which the human body can be put.

175

ACKNOWLEDGMENTS

Three groups have made this book possible: my family and friends, a host of individuals and organizations in the sports world, and a dedicated and talented publishing team at Harry N. Abrams and C. V. Mosby.

My wife, Cy, and our children, Cathy, Tony, Piper, Alyssa, and Nick, have long endured the smell of oil paint permeating every room in our home and have consistently been my best and most devoted critics. Cy's hard work, enthusiasm, and support in the preparation of this book have been extraordinary.

My first inspiration for painting came from the late unforgettable Zero Mostel. Other artists who stood by me with a loyalty I shall always cherish include Jim Dine, Jasper Johns, Aristodemos Kaldis, Willem de Kooning, Herb Katzman, Jimmy Ernst, Syd Solomon, and Robert Kulicke.

Members of the sports world—athletes, writers, publishers, editors—have long made me welcome in their inner sanctums and generously offered knowledge, materials, and encouragement. Again and again, they have made me one of their family. The *New York Times* Sports Department and *Sports Illustrated* have been particularly helpful over the years. I am most grateful to Dick Gangel, George Bloodgood, Joe Vechionne, Frank Litsky, Arthur Pincus, John Radosta, and Dr. Therese Southgate. At one time or another, Tom Seaver, Reggie Williams, the National Football League, the New York Yankees, the New Jersey Generals, the New York Racing Association, the U.S. Tennis Association, the National Football League, and *Sporting News* all kindly supplied background or photographic materials helpful in rendering my paintings. I would also like to pay special tribute to the great sports photographers who risk life and limb to provide us with true, life-enriching sports action images:

I am grateful to D. James Dee, who photographed, so skillfully, the majority of the paintings reproduced in this book. My thanks also to the following individuals who supplied additional photographs: eeva-inkera, Lorraine Sylvestre, Mal Warshaw (page 25), and Sheila Yurman (pages 26, 32, 174).

The making of the book was joyful from its inception. Paul Gottlieb, the President of Abrams, provided constant encouragement and support, as did his counterpart, Pat Clifford, President of Mosby. Karen Berger, Editor in Chief at Mosby, was enormously helpful in getting the book off the ground. Margaret Donovan, Senior Editor at Abrams, has been a tower of support, providing all the attributes you dream of in an editor; she has contributed an extraordinary amount of care, energy, and talent to shaping the book. Michael Hentges approached the design of the book with an amazing instinct and sensitivity, as if he had worked with me in my studio these past twenty-five years.

Finally, I want to express my appreciation and gratitude to all my other friends—unnamed here—in art, sports, and medicine who have been there for me and have helped in countless ways to make this book a reality.